JERSEY SHORE

VINTAGE IMAGES OF BYGONE DAYS

EMIL R. SALVINI

gpp

Guilford, Connecticut

Front cover photo from the collection of Robert E. Ruffolo, Jr., Princeton Antiques. Back cover photo from the author's collection.

Text design by Casey Shain

Map © 2008 Morris Book Publishing, Inc.

Library of Congress Cataloging-in-Publication Data is available on file.

ISBN 978-0-7627-4095-6

Printed in China

10 9 8 7 6 5 4 3 2 1

To my wonderful daughters Amy and Beth

To the memory of Natalie Sickels,
who loved the Jersey Shore.

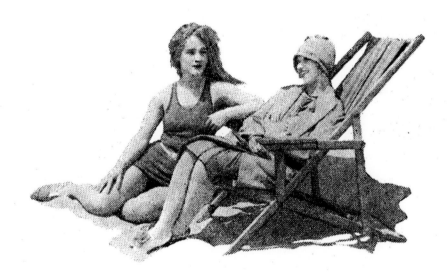

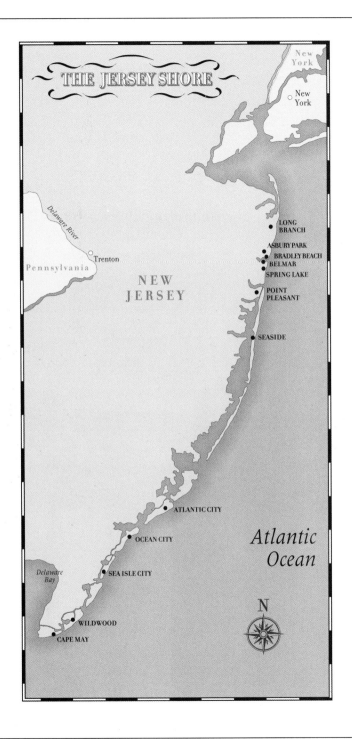

THE JERSEY SHORE

New
York

New
York

Delaware River

Trenton

Pennsylvania

NEW
JERSEY

LONG
BRANCH

ASBURY PARK
BRADLEY BEACH
BELMAR
SPRING LAKE

POINT
PLEASANT

SEASIDE

ATLANTIC CITY

OCEAN CITY

Atlantic
Ocean

Delaware
Bay

SEA ISLE CITY

WILDWOOD

CAPE MAY

N

Contents

Preface

THE NEW JERSEY SHORE IS A SUMMER PLAYGROUND where every year generations of families create treasured memories. The popular shore points begin at Sandy Hook and continue 127 miles south to Cape May Point. The shore resorts of the Garden State, not including Atlantic City, accounted for 30 percent of the $37 billion spent on tourism in New Jersey in 2006.

In the following chapters I'll take you on a journey where we will see the Jersey Shore of a bygone era. The focus of this book is its photos as photographs are windows to the past. Just as patches of colorful fabric create an heirloom quilt, vintage images form our mosaic of a vanished land of wooden elephants, palace-like steam ships, and diving horses. We will visit the unique amusements that dotted miles of boardwalks and recall the vicious storms that claimed many wooden walkways for the hungry Atlantic Ocean. From hand-carved carousels to concrete ships to a resort where canvas tents graced the seaside landscape, the Jersey Shore represents a unique rich heritage to be cherished and enjoyed.

My own love affair with the Jersey Shore began when I was a child and "down the shore" meant visiting one of the more popular north shore resorts like Asbury Park or Bradley Beach. After college when I had a family of my own, my wife and I began to venture further south and eventually landed in Cape May, a National Landmark, where hundreds of Victorian structures have survived into the twenty-first century. Our move to our summer home was the catalyst for my writing my first book on Cape May, and visits to the more than dozen unique shore points that hug the parkway as we traveled south were the impetus for my book *Boardwalk Memories, Tales of the Jersey Shore*. But there was more to be told, and here it is in this new collection.

The Jersey Shore today is a vibrant collection of summer cities that while sharing the Atlantic shoreline possess wonderfully different characters. Some, like Asbury Park and Long Branch, are reclaiming their former glory while others, like Ocean Grove and Cape May, have recognized that preserving their past has assured their future. Others, like Wildwood and Seaside, offer the quintessential Jersey Shore boardwalk amusement experience, and a few, like Spring Lake and Sea Girt, are home to breathtaking mansions by the sea. All this and more stands in wait for the hundreds of thousands of families that each summer pack the car, load the kids, and head to the beach to carve out their own Jersey Shore memories.

Acknowledgments

ALTHOUGH THIS BOOK LISTS JUST ONE AUTHOR it could not have been possible without those people who generously gave of their time and provided many of the vintage photos used in *Jersey Shore: Vintage Images of Bygone Days*. As always I am deeply indebted to my wonderful wife Nancy who cheerfully accompanied me on dozens of excursions to museums, libraries, antique shops, and historical societies. She is the first person to review my writing and her insight and constructive criticism are invaluable. I am also grateful to my daughters Amy and Beth and my son-in-law Peter, who put up with my frequent absences while I worked on the manuscript.

Jersey Shore: Vintage Images of Bygone Days was also made possible by an invaluable group of friends, collectors, librarians, archivists and Jersey Shore enthusiasts that generously shared their memories and photographs with me. A special thanks to Ann Stahl, Peter Lucia, Curtis Bashaw, Robert Ruffolo Jr., Don Stine, Beth Wooley, Chris Lepore, Joseph Bennett, Christine Moore, Linda Kay, Amy Salvini Swanson, Beth Salvini, Peter Swanson, Norris Clark, Hank Glaser, Mike Stafford, H. Gerald MacDonald, Paul Anselm, Robert J. Scully Sr., Bruce Minnix, Morey's Piers, Spring Lake Historical Society, Ocean County Historical Society, Dr. Floyd L. Moreland, Casino/Pier Breakwater Beach, Sea Isle City Historical Museum, Ocean City Historical Museum, Wildwood Historical Society, Rick Zitarosa, Jenkinson's Boardwalk, Cape May County Historical Society, Monmouth County Historical Association Library and Archives, Shirley Ayres, Troy Bianchi, Anne Burrows, Scott Nagle, Larry Samu, Jeanette M. Lloyd, The New York Public Library, Joel Bernstein, and Duke University.

I am also indebted to my publisher, The Globe Pequot Press, and especially my editors Mary Norris and Gia Manalio; the manuscript benefited a great deal from their attentions. Finally there is book designer Casey Shain, who took a manuscript and dozens of photographs and created a beautiful book.

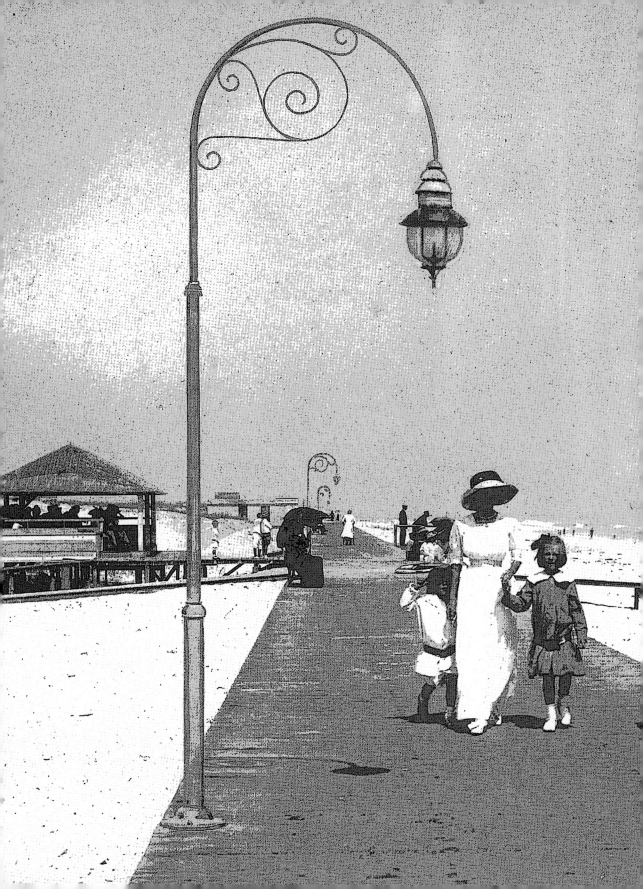

Boardwalks and Beaches

THE SHORELINE OF THE JERSEY COAST is more than 127 miles long, and there are more than 31 miles of boardwalks along the shore. The walkways come in all styles and shapes and range from the 5-mile-long mother of all boardwalks at Atlantic City to the tiny 200-foot promenade at Sea Bright.

Whatever your taste, there is a walkway to suit you. There are noisy, riotous stretches of midways that are lined with circus barkers, games of chance, amusement rides for the adventurous, with a cacophony of magical sounds that could not be confused with anything else in the world. The smell of these high-decibel wooden amusement parks by the sea could only be described as a delirious mixture of sea air, roasting peanuts, cotton candy, machine grease, and a touch of suntan lotion to boot. Pure bottled boardwalk.

For those seeking a more peaceful retreat, there are the walkways that were never commercial or those that rid themselves of the circus atmosphere over the last century. Some are no longer wood—like the just under 2-mile stretch at Spring Lake, which is composed mainly of recycled plastic. This promenade along the ocean is a haven for walkers and joggers seeking a quiet seaside experience.

Ocean Grove, the old Methodist campsite, at one time gave in to the need to attract visitors with amusements and even a camera obscura. Time and nature slowly took its toll on the Ocean Grove boardwalk, and today it is a noncommercial blend of wood and plastic and another favorite of those seeking a quiet walk along the Atlantic.

The origin of the Jersey boardwalk is based on pure practicality. Before the wooden walkways made their appearance in the mid-nineteenth century, visitors to the seaside promenaded on the sand. The medical community of the era wrote of the health-giving benefits of the sea air, and visitors could not get enough of it. Unfortunately for the owners of the posh hotels that were springing up in every resort, their guests carried the beach sand back with them on the soles of their shoes to the lobbies and rooms. The owners of the hostelries, along with the railroad conductors, were fighting a daily battle to keep the sand out of their luxury hotels and plush first-class railcars. Something had to be done.

Cape May had a "flirtation walk" in 1868 that appeared to be the answer to the problem. Its neighbor to the north, Atlantic City, was growing exponentially, and by 1870 the sand problem had become intolerable. Upwards of thirty thousand pairs of feet were carrying sand everywhere during the height of the summer season. Hotel owner Jacob Keim and railroad conductor Alexander Boardman called a meeting of the press, town government, and business owners in the spring of 1870 to propose their walkway of wood, or "board walk," as a solution to the sand problem. All in attendance agreed, and by May the city passed a resolution to spend $5,000 on a 1½-inch-thick walkway constructed just 18 inches above the sand. The 12-foot sections would be portable and moved to high ground at the end of each season. The first of five Atlantic City boardwalks was dedicated on June 26, 1870, with another new innovation, the boardwalk parade. There were no railings on the original walkways, and many a couple too busy flirting to pay attention to where they were walking took the 18-inch plunge off the edge. Serious injuries were few, but bruised egos abounded, as the newspapers loved to report the incidents.

The first boardwalks were not intended for commercial use, and many of the hotel owners were afraid that structures on the walkways would block their view of the ocean. Ordinances were passed to appease them, but it did not take long for entrepreneurs to realize the value of this manmade ocean-front property. In short time the ordinances disappeared, along with many of the hotel ocean views. Nineteenth-century alchemists discovered how to turn

sand into gold. Food and souvenir shops began to appear on the boardwalks, along with carousels and, eventually, roller coasters and Ferris wheels. Before long the ocean pier was born. An immediate success, the pier provided additional "land" for pavilions, concessions, and amusements and a place for the new luxury steamers of the day to dock.

Today the boardwalks along the Jersey coast have evolved along with the resorts that support them and reflect the culture of those towns. They have all been shaped by both humans and nature. Massive hurricanes and vicious nor'easters have taken their toll on the fragile walkways. Some resorts, such as Beach Haven, Bay Head, Stone Harbor, and Ventnor, gave up and never rebuilt. Others, like Long Branch, have chosen the lucrative condo route, and one of the oldest and most historic, Asbury Park, has been fighting its way out of poverty and neglect. For the more natural experience, there are walkways in Spring Lake, Cape May, and Ocean Grove; and for the love of the midway in all of us, there will always be Wildwood, Seaside, Ocean City, and the granddaddy of them all, Atlantic City.

MANY OF THE THOUSANDS OF TOURISTS *and vacation-home owners who visit the popular summer destination of Long Beach Island have no idea that a boardwalk once existed on their tony island. However, there were actually three successive wooden walkways at Beach Haven, the first consisting of rows of wood planks that permitted beach bathers to go between the hotel bathhouses. The wooden walkways were purely practical and were there to keep the sand out of the plush hotel lobbies back when hotels provided bathhouses on the strand and forbade guests from traveling from the beach to the hotels in bathing attire. By 1898 a more recognizable 12-foot-wide, ½-mile-long boardwalk was built, and it survived until World War I. The wooden pathway was illuminated with kerosene lamps, and a lamplighter was hired by the town to keep the lamps filled, clean, and lit after sunset. When in 1907 Beach Haven invested in an acetylene gas plant, the boardwalk benefitted. This early-twentieth-century image shows how the resort installed ornate gooseneck*

gas lamps along its boardwalk. The town expanded in 1914, when the newly constructed causeway opened the island to automobile traffic, and a new walkway was needed. The new boardwalk, just a little bit longer than a mile, was completed in 1917. The new walk became the place to be seen in your Sunday best, and in a short time a few businesses took advantage of the beachfront location.

During its glory years, the Beach Haven boardwalk had an ice cream parlor, a small amusement arcade, a dress shop, a store, and, in the early days, a Japanese novelty shop. The Edwardian-era public wanted to feel exotic, and few boardwalks did not possess such a store full of trinkets, pottery, bamboo fans, kimonos, and, of course, fireworks.

The Beach Haven boardwalk, along with its handful of shops, was claimed by the unpredictable Atlantic Ocean during the Great Atlantic Hurricane of 1944. Nothing remained but tattered pilings. Although the town debated the topic for years, it was decided that it would be too costly to rebuild.

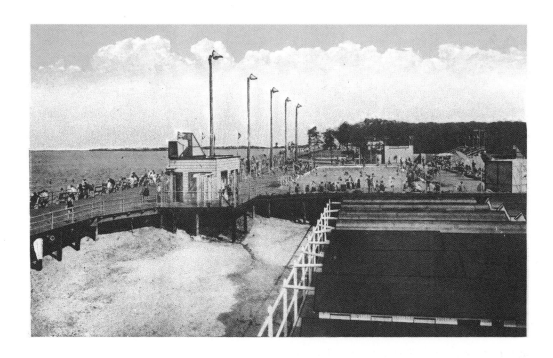

ANOTHER JERSEY BOARDWALK GHOST IS SPORTLAND POOL *and the old wooden walkway at Cliffwood Beach. Located in Monmouth County, Cliffwood is a Raritan Bay town and was a popular resort for New York tourists before the bay was spanned and families could conveniently travel south to the big-name ocean resorts. The boardwalk was built in 1924 to help sell building lots, and at one time it was 24 feet wide and spanned more than 500 feet. A popular restaurant formed the northern boundary, and the Casino was located at the southern end. The walkway hosted baby parades to crowds of tens of thousands. In 1929 George Kojac, the world's backstroke champion, broke the world's record for the 100-yard distance swim in the saltwater pool located along the boardwalk. The Cliffwood Beach boardwalk was battered by a series of hurricanes in the 1950s and was eventually destroyed.*

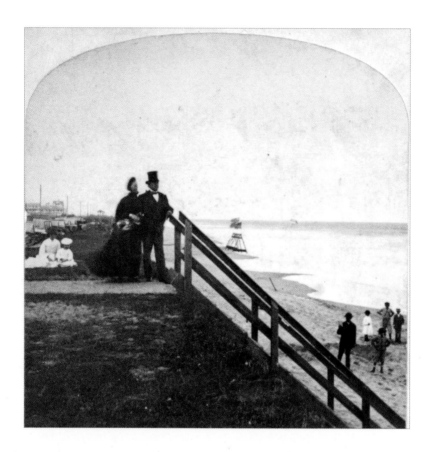

IN THIS CIRCA 1875 IMAGE OF THE FAMOUS BLUFF *at Long Branch, a Victorian-era couple enjoys the view on a summer day. Unlike most New Jersey shore resorts, which are constructed on sandbars, Long Branch is part of the mainland, with grass and majestic trees. Access to the strand was via a series of stairways built by the hotel owners. A boardwalk was not added until many years after this photograph was taken. Where is the bluff today? Years of tidal action and erosion slowly destroyed the landmark and sent the sand to the north of Long Branch.*

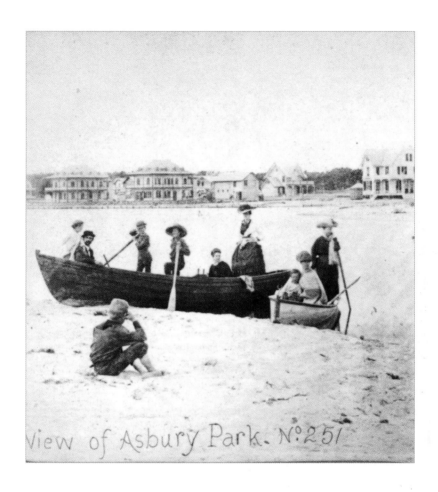

View of Asbury Park. Nº 251

ASBURY PARK HAD ONE OF THE EARLIEST BOARDWALKS *on the northern Jersey Shore, and it can be seen positioned along the beach in front of the cottages. The first walkways were often just portable paths of wood that kept the sand out of the cottages and hotels. Here, in this photo taken circa 1890, a family takes a moment from their Asbury Park vacation to pose in one of the lifeguard boats. A young child and his mother sit in the small children's boat to the right.*

THE LARGE AND REPUTABLE HOTELS *along the beachfronts would not permit their guests to travel between the beach and the plush buildings in bathing garb. They built bathhouses to provide a convenient place for guests to change, and most rented robes, along with flannel and wool bathing suits. Fines were levied by the resorts on those who were caught on the street in bathing costumes. As train travel improved and day-trippers arrived on the scene, they needed a place to change into their suits. Their bathhouses were separated from the cottage owners and hotel guest facilities, which were of a higher caliber. The Stockton Hotel, built in Cape May in 1869 by the West Jersey Railroad, could accommodate almost five hundred guests. Pictured here are the Stockton Baths, built in the late 1870s. During this era Cape May had more than two thousand bathhouses along its famous strand. Notice the heavy flannel suits drying on the lines above the bathhouses.*

THE ATLANTIC CITY BOARDWALK *was known for its magnificent piers; one of the most famous was Young's Million Dollar Pier. John Lake Young began his career in Atlantic City working for famed carousel creator Gustav Dentzel. He recognized the profit potential in amusements and began a series of ventures with a friend, Stewart McShea, who provided the capital. In 1906 Young opened his Million Dollar Pier at the end of Arkansas Avenue. The imposing pier, with its three-story corner towers, was the wonder of Atlantic City and was described by historian William McMahon as "a glittering palace with the world's largest ballroom, a hippodrome, exhibit hall, Greek temple, the city's first aquarium and deep sea net hauls." Teddy Roosevelt took advantage of the pier's popularity to give a campaign speech in 1912, and Harry Houdini was the house magician. The hippodrome featured live entertainment well into the twentieth century, when Ethel Barrymore and Al Jolson would play the Million Dollar Pier.*

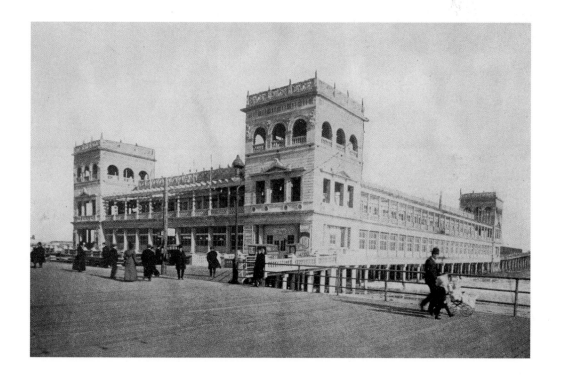

THE WEEKLY SURF MEETING *at Ocean Grove. Every Sunday at 6:00 p.m. sharp, a surfside service was held at the pavilion located at the foot of Ocean Pathway in Ocean Grove, which had been founded as a Methodist camp meeting site in 1869. The pathway was an expansive walkway that led from the ocean to the Great Auditorium, the center of worship in the resort. Thousands,* *many who resided in canvas tents for the summer season, would attend the weekly meetings and sing hymns while waiting for the sermon. Driving was not permitted on the Sabbath, so the faithful would leave their horses and carriages home and walk to the service. This stereograph shows a crowd in the late nineteenth century, with standing room only on the pavilion roof.*

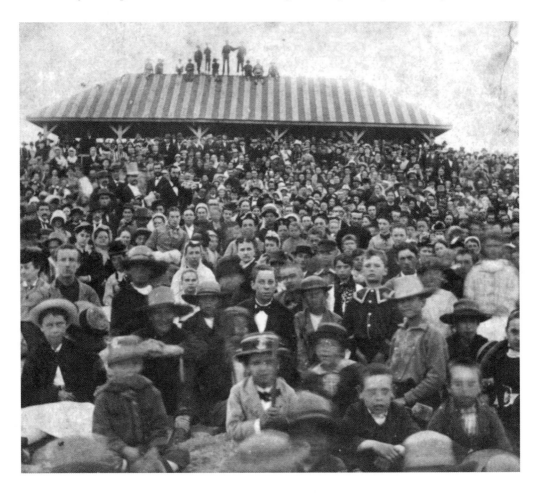

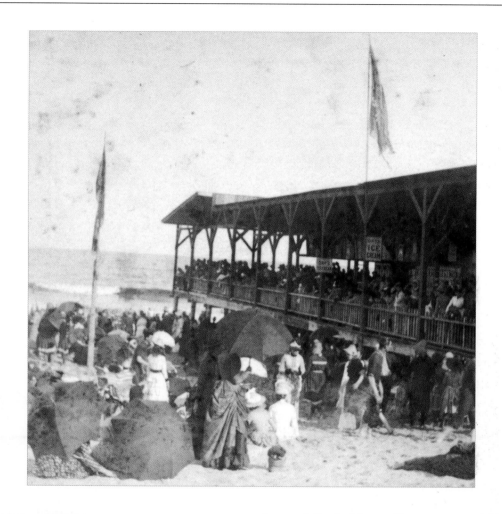

ALTHOUGH THE FOCUS OF OCEAN GROVE was religion, there was an element of pleasure along the beautiful Atlantic Ocean. Joseph Ross, a local businessman, recognized the potential of improving the amusement facilities available to the Methodists during the other six days of the week. He leased bathing concessions from the Ocean Grove Camp Meeting Association (wisely, the association never sold land) and built one of the resort's first bathing pavilions. Ross opened the pavilion at the northern boundary of Ocean Grove and filled his new enterprise with benches for his patrons to enjoy the refreshing sea breeze, gaze at the people below, and share the latest gossip. He also provided bathhouses and a small food concession that sold ice cream and cold drinks. Shown here is Ross Pavilion circa 1890.

ATLANTIC CITY PUT THE B IN BOARDWALK *when the resort passed a city ordinance in 1896 adopting Boardwalk as an official street name. Everything was done in a big way, as can be seen in this early view of the gargantuan Steel Pier. All other beach pavilions along the Jersey Shore paled in comparison. What other resort could top the opening of the Steel Pier, which in 1898 presented famed sharpshooter Annie Oakley, who gave a demonstration to thousands? The pier itself stretched 1,600 feet over the beach and ocean from Boardwalk at Virginia Avenue, and the double-decker structure was covered with a wooden deck to shade the patrons. The owners created a new business model for the era: Instead of paying individually to play each amusement or to see a live act, there was one charge, 10 cents, for admittance to all of the attractions. The second-floor esplanade was filled with benches for those seeking a refreshing sea breeze, and, of course, the opportunity to have the best vantage point to "people watch." The first floor contained all of the action, such as a 12,000-square-foot dance pavilion and a theater known as the Casino, where all of the big-name acts of the era appeared. There was even an aquarium stocked with sea lions. The pier was covered with thousands of miniature electric lights and could be seen for miles on a clear evening. The trademarks of the Steel Pier were the High Diving Horse, an act in which horse and rider dove 45 feet from an elevated platform into an 11-foot-deep tank, and the famous Diving Bell, where up to fifteen anxious but excited people took a trip beneath the waves. Almost every celebrity from Frank Sinatra to the Beach Boys performed at one time or another at the Steel Pier. As this photo (circa 1900) demonstrates, beach lovers could picnic in the shade of the pier for free.*

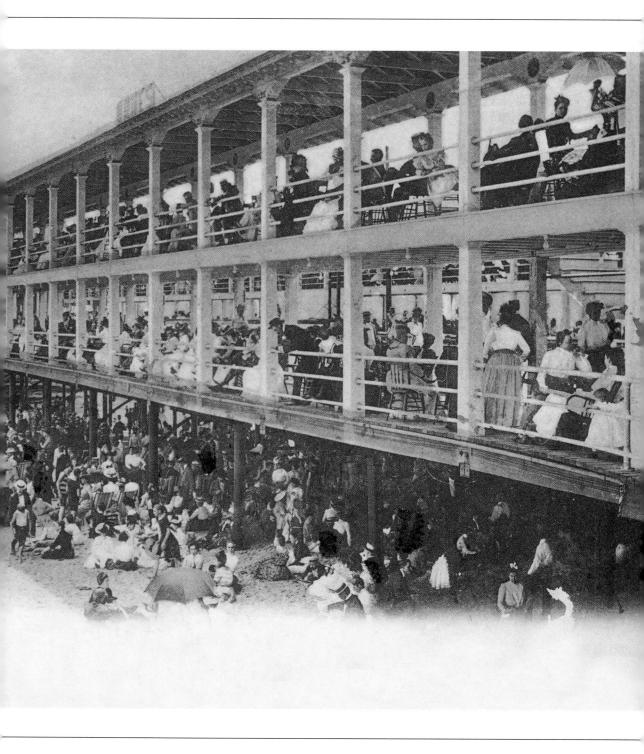

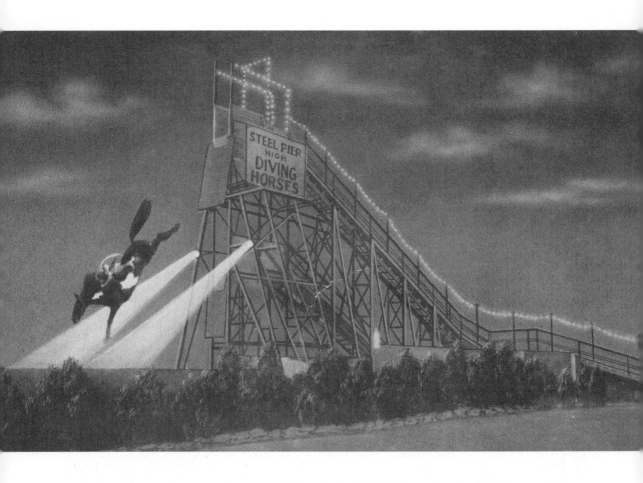

WHEN I THINK OF THE STEEL PIER *and the High Diving Horse and rider, it is difficult not to imagine a farm boy from the Midwest in the 1930s who not only sees the ocean for the first time but also writes home to his mother that he saw a woman on a horse jump 45 feet into a tank of water. Only in Atlantic City. As can be seen in this 1940s stylized postcard, the horses and riders dove day and night at the great Steel Pier. The act was booked in 1929 for one week only but was so popular that it became a fixture and the most popular attraction until the pier closed in 1978. The managers would battle over the decades with the SPCA, but they pledged to the animal rights group that the horses were treated like royalty and that no animal was ever hurt during the almost half century that the act was in existence.*

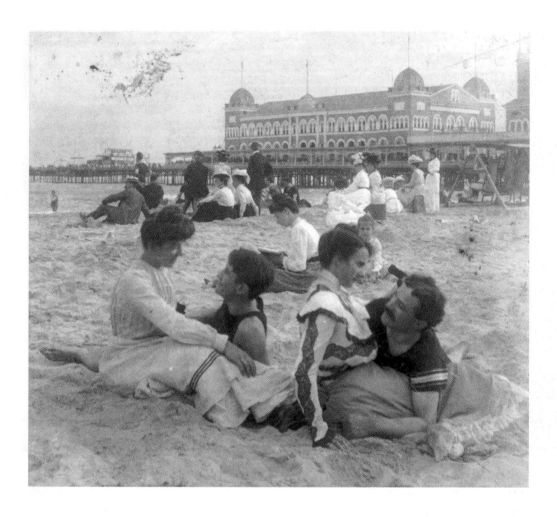

THE STEREOGRAPH READS "LOVE AT THE SEASIDE—*Atlantic City, NJ"*
and was taken in 1902. The great resorts like Atlantic City spent millions of dol-
lars creating the allusion in their advertising that true love was to be found on
the boardwalk and beach. Occasionally, a wedding engagement would take place
at the end of a season, and the local public relations firms saw that the story was
placed with their contacts at the large city newspapers.

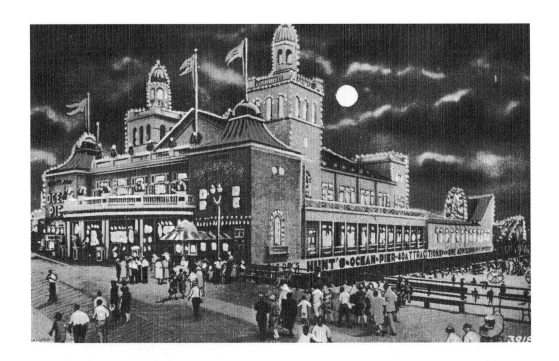

WILDWOOD'S OCEAN PIER WAS BUILT *in the 1905–1906 season and was the center for amusements and socializing on the boardwalk. It was located between Juniper and Poplar Avenues and offered everything from bowling to dancing to Skee-Ball. By the early 1920s it became Wildwood's modified version of George Tilyou's Steeplechase Park. So popular was the landmark that it was moved along with the boardwalk as the Wildwood beach grew each year from the sand flow of the Atlantic. After struggling during the Great Depression, it had been taken over by showman Bill Hunt, who quickly christened it Hunt's*

New Ocean Pier. The boardwalk monster was something to be seen at night, as pictured here, with thousands of lightbulbs outlining the structure. Hunt hired William Fennan, who had managed the Steeplechase Pier in Atlantic City for twenty-five years, and they immediately turned Hunt's into a second-to-none amusement center. Seen on the far right of this image is the giant Kelly Slide, which they added to the end of the pier. Their bold announcement written on the side of the pier was 40 ATTRACTIONS FOR THE PRICE OF ONE. *The pier burned to the ground in a terrible boardwalk inferno on Christmas Day 1943.*

PAVILIONS WERE PART OF THE MAJOR BOARDWALKS, *and pictured here is an early view of the Seventh Avenue Pavilion in Asbury Park during the resort's heyday in 1900. It was an early-twentieth-century tradition that the high-society cottagers and hotel residents would dress up in their finest for the noonday stroll past the pavilion and along the wooded walkway. The second-floor, rounded corner of the building provided the best location for an ocean view, a sea breeze, and people watching.*

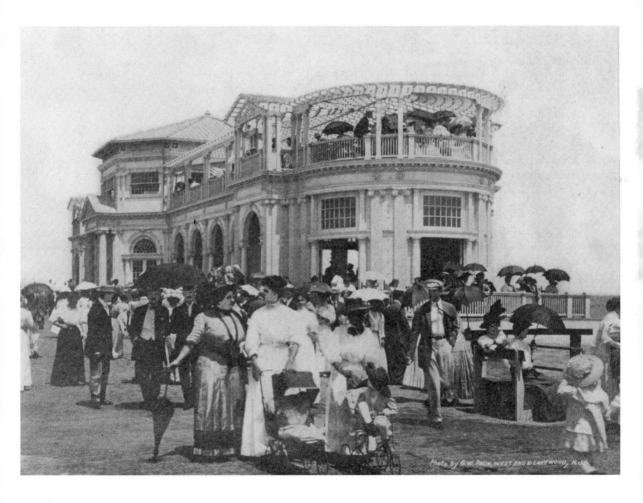

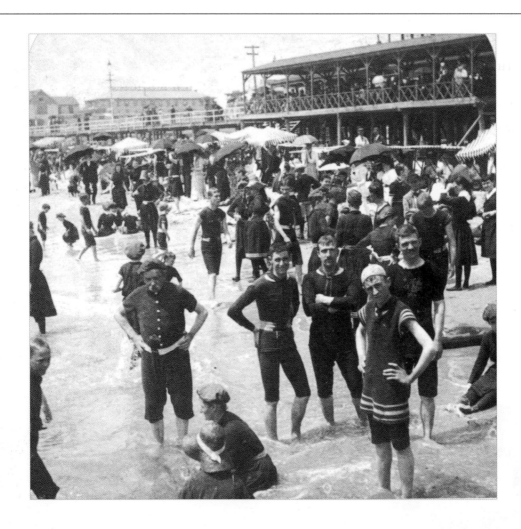

THIS STEREOGRAPH STATES, *"We love to bathe in the ocean wave." By 1901 Atlantic City was America's Playground, and millions crowded the beach every year. Automobiles were in their infancy, and Atlantic City's train transportation monopoly guaranteed a steady flow of all-season tourists, along with the "shoobies," or day-trippers. The hotel and restaurant owners disdained the shoobies because they brought their lunches in shoe* *boxes (thus the name) and only used the beach for the day. No money to be made with that lot. Faster train travel was a two-edged sword and now permitted Philadelphians to visit the beach for just a day. This photo portrays an innocent era as these young men enjoyed the surf with no thought that two world wars were on the horizon and that the automobile and airplane would soon change their summer playground forever.*

THE PAVILION AT LONG BRANCH. *By the time this image was taken circa 1918, Long Branch had lost its famous bluffs along with the gamblers and fast money that had made it the most successful resort in New Jersey in the mid-nineteenth century. Its racetrack closed when gambling in the state was prohibited in 1897. No longer the summer playground of seven U.S. presidents, Long Branch struggled to reinvent itself. The resort's promoters were advertising the "New Long Branch," and the town added a boardwalk, pictured here, in an unsuccessful attempt to compete with Asbury Park, Cape May, and Atlantic City. The old pier was replaced using the carcass of the original, and the promise to make the pier and Long Branch a first-class amusement center never materialized. Today the pier is gone, and condominiums cover the oceanfront.*

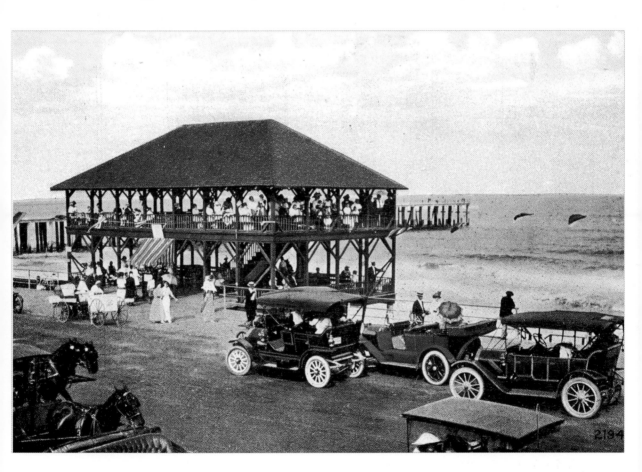

THE ASBURY PARK BOARDWALK *in all of its glory on a summer day in 1919. The commercial development of the walkway had been hindered by founder James A. Bradley, who had strong ideas on every subject, from couples holding hands on his boardwalk to the sale of hot dogs, which he banned from his walkway on Sundays. Bradley, who liked to be referred to as the "Founder," never lived in the resort but would travel daily by train from his apartment in Manhattan to watch over his creation. Once the city government purchased the beachfront and boardwalk from the Founder in 1903, the walkway grew exponentially.*

This wonderful view looking north shows in the upper right the beautiful Natatorium, which was home to a massive saltwater pool and a collection of shops. Behind the Natatorium can be seen the Asbury Park Steeplechase, the forerunner to the modern roller coaster. Opposite the Natatorium on the beach can be seen the octagonal mini-pavilions that were created on the edge of the boardwalk to provide a place to escape the summer sun and watch the crowds on the beach. Each day and evening men with their dapper white straw hats and women in their summer linens would "promenade" the mile-long boardwalk. The stand in the center of the photograph was a refreshing oasis on a stifling day, providing ice-cold root beer, orange juice, and ginger brew.

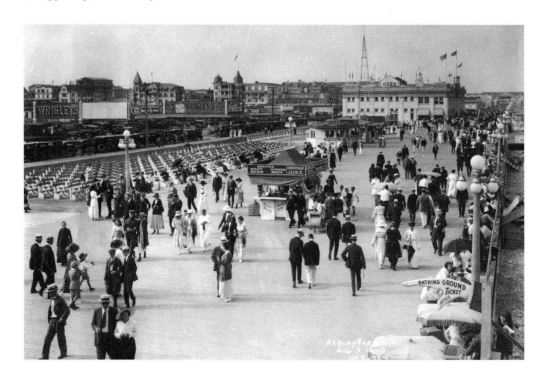

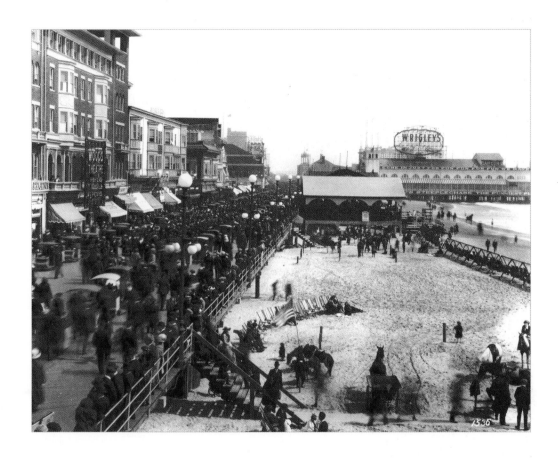

THE RESORT OF ATLANTIC CITY WAS *successful because it offered everything from the unique Steeplechase Pier, on the right hand side of this circa 1920 image, to pony and horse rides on the beach and along the surf. The walkway, which became the place to be seen, is mobbed with rolling chairs. People watchers can be seen lined with their backs to the iron railings. The Woods Theatre on the boardwalk promises first-class vaudeville pictures. The two white domes at the center of the photograph were the top of the boardwalk entrance to the Steel Pier. Wrigley's and other companies took advantage of the popularity of the piers and would rent space on top for massive signs that were illuminated with hundreds of lights in the evening.*

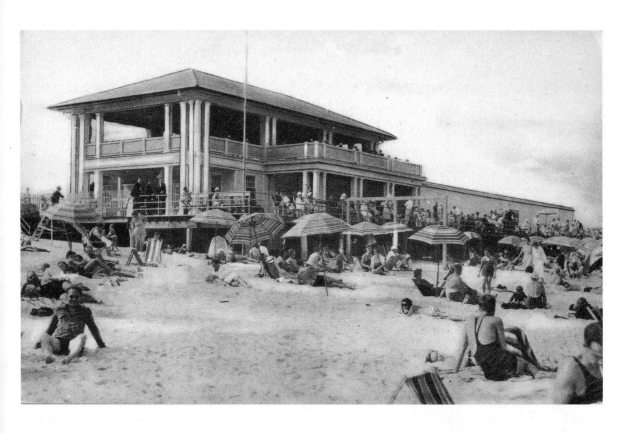

THE BEACH AT THE PICTURESQUE TOWN *of Sea Girt features a ¾-mile-long noncommercial boardwalk. Residents of the tony town like the nontourist atmosphere of their community, and the price of property in the 1-square-mile resort has skyrocketed over the last few years. Sea Girt is today the territory of Manhattan hedge fund managers, private bankers, and those fortunate enough to own property before the boom. The town is separated from its equally wealthy neighbor to the north, Spring Lake, by Wreck Pond. This mid-twentieth-century image shows a day on the beach at Sea Girt and the old pavilion.*

THE BEACH AT SPRING LAKE *in the early twentieth century. Spring Lake's boardwalk is also noncommercial, decreed so by the city fathers circa 1900, anchored on the north and south by two large pavilions complete with swimming pools and bathhouses. The beach was the site of one of the famous shark attacks in 1916 when Charles Bruder, a popular hotel bell captain, was attacked and killed by what was believed to be a great white shark just a thousand feet offshore. The old Essex and Sussex Hotel can be seen in the left of the image.*

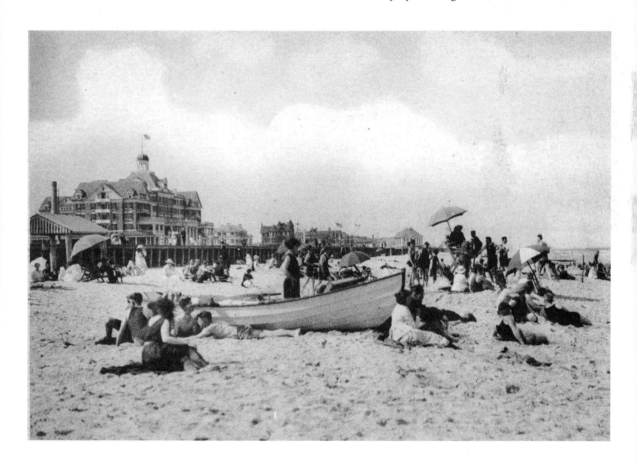

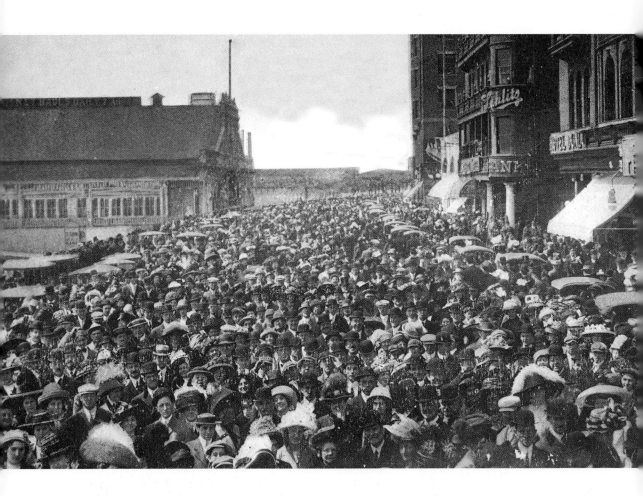

A BUSY DAY AT THE TURN *of the century on the Atlantic City boardwalk in front of Young's Million Dollar Pier. Atlantic City had a total of five boardwalks, with the first built in 1870 and the fifth and final in 1896. While other Jersey coast resorts such as Wildwood, Ocean City, and Asbury Park could boast of popular wooden walkways, no city on the Jersey Coast has anything the size and scale of Atlantic City's: On a hot summer day, "America's Playground" would host tens of thousands of travelers from around the nation.*

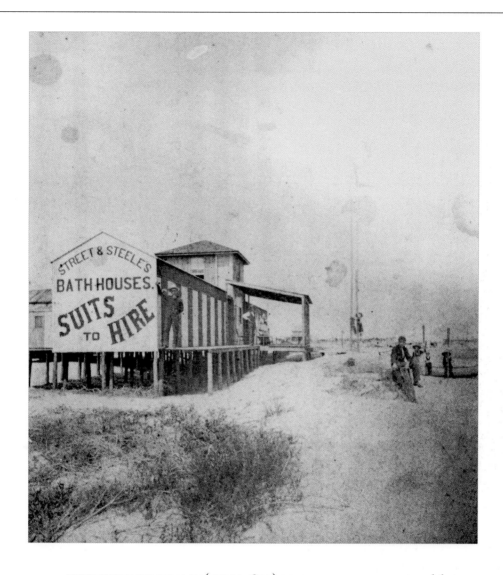

THIS VENERABLE IMAGE (CIRCA 1890) DEPICTS THE BARREN *strand that was Ocean City, New Jersey, when people first started sea bathing. It was essential for every fledging resort to offer a bathhouse for changing. The enterprising Street and Steele partnership also offered "suits for hire." Ice-cream and root beer concessions followed and, soon after, souvenirs. Many establishments like this were dismantled at the end of the season and dragged to high ground for the stormy winter.*

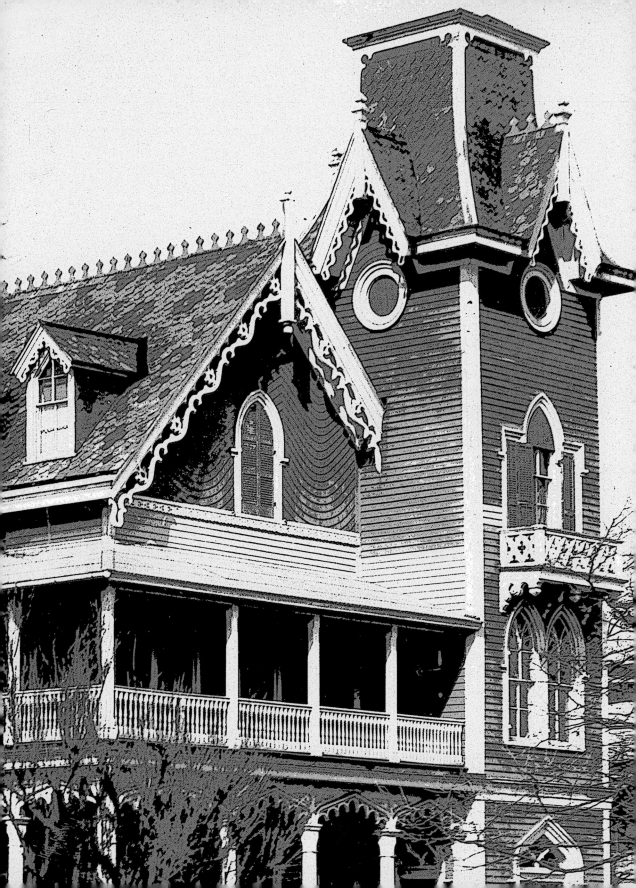

Architecture

THE HOMES AND HOTELS ALONG THE 127-MILE-LONG New Jersey Shore region vary from the massive modern glass-and-steel hotels in Atlantic City to the quaint gingerbread cottages in Cape May, Spring Lake, and Ocean Grove. The latter resorts fortuitously preserved their nineteenth-century structures and are now nationally known for their Victorian cottages, many used as bed-and-breakfasts and guesthouses. Other resorts fell out of favor for a host of reasons over time, lost their architectural heritage, and are now landscaped with condominiums, town houses, and "McMansions."

The original "business model" for resorts drove the early architecture. Land speculators would buy up remote farmland along the sea for pennies on the dollar. The first primitive hotels would be built to shelter the new guests. Eventually, the farms were subdivided into streets and avenues, creating a seaside canvas for the first cottages, boardinghouses, and retail establishments. The next and most important step was to obtain the lifeline of the summer trade—a railroad connection. Many of the original hotels were built by land development companies that were in turn owned by the railroads. The traditional L-shaped structure became popular, as it provided the best ocean views and sea breezes in days before air-conditioning.

Atlantic City, the quintessential railroad resort, was created when speculators realized that the direct route to connect Philadelphians to the Atlantic Ocean was a railroad from Philadelphia to remote Absecon Island. Five hotels were already awaiting tourists when the first train arrived in July 1854. The

original hotels were plain frame buildings no more than three stories: the Atlantic House, Bedloe House, Ocean House, Cottage Retreat, and United States Hotel. Fifty-foot-high sand dunes separated them from the ocean.

In Cape May, the original Congress Hall (the current structure is the third of that name) was completed in 1816 and was known as the Big House or the Large House. Locals referred to it as "Tommy's Folly," after its owner, Thomas H. Hughes. They believed he would never find the hundred guests needed to fill his hotel. The joke was on them, for the barnlike structure, approximately 100 feet long by 30 feet wide and void of paint and plaster, was filled to capacity as soon as it was opened. The first floor was used for dining and food preparation, and guest rooms filled the second and third stories.

By 1838 Cape May did not have enough hotel capacity, as described in the journal of Miss Sarah A. McAllister: "[The Mansion House was] crowded; we are obliged to sleep over a half mile away and come to the hotel for meals; the omnibus came at 7:00 a.m. and did not return until 11:00 p.m."

It was not unusual for the architecture of a new resort to reflect the beliefs of the founders, as in Ocean Grove. Created as a Methodist retreat, Ocean Grove at first was dotted by canvas tents. The tents were so plentiful that the resort became known as the "little canvas village." In 1892 the author Stephen Crane wrote in the *New York Tribune*: "The cool, shaded auditorium will soon begin to palpitate with the efforts of famous preachers delivering doctrines to thousands of worshippers. The tents, of which there are hundreds, are beginning to rear their white heads under the trees."

The auditorium that Crane referred to was the Great Auditorium, completed in 1894 and the house of worship for those tent dwellers. As the resort evolved, unassuming, gingerbread-style cottages and hotels began to appear in the canvas village. Few could afford to hire architects to design mansions by the sea, so many chose to work with local builders, who worked from pattern books—plan books that builders and owners could use without the services of an architect. Pattern-book homes became very popular in the late nineteenth and early twentieth centuries. These charming, modest homes exist in every town along the coast. Cape May and Ocean Grove are fortunate, in that so many of their pattern houses still exist today.

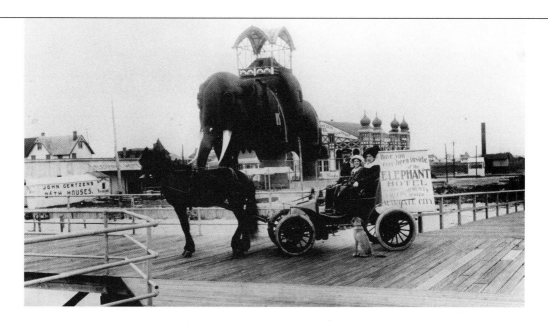

Several resorts along the coast benefited from the 1876 Centennial Exposition held in Philadelphia. After the event came to a close, the organizers found themselves with grand buildings on their hands, so they sold them to the highest bidders. Known as "Centennial relics," they were dismantled and transported by rail in an era when labor was less expensive than lumber. Spring Lake benefited by acquiring four of these relics: the Department of Public Comfort Building, the Missouri State Building, the Portuguese Government Pavilion, and the New Hampshire State Building.

In the late nineteenth century, "elephant hotels" became a fad, and three were built along the New Jersey/New York coast. Lucy, the first, built in 1881 in Atlantic City, was used as a real estate gimmick to market land in the southern section of the resort, which later became Margate. The next was Elephantine Colossus, which was constructed in 1884 in Coney Island, New York, and boasted thirty-four guest rooms. The Light of Asia was built the same year in Cape May. The former was lost in a fire in 1896, and the latter was razed in 1900. As Coney Island became associated with disreputable behavior, its elephant hotel was used for a time as a brothel. "Seeing the elephant" became synonymous with an adventure that you would not discuss with your wife or children.

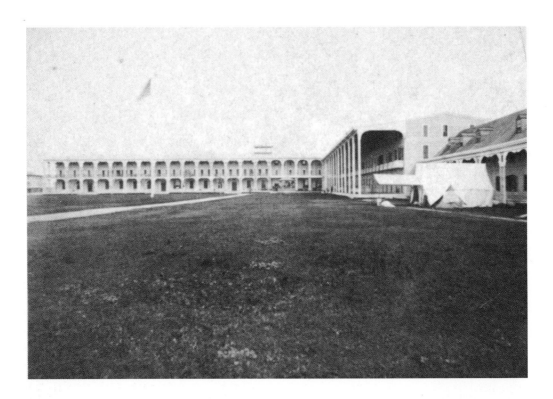

THE ORIGINAL HOTELS ALONG *the Jersey coast were great barnlike structures built in the shape of an L to maximize the ocean view and refreshing sea breezes. Many were whitewashed, lacked plaster and lathe on the interior walls, and were strictly functional, with separate sleeping quarters for men and women and cavernous dining halls to accommodate the ravenous travelers. Thomas H. Hughes built the Big House in Cape May in 1816. It was later christened Congress Hall in 1828 and was advertised as one of the largest hotels in the United States. Pictured here is a rare stereograph of the* original hotel, which was lost in the Great Cape May Fire of 1878 that destroyed most of the resort. The hotel was rebuilt after the fire as a smaller version of the original, employing brick construction to reduce the chance of another fire. During the latter part of the twentieth century, the hotel fell victim to neglect due to financial problems. After years of battling with a handful of unhappy neighbors who could not agree on an acceptable plan, the owners lovingly restored the hotel to its former grandeur, and Congress Hall opened in 2002 as one of the resort's most beautiful destinations.*

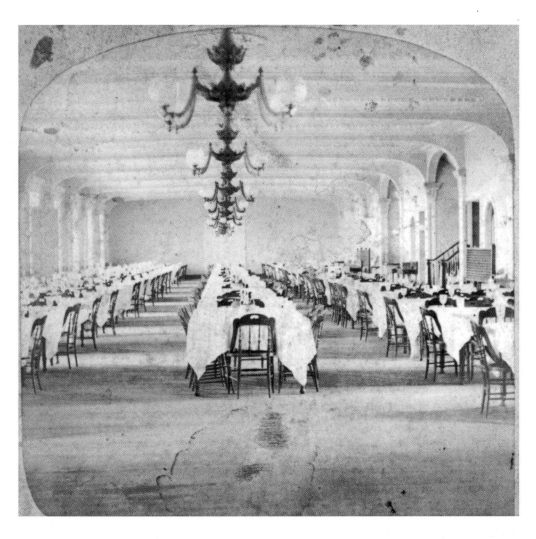

BY THE TIME THIS DINING HALL *photograph was taken of the original Congress Hall in Cape May around 1870, amenities such as plaster walls and the latest in gas chandeliers had been added. An old history of Cape May states that in the early years of the hotel, not a piece of beef was served all season long. Guests enjoyed fresh vegetables from the Cape May farmlands, along with the bounty of the sea and sky. The entire hotel was lost in the 1878 fire.*

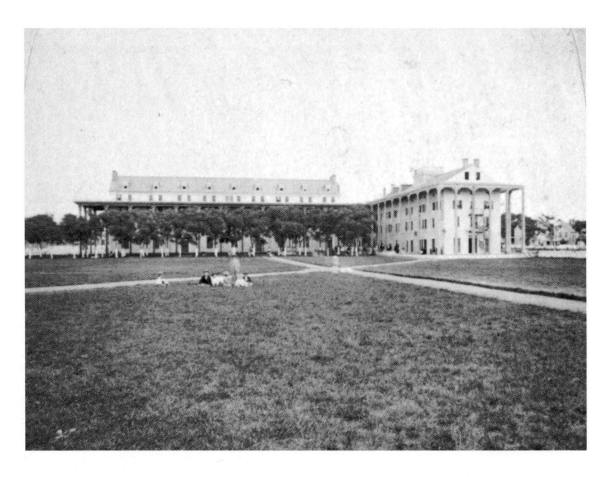

ANOTHER EARLY-NINETEENTH-CENTURY hotel in Cape May was the picturesque Columbia House, built in 1846 for Captain George Hildreth. The tree-lined property was located between Decatur and Ocean Streets. In 1864 investor John C. Bullitt, along with Frederick Fairthorne, acquired the Columbia and hired noted architect Stephen Decatur Button to give the hotel a facelift. It immediately became one of the popular watering spots on Cape Island. A horrific fire in 1869 destroyed numerous Cape May landmarks. The owners of the Columbia drenched the old wooden hotel with buckets of water from their artesian wells and were dragging out the furniture when fate smiled on them and the wind shifted, sparing the building. Sadly, a fire did claim Columbia House eventually, along with Congress Hall and thirty-five acres of cottages, hotels, and commercial property—in 1878.

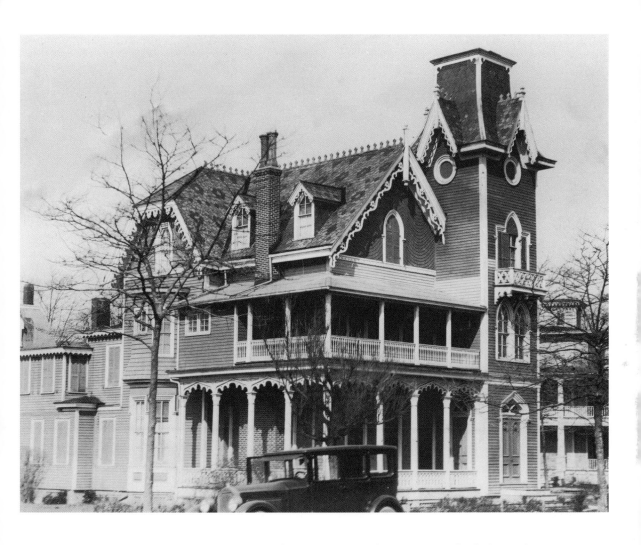

STEPHEN DECATUR BUTTON WAS *the most influential architect involved in the development of the oldest resort on the Jersey coast, Cape May. It is estimated that over three decades the Philadelphia architect designed more than forty buildings in the tiny resort, ranging from massive hotels to summer cottages. His influence was even* *greater because pattern books featured structures that had the Button imprint. One of his surviving masterpieces is the John McCreary House, pictured here, located at Columbia Avenue and Gurney Street. McCreary was a coal baron who resided in Philadelphia and summered in Cape May.*

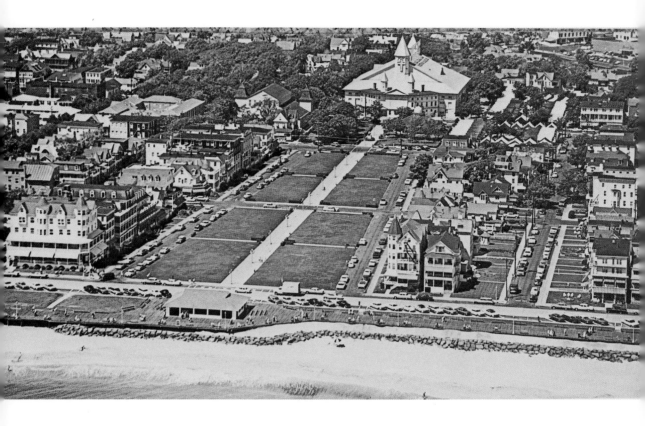

OCEAN GROVE, ON THE NORTHERN *Jersey Shore, is considered by many to be a miniature version of Cape May, with its charming tree-lined streets and dozens of Victorian cottages. The Great Auditorium, pictured here, along with the Ocean Pathway, was constructed in just ninety-two working days in 1894. While on the job, the contractors agreed to refrain from using profanities, and no work was ever done on the Sabbath. The faithful would meet for Sunday evening "surfside meetings" at the end of the Pathway, which gently widens to connect the Atlantic to the Almighty.*

The Great Auditorium is 225 feet long and 161 feet wide. The interior is almost six-tenths of an acre, with almost 100 doors and 164 windows. The spectacular ceiling is made of southern hard pine wainscot, and the building has a total seating capacity, when folding chairs are included, of almost ten thousand people. The auditorium has more than a thousand incandescent lights, and in 1907 the front of the Great Auditorium was extended to accommodate the gigantic Hope-Jones pipe organ, which at the time was one of the largest in the world.

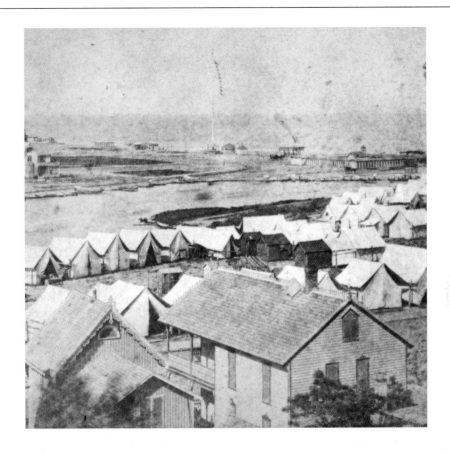

A VINTAGE BIRD'S-EYE VIEW OF *Ocean Grove and its sister resort, Asbury Park. Ocean Grove became known as the "little canvas village," because of its origins as a Methodist camp meeting/tent village. The town was structured after a similar resort, Oak Bluffs, on the island of Martha's Vineyard, Massachusetts. At one time, more than six hundred tents were erected each season for the religious meetings held at the end of August. Today, approximately 114 remain, and they are in great demand, most passing from one generation to the next. The tents are alike on the outside but have the stamp of their owners' personalities inside. The Ocean Grove Camp Meeting Association never sells the land but provides long-term leases, thus guaranteeing control. That control was tested in the late 1970s, when the association's "no driving on Sunday" law was challenged. The New Jersey State Supreme Court decided the Ocean Grove government was unconstitutional, based on the principle of separation of church and state, and terminated the robust civil powers yielded by the association.*

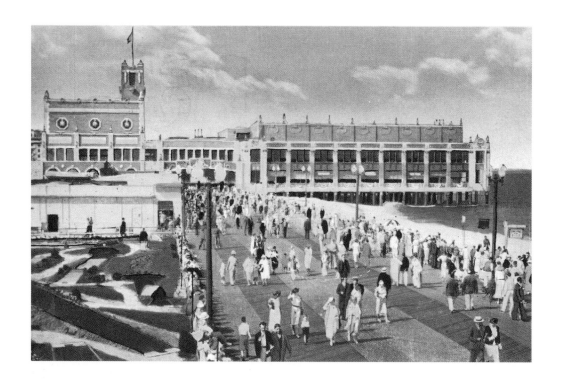

THE CONVENTION BUSINESS WAS *lucrative and coveted by the competing resorts along the Jersey Shore. Officials in Asbury Park had discussed plans for a modern convention center for more than a decade before they settled on a design. The city government eventually hired noted architects Warren and Wetmore, the firm that designed New York's Grand Central Station, to build Convention Hall in 1930. The new convention center would define the northern end of the walkway by crossing over the boardwalk and extending over the Atlantic Ocean, as seen in this image from the 1940s. Over the years, the Asbury Park Convention Hall played host to Glenn Miller, Gene Krupa, Tommy Dorsey, and later the Rolling Stones, the Doors, and Mr. Asbury Park himself, Bruce Springsteen.*

THE UNITED STATES HOTEL BUILT IN *Long Branch in 1852 was the quintessential seaside resort. Although it was originally built as a three-story structure with a traditional hip roof, a fourth floor was added before this image was taken in 1870—a small section of the original older hotel can be seen at the far left of this stereograph. Instead of offering the usual Jersey Shore food that was standard for the era, the hotel hired the chef of the noted St. Nicholas Hotel in New York City.*

There were expansive piazzas with ocean views on three sides of the hotel, a house orchestra for daily music and the three weekly hops, and a well-manicured lawn, where croquet was the traditional favorite. The proprietor even provided his guests with a lifeguard in the days before towns offered the service. The hotel regulated swimming times by the use of a flag system, and there were separate times for men, women, and young children. The cost at this time during high season was $4.

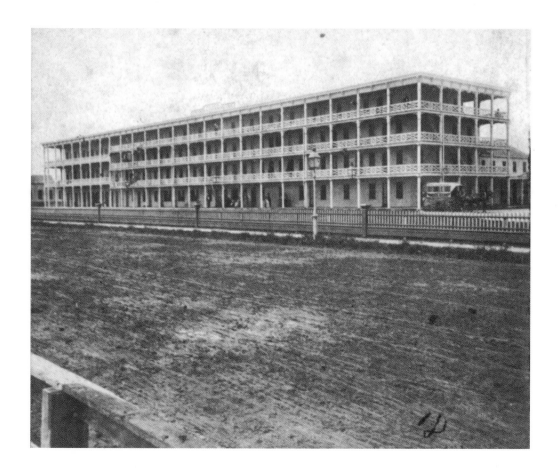

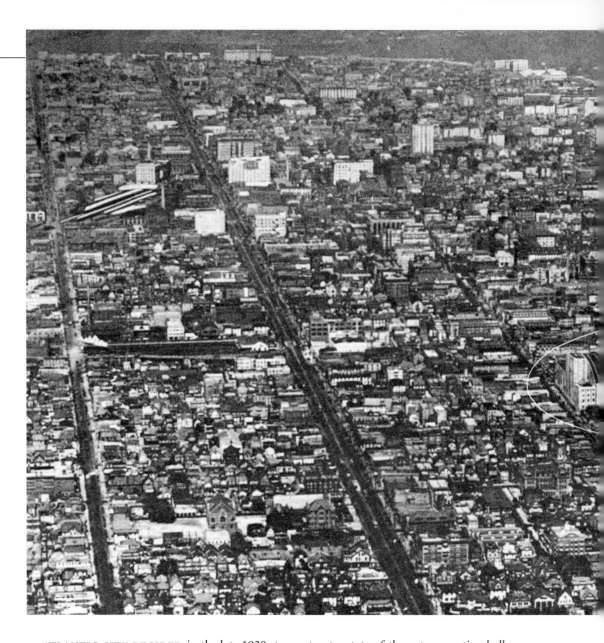

ATLANTIC CITY DECIDED *in the late 1920s to construct a state-of-the-art convention hall, officially known as the Atlantic City Auditorium. This aerial photograph depicts America's Playground at the height of its popularity, just before the automobile and better roads began to erode Atlantic City's railroad transportation monopoly. Convention Hall was not yet complete when the promotional brochure that contained this image was printed, so artistic license was taken, and the building was added and circled in white. When the auditorium opened on May 31,*

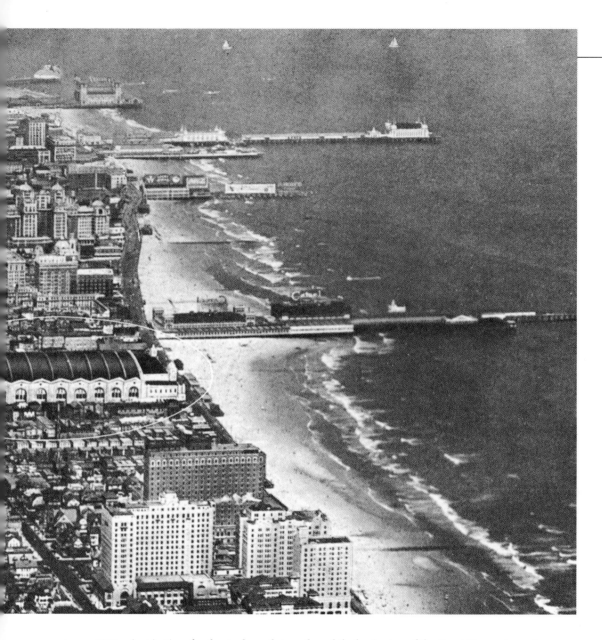

1929—just in time for the stock market crash and the beginning of the Great Depression—it was the largest building in the world without pillars and roof posts. In an effort to attract every type of conventioneer, the builders added what was the largest pipe organ in the world. The mammoth instrument boasted thirty-two thousand pipes, producing wind pressure twice that of the Liverpool Cathedral, which up to that time was the most powerful pipe organ in the world.

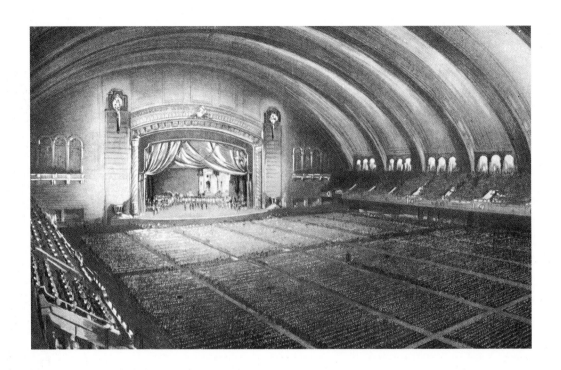

THIS DRAWING FROM A PROMOTIONAL brochure depicts how the interior of the new Convention Hall in Atlantic City would appear after completion in 1929. The building cost $10 million and occupied an entire city block, from the boardwalk to Pacific Avenue between Georgia and Mississippi Avenues. The builders bragged that the entire permanent population of Atlantic City (at the time, sixty-six thousand people) could be seated in the building with room to spare. The stage pictured here would be the largest in the world. To prove just how expansive the interior was, with typical Atlantic City flair, a helicopter flew Miss America around the inside of the massive hall in 1973.

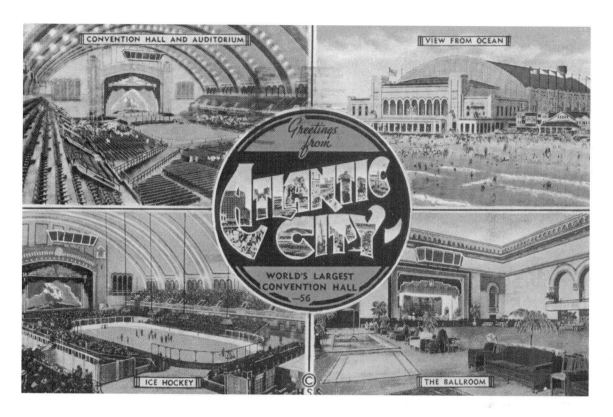

THE ATLANTIC CITY CONVENTION HALL *became a popular subject for postcards as soon as it opened in 1929. More than twelve million tons of structural steel was used to construct the auditorium, along with 42 cubic yards of concrete and ten million bricks. The promoters and builders waxed poetic at the opening of the building, writing: "It is perfect, but with the perfection of science and art, and particular the latter; for art, in its broadest sense, is the rock upon which* CONVENTION HALL *is as firmly set as the Pyramids of the Egyptian desert, or the broken stones of the Parthenon under the sunlit skies of Greece." After all, where else could you play ice hockey just feet from the beach—and that was only one of the amazing venues that the building offered.*

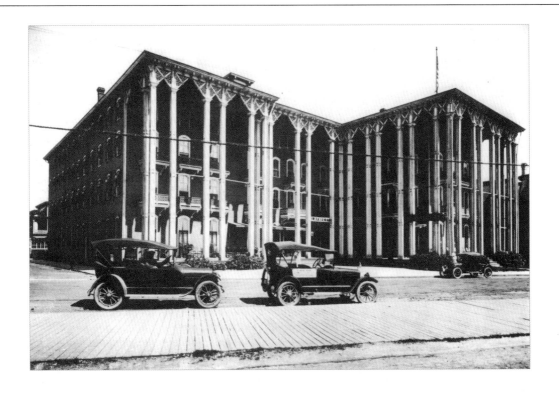

THE ORIGINAL LAFAYETTE HOTEL, *located on Beach Avenue in Cape May. Plans for the construction of the beachfront hotel were announced to the public in the* Cape May Ocean Wave *in the summer of 1882. The Lafayette was built only four years after the Great Cape May Fire of 1878 created a thirty-five-acre canvas just waiting for architects and investors to decide in which direction to take the resort. Cape May chose the conservative route and rebuilt in an architectural style that, for the most part, mimicked the pre-fire city. Stephen Decatur Button, who had designed homes and hotels in Cape May for years, was in his late sixties when he designed the traditional L-shaped, four-story hotel for owner Victor Denizot. The choice to use Button, or pattern-book, "Button-style" building plans, for the rebuilding of Cape May after the fire helped create the charming Victorian national landmark resort that is so popular today. The local newspapers described the hotel's colors as Naples yellow and Tuscan red, and the massive veranda was a Button trademark. This image shows the hotel in the early twentieth century, with horseless carriages parked on Beach Avenue along the primitive boardwalk. The hotel was razed in 1970 to make room for its namesake—a modern, unremarkable structure that could accommodate parking.*

THE TRAYMORE HOTEL IN ATLANTIC CITY *was once synonymous with the evolution of America's Playground. The hotel grew from a modest boardinghouse built in 1879 to the resort's largest hotel in 1915. Legend has it that a perennial guest of the boardinghouse, "Uncle Al" Harvey, hailed from Maryland and loved nothing more than to talk about his Baltimore estate, Traymore. When the owner of the hotel, Daniel White, began a robust expansion program in the early twentieth century, he named his massive hotel the Traymore. Concrete was becoming popular for large structures when the hotel was constructed by noted architect William Price. His firm had designed the stately Blenheim, in Atlantic City, in 1906, using reinforced concrete manufactured by a company owned by Thomas Edison. By the time the Traymore was completed, it stood fourteen stories high and added six hundred guest rooms to the busy resort. Architects marveled at how Price used concrete forms to create a smooth building facade that seemed to rise miraculously from the Jersey Shore beachfront and took maximum advantage of the ocean views. A newspaper article in the 1920s referred to the Traymore as the Taj Mahal of Atlantic City.*

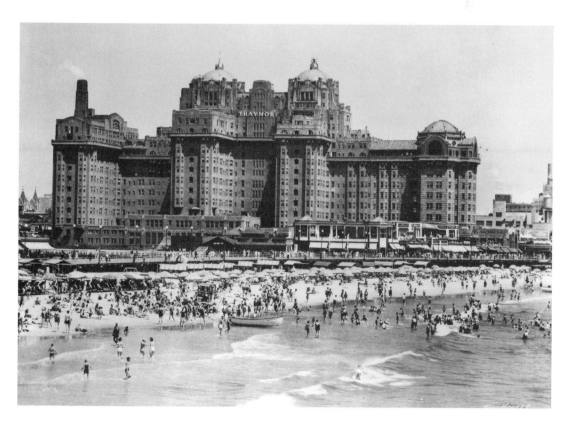

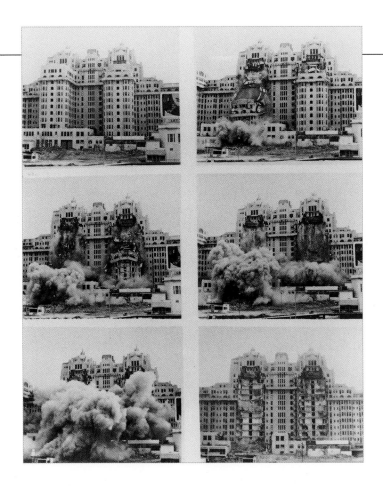

THE ATLANTIC CITY BEACHFRONT *had been one of the most famous in the world for more than half a century; but as the automobile and passenger jet provided new travel destinations, the resort began a steady spiral into decline. Empty and neglected hotels were razed, and as each landmark fell, the tired beachfront became less desirable to more mobile tourists. Many historians believe that the 1964 Democratic presidential convention accelerated Atlantic City's decline. With incumbent President Lyndon B. Johnson's lock on the nomination, the hungry television cameras, searching for a story, turned their lenses on the ail-*

ing resort, and the American public did not like what they saw. Poverty, decay, and crime were everywhere. Atlantic City was no longer the place to be seen. In 1979 Louis Malle's film Atlantic City *featured dramatic aerial footage of the magnificent Traymore being demolished to make way for new hotels and to signal the end of the era of pre-casino Atlantic City. Malle used artistic license in his film, for the actual demolition—a Guinness world record holder for the largest controlled demolition—actually took place in April 1972, six years before gambling was legalized in America's Playground.*

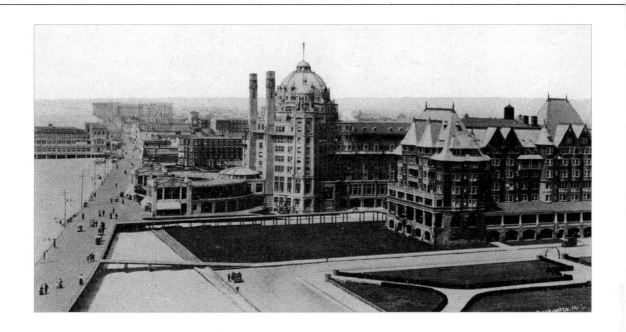

THE **MARLBOROUGH-BLENHEIM HOTEL** *was a hybrid made of turn-of-the-century Atlantic City guesthouses the Marlborough House and the Blenheim House. Completed in 1906, the hotel was designed by noted Philadelphia architect William Lightfoot Price and was the first hotel in the world composed of reinforced concrete. Thomas Edison, a frequent traveler to Atlantic City and the inventor and owner of the new construction process, spent many days at the work site overseeing the pouring of the concrete forms. When completed, the Marlborough-Blenheim was the first hostelry in Atlantic City to provide private baths in each room, complete with cold and hot seawater on tap. For the first time, visitors to America's Playground could take the saltwater cure in the privacy of their own room. Writing for the* New Cosmopolis, *James Huneker described the Marlborough-Blenheim Hotel when it first opened:*

> *"The architecture of one section is so extraordinary that I gasped when I saw it. … The architecture might be Byzantine. It suggests St. Marco's at Venice, St. Sophia at Constantinople, or a Hindu Palace, with its crouching dome, its operatic façade, and its two dominating monoliths with blunt tops. Built of concrete, the exterior is a luxurious exfoliation in hues, turquoise and fawn. … If I ever go again it will be to see this dream architecture, with its strange evocation of Asiatic colour and music."*

A hotel of dreams for almost a century, the odd combination of Queen Anne and Moorish architecture was razed in the 1990s to make room for yet another gaming palace.

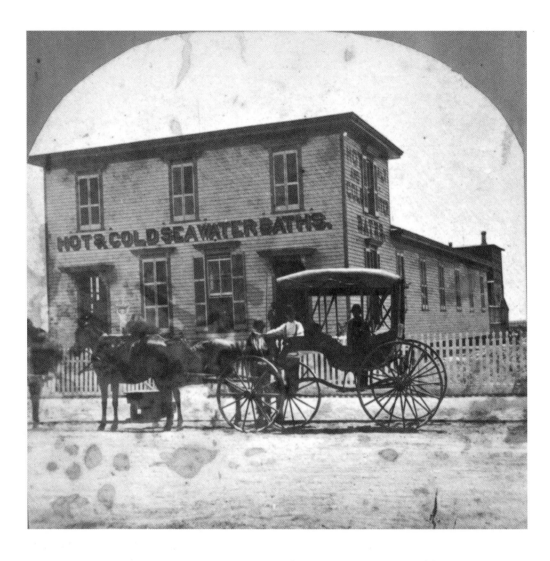

THIS BUILDING DOCUMENTS THAT *Atlantic City was at one time like Cape May and Long Branch, a resort of clapboard, quaint wooden hotels, commercial establishments, and small summer cottages. While its feeder city, Philadelphia, had embraced larger urban-style building methods, Atlantic City like other resorts believed that brick or concrete buildings belonged in the city and not by the rolling surf.*

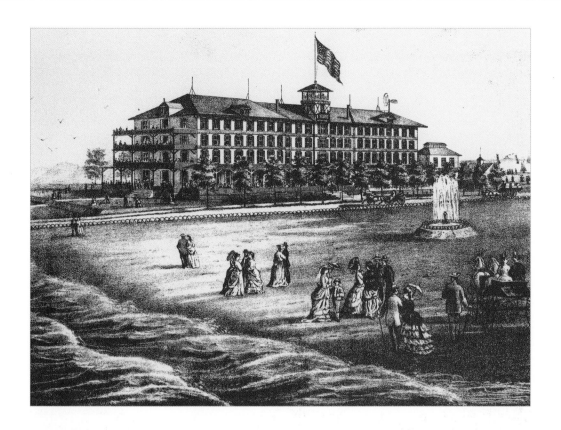

THE ENGLESIDE HOTEL, LOCATED *at the resort of Beach Haven on the barrier island known as Long Beach Island, as it appeared in 1878, two years after it opened to the public. Owned by Robert Barclay Engle, the hotel had a name that was a play on words—a combination of his surname and the Scottish term for fireside, ingleside. Fifty carpenters built the massive hotel in less than six months—no small achievement, considering that the railroad had not yet reached the island, and all of the materials had to be shipped from the mainland terminus at Tuckerton via barges to the island and hauled by oxcarts over the soft sand to* *the construction site. There is no doubt that the illustrator took some artistic license in this romanticized sketch, but the size and scale of the Engleside are fairly accurate. The illustration predates a five-story tower that the hotel was known for during its sixty-four-year existence. A bit of trivia: Twenty-four-year-old stockbroker Charles Vansant had just checked into the hotel with his family in 1916 when he decided to take a quick swim as the hotel staff unpacked his luggage. The unfortunate Vansant was the victim of one of the shark attacks that took place along the Jersey coast that season and later inspired the book and motion picture* Jaws.

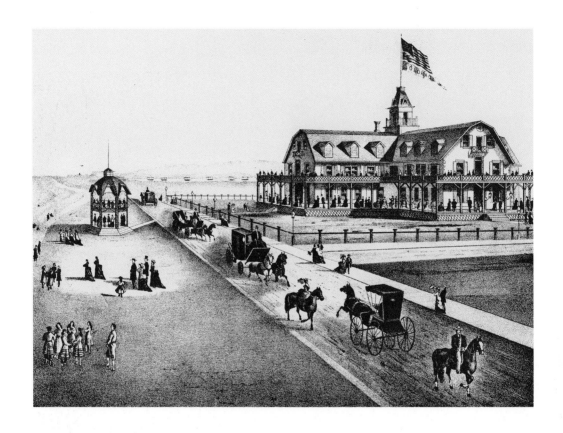

AFTER THE 1876 CENTENNIAL EXPOSITION *ended in Philadelphia, Ocean Beach, known today as Belmar, moved the building that had housed the Kansas and Colorado exhibit and christened it Colorado House. The hundred-room hotel was rebuilt on a raised brick foundation that permitted it to locate its bath-houses in the basement and afforded guests an unobstructed view of the ocean.*

A LONG LOST ERA: COOK'S COTTAGE, *when Atlantic City was a wonderland of charming gingerbread, clapboard cottages surrounded by delicately scrolled porches and quaint wooden fences.*

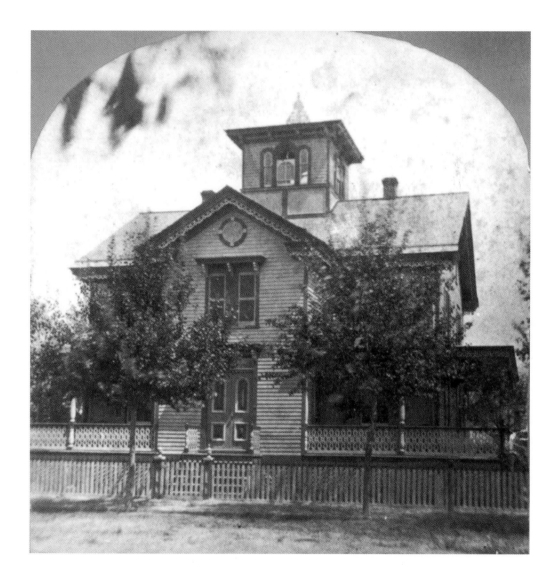

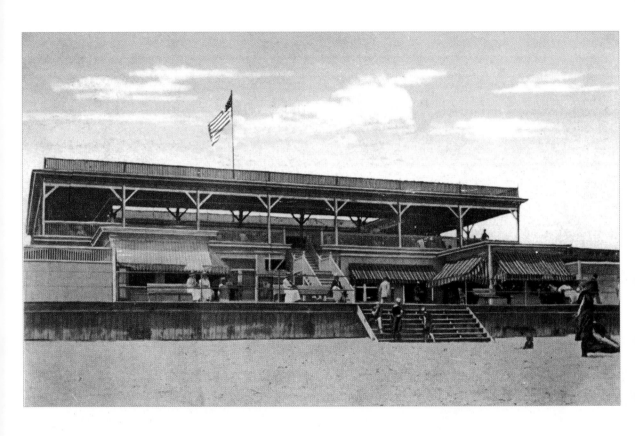

SPRING LAKE HAS ALWAYS MAINTAINED *a commercial-free boardwalk and provided visitors with two pavilions on the north and south end of the walkway. Pictured here is an image of the original South End Pavilion, which included a saltwater pool and bathhouses. The structure employs Stick-style brackets and a flat roof that created a convenient observation deck. By 1926 the resort believed both pavilions had outlived their usefulness. By 1929 the present-day South Pavilion was completed, and the new North Pavilion debuted in 1931.*

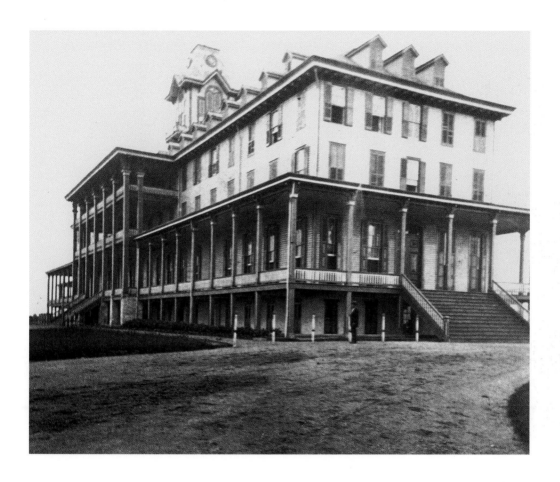

STEPHEN DECATUR BUTTON, *the primary and premier architect of Cape May, ventured north and designed the first major Spring Lake Beach hotel, the Monmouth House. The massive four-story hotel opened for business in 1876 and marked the beginning of a building boom that included the transportation of several "Centennial relics" from the 1876 Philadelphia Centennial Exposition. Natural air-conditioning was provided by gentle sea breezes that circulated through the massive sash windows that surrounded the porch. While the rest of the resort rushed to construct additional hotels, the Monmouth had the luxury of offering visitors hallway cots during high season. The hotel was lost in a fire in 1900.*

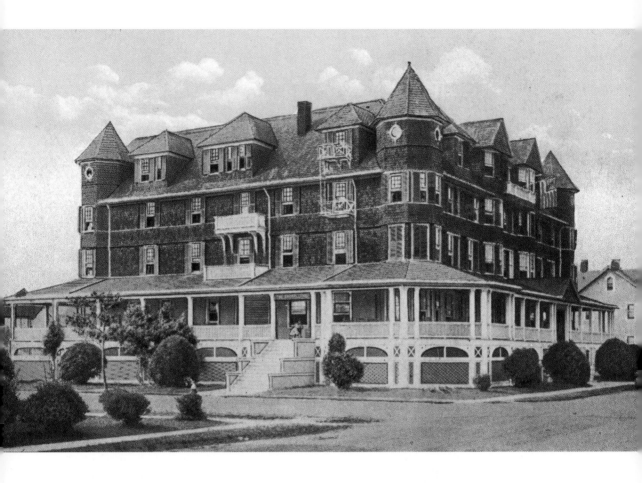

THE CARROLLTON HOTEL WAS BUILT IN POINT PLEASANT *by New York resident John Casey in 1898. The popular hotel was a Point Pleasant landmark until it was claimed by a fire in 1930, a demise met by much of the early architecture along the Jersey coast.*

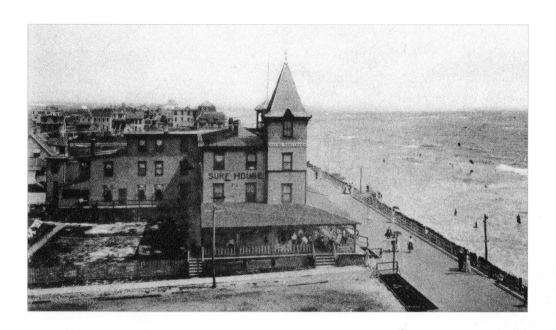

A VERY EARLY VIEW OF THE SURF HOUSE *located on the boardwalk in Sea Isle City. The hotel, with its expansive porch and four-story observation tower, was built to take advantage of its proximity to the ocean. The picture dates to a time when the wooden boardwalk was lower than the porch, as evidenced by the front porch ramp.*

Later views depict a newer boardwalk built to the height of the veranda floor. Ironically, it was the hotel's coveted location—so close to the Atlantic and the "surf"—that was its demise. The Great Atlantic Hurricane of 1944 claimed the Surf House, and the resort's last wooden walkway was lost to the Great Atlantic Storm of 1962.

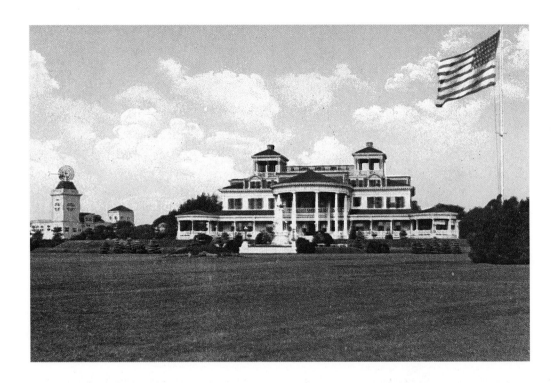

LONG BRANCH RELISHED ITS CLAIM that seven U.S. presidents visited or summered in the resort. For a time this association kept the resort popular with those who wished to be associated with power and style. Shadow Lawn was the summer White House of Woodrow Wilson. After suffering from a long decline, the resort experienced a brief renaissance when Wilson decided to launch his reelection campaign from the state of New Jersey, where his political career began as governor. Originally built for the president of the New York Life Insurance Company, Shadow Lawn was provided for the Wilsons' use by then owner J. B. Hunt. Although the grand house was technically located in West Long Branch, the newspapers and even the president referred to it as being located in the "Branch."

ANOTHER U.S. PRESIDENT, *Ulysses S. Grant, frequented Long Branch so much during and after his presidency that business associates had this summer cottage built for him. This stereograph image had special meaning, since it was taken by the Pach Brothers photographic studio. Grant was so pleased with their early work in the resort that he convinced two of his wealthy friends, George Childs and Anthony Drexel, to lend Gustavus, Morris, and Gotthelf Pach one thousand dollars to upgrade their equipment. Their firm became nationally prominent, the largest in Manhattan, and anyone who was anyone wanted a Pach Brothers portrait. Fortunately for historians, the Pachs also took some of the earliest images of the Jersey Shore.*

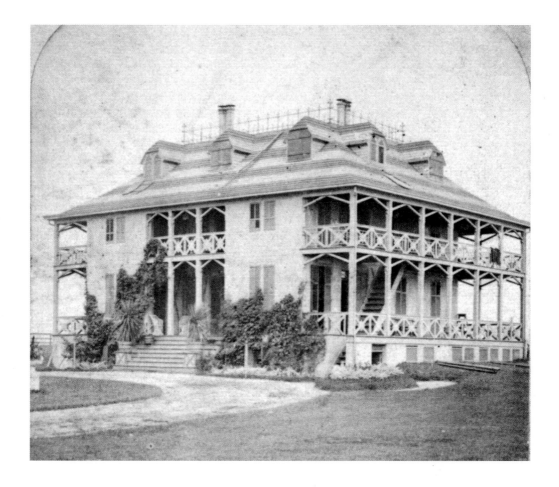

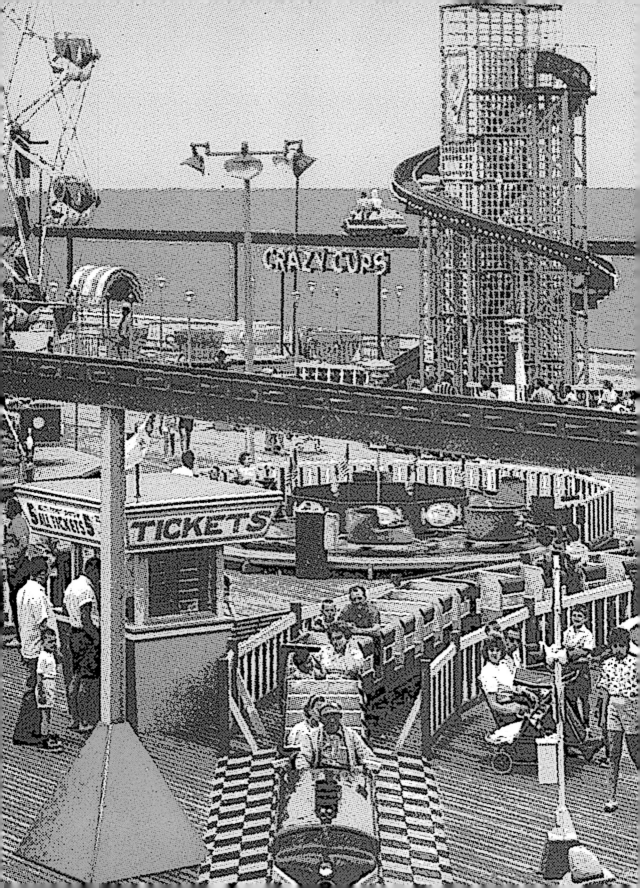

Amusements

THE LONG HISTORY OF AMUSEMENTS IN EUROPE was part of the DNA of every American immigrant. As early as the fourteenth century, pleasure parks flourished on the outskirts of major cities in Europe. The big three amusements that evolved on the boardwalks of New Jersey—carousels, Ferris wheels, and roller coasters—all traced their roots to these pleasure parks.

The attraction of boardwalk and pleasure park amusements ran much deeper than a spin on a handcrafted, colorful wooden carousel horse. In the final decades of the nineteenth century, as boardwalks along the Jersey Shore evolved and offered a variety of unique amusements, they also provided something more important and valuable to the average city dweller. The boardwalks provided an opportunity to participate in mixed gender activities in an era when young men and women found themselves existing in a world of strangers yet still bound by the social mores of the Victorian age. The old village form of life was vanishing, and office workers, shop girls, teachers, and blue-collar laborers were starved for ways to socialize, to reach out to strangers in a safe, controlled environment.

Atlantic City was the grandfather of all amusement boardwalks. Hundreds of thousands of middle-class men and women took the train from Philadelphia to America's Playground, and once they stepped onto the platform, a new world unfolded before them. First and foremost was the feeling that, if dressed properly, a shop girl could be riding alongside a factory owner on a rolling chair. The opportunity to socialize in an anonymous fantasy

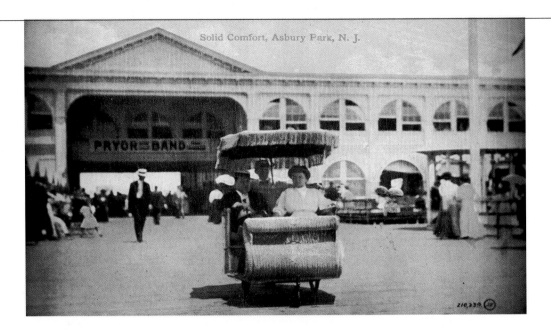

Solid Comfort, Asbury Park, N. J.

world and to even be "served" as the rolling chair operator pushed patrons along the promenade was a powerful draw.

The wooden walkway provided a magical place to see and be seen, and the rides and attractions, designed to be the opposite of the orderly, industrial life at home—the more absurd, the better—were the icing on the cake. One of the most popular attractions, the camera obscura, did not involve moving at high speeds or traveling in a gondola at dizzying heights over a resort; it did, however, fulfill the powerful need to see and be seen. Author Stephen Crane, who spent part of his childhood in Asbury Park before achieving worldwide fame for *The Red Badge of Courage*, described it as a "scientific curiosity." It was that and more. The boardwalk version of the camera obscura consisted of a darkened room where visitors could watch images of the outside world projected on the surface of a small table. A hand-operated rotating lens at the top of the building provided customers with a detailed view of the resort. Although the device was advertised to project scenic views of the surf, passing ships, hotels, and so on, popular cartoonists of the era recognized that most of the camera obscura clients were more interested in spying on couples "spooning" on the beach or strolling hand in hand on the boardwalk. It was the ultimate turn-of-the-century amusement.

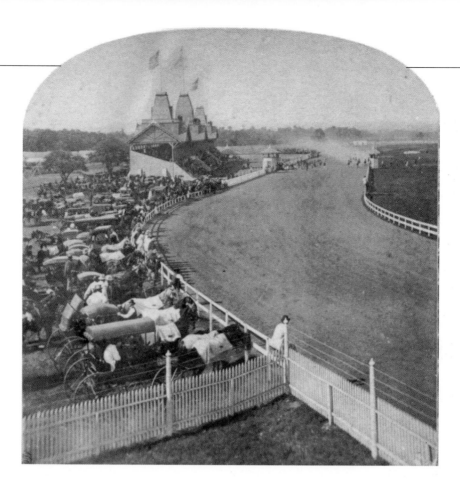

LONG BRANCH OWED ITS RISE *and eventual fall to the racetrack at Monmouth Park, which opened for business in the summer of 1870 and was an immediate success. This rare stereographic view shows the facility and a race in progress, as indicated by the cloud of dust at the far end of the track.*

Long Branch prospered as thousands of gamblers swarmed to the resort, and the hotel and restaurant owners were more than happy to accommodate them. The track was a favorite of celebrities from New York and Philadelphia, and the talk of the town was the day Diamond Jim Brady won a $32,000 bet on a long shot. President Ulysses S. Grant visited Monmouth Park often.

The park also provided a way for proper Victorian women, who would never step in a gambling parlor, to place a small wager.

Gambling clubs began to flourish in Long Branch, and there was no stopping its rise in popularity until the New Jersey legislature, led by James A. Bradley, founder of the competing resort Asbury Park, closed the track and prohibited gambling in 1897. The gamblers and fast money abandoned the resort for places like Saratoga Springs, New York, and the original social set had long since left Long Branch to the gamblers. The resort fell on hard times and was never again a serious competitor of Saratoga Springs or Newport, Rhode Island.

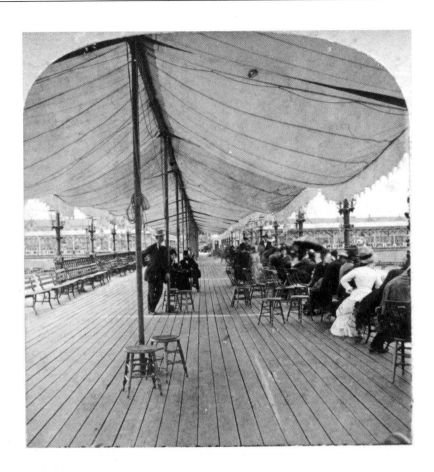

PIERS BECAME MAJOR AMUSEMENT *centers along the Jersey Shore when promoters realized that once they purchased boardwalk property, they could build out into the ocean as far as the technology of the day would allow. Long Branch had a series of piers that did not last long due to poor construction and severe weather until the Ocean Pier was completed in 1879. Made of tubular iron, it projected 600 feet into the Atlantic Ocean and was known as the stepping-stone to the Jersey Shore because large steamboats like* Plymouth Rock *could dock alongside the pier. It was now possible to transport almost two thousand day-trippers to the resort from Manhattan for a one-way fare of 50 cents. The pier was replaced in 1881 when a December snowstorm demolished the original. Pictured here is one of the few remaining images of the 1879 pier where tourists could socialize in the shade and enjoy the ocean breeze as they waited for a steamboat to arrive. The direction and strength of the wind would determine on which side of the pier the boat docked.*

PHOTOGRAPHY BECAME AN EARLY FORM of amusement, and many of the Pach Brothers photographs are the only record of what the Jersey Shore looked like during the Victorian era. The brothers Gustavus, Morris, and Gotthelf Pach, all German immigrants, began to work in New York City in 1866. During the summer of 1868, they traveled to Long Branch to take the portraits of the rich and famous who summered at the fashionable resort. Their work caught the eye of Ulysses S. Grant. They were introduced to the president by his wealthy friends the Drexels and the Childses. Grant, who summered at Long Branch during and after his presidency, and his friends were so impressed with the work of the brothers that they funded the Pachs' first Long Branch studio on the grounds of the United States Hotel. The sign over the door reads STEREOGRAPHS, a popular fad of the era in which a double-image gives a three-dimensional effect when viewed through special glasses. Several of the images in this book are Pach Brothers stereographs.

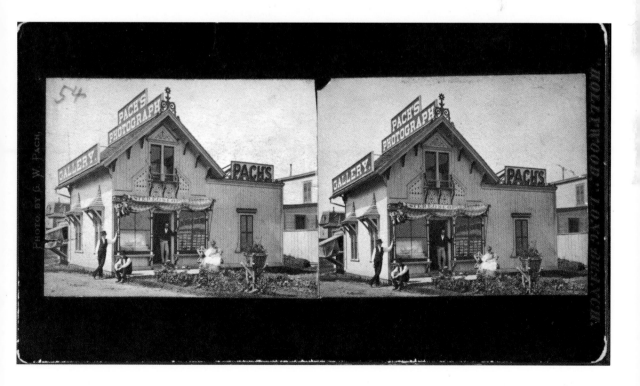

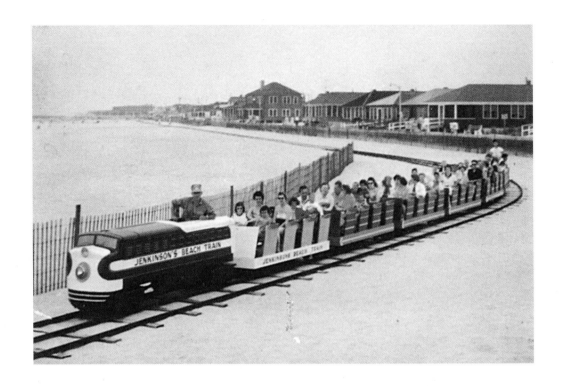

FEW VISITORS TO THE NORTH JERSEY SHORE *during the period from late 1949 to the 1990s do not have a special memory of the Jenkinson's Beach Train. The miniature train was born out of practicality, connecting the original Jenkinson's amusement center in Point Pleasant to the new property the family-run business acquired near the Manasquan Inlet. The ride quickly became the first stop on most family visits to Point Pleasant.*

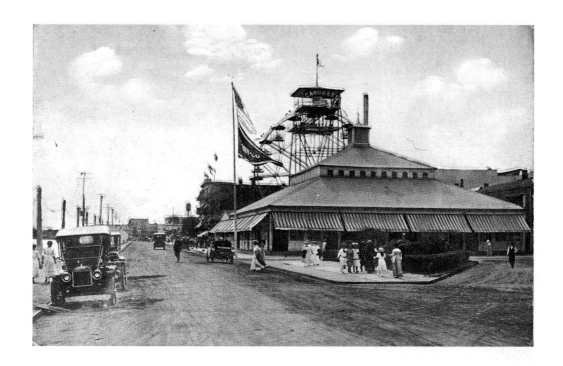

FOR ALMOST A CENTURY, *Palace Amusements was synonymous with Asbury Park and Jersey Shore entertainment. The tradition began in 1888, when Ernest Schnitzler built a pavilion to enclose his new carousel known as the Kingsley Street Merry-Go-Round. The entertainment entrepreneur added more amusements and in 1895 christened his latest sensation, the Roundabout and Observatory. Pictured here is the Roundabout, or, as we know it today, a Ferris wheel, which rose above the roof of the pavilion and provided the riders with an Observatory, or platform, from which they could view the resort below while enjoying the refreshing sea breeze. Eventually renamed Palace Amusements, the complex was made famous by Bruce Springsteen, in his songs "Born to Run," "Tunnel of Love," and "4th of July, Asbury Park (Sandy)."*

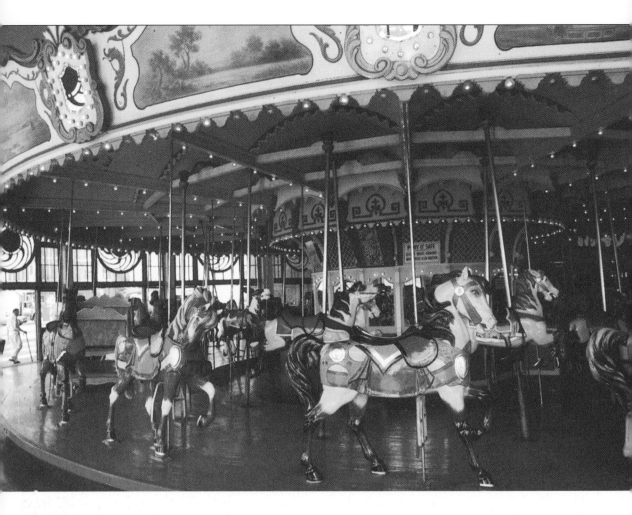

ASBURY PARK WAS FAMOUS FOR *two hand-carved carousels that provided generations of children and adults with wonderful memories. The first carousel was Schnitzler's Kingsley Street Merry-Go-Round, later known as the Palace Carousel, and the second was the beautiful Casino Carousel, pictured here. The magic machine was lovingly crafted by the Philadelphia Toboggan Company. The colorful carousel was housed in a copper-and-glass structure covered with mysteri-ous medallions that evoked the mystery of the Greek gods. Music and lights surrounded the riders, and each chariot and horse was a work of art. Sadly, almost all of the carousels that once dotted the New Jersey Shore were broken up and sold to collectors. In 1988 the Palace closed, and the hand-carved figures were sold off to the highest bidders. In 1990 the Casino carousel figures were sold and replaced with fiberglass copies.*

ALTHOUGH THE JERSEY SHORE RESORTS were built along one of the largest natural swimming pools in the world—the Atlantic Ocean—saltwater pools were very popular and dotted the shoreline. A favorite during the first half of the twentieth century was the Seventh Avenue Pool and Pavilion located in Asbury Park. The pavilion (not pictured here) sat on the beach and was separated from the pool by the Asbury Park boardwalk (which would have been water level to the right of this photograph). Swimmers occupied the lower tier, while people watchers lined three sides of the pool and were protected from the sun by two covered mini-pavilions, as can be seen in the right-hand corner of this image. The top left corner shows a line of cars along the street side of the facility. The pool was abandoned by the 1980s as Asbury Park fell into disrepair.

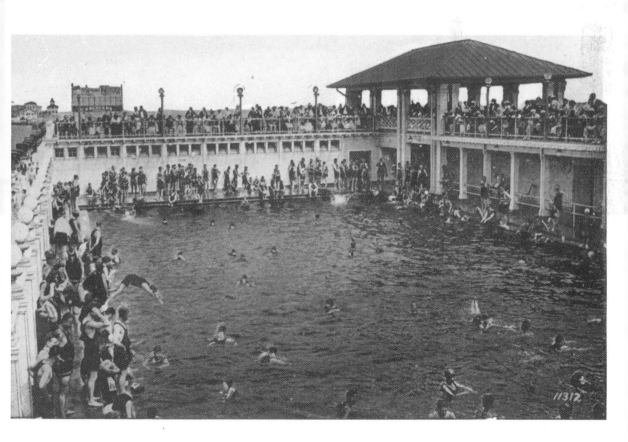

NO TRIP TO AMERICA'S PLAYGROUND, *Atlantic City, would be complete without a visit to Steeplechase Pier. As can be seen in this vintage image, amusement innovator George C. Tilyou did not want anyone to forget that it was his pier. You can also see the demonic clown face that was the genesis of the famous figure of "Tillie" that later became synonymous with the Palace Amusements in Asbury Park.*

Tilyou began his career in Coney Island with his wildly successful Steeplechase Park, and in 1904 he brought his magic to Atlantic City. One of Tilyou's keys to success was that he realized the potential of replacing the ubiquitous live entertainment with amusement rides and a fun house. Tourists could not get enough of his Human Roulette Wheel, a giant spinning platform that would toss and tumble the riders into a mass of humanity. Tilyou encouraged the paying public to let their hair down when visiting his pier, or the "funniest place on earth," as he advertised it. He even had a game where, for a nickel, people could go wild throwing a baseball at stacks of inexpensive cups and plates. From time to time he would add celebrities to the mix, including bandmaster John Philip Sousa, who played many times at the Steeplechase.

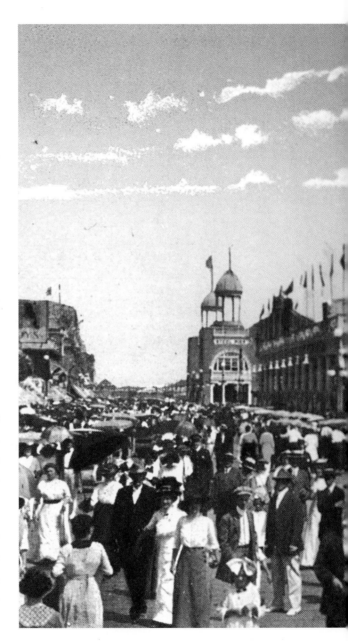

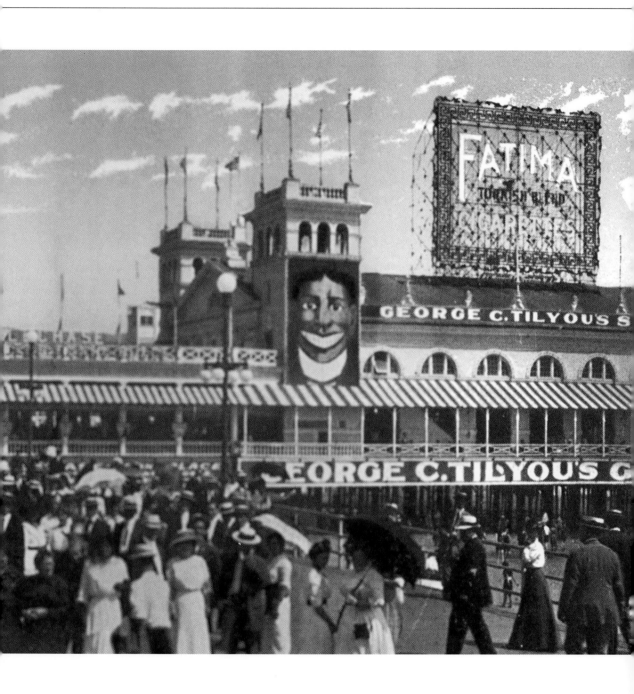

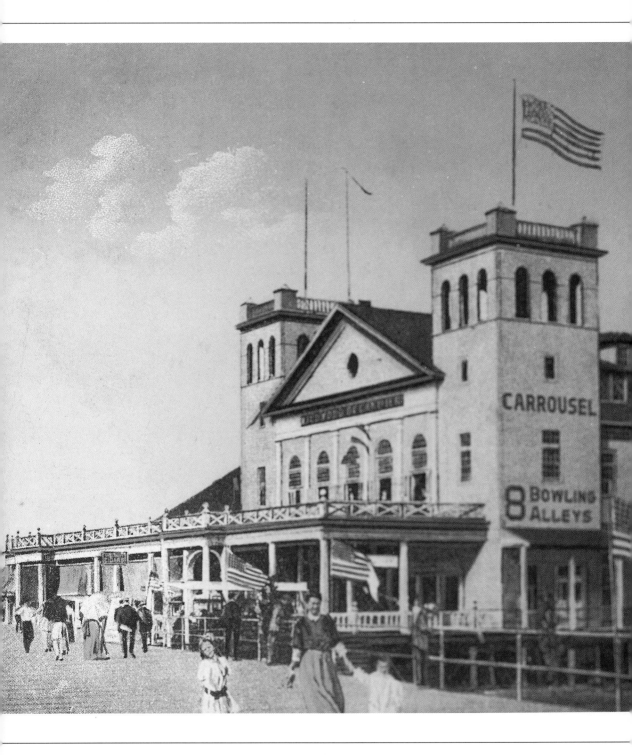

Jersey Shore

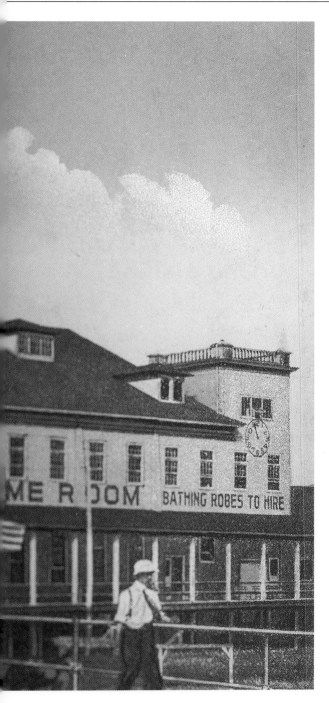

OPENED FOR BUSINESS IN THE *1905–1906 season, the Ocean Pier of Wildwood was a favorite for generations of Wildwood "board rats." By the turn of the century, Atlantic City had claimed so much of Wildwood's amusement trade that drastic action was required. Located off Poplar and Juniper Avenues, the pier extended 1,000 feet. There was something for everyone, including, as can be seen in this image, eight bowling alleys, a theater, a cavernous ballroom, a roller-skating rink, a carousel, and a second-floor dance hall. Bathhouses were provided, along with an opportunity to rent bathing robes for a day on the beach. Live entertainment, the same vaudeville acts that worked the Atlantic City circuit, was offered. Concession stands sold souvenirs and boardwalk staples, such as hot dogs, ice cream, roasted peanuts, and, naturally, Wildwood's own Sagel's Original Salt Water Taffy. The Wildwood beach continued to expand with Mother Nature's assistance, and as the boardwalk was moved closer to the Atlantic Ocean, the Ocean Pier was moved with it.*

As the century advanced, new owners added a motion picture theater and hosted all of the fads, such as beauty pageants and Great Depression–era marathon dancing in the ballroom. After providing almost forty years of memories, the Ocean Pier itself became a memory on Christmas Day 1943, when a monstrous fire claimed it.

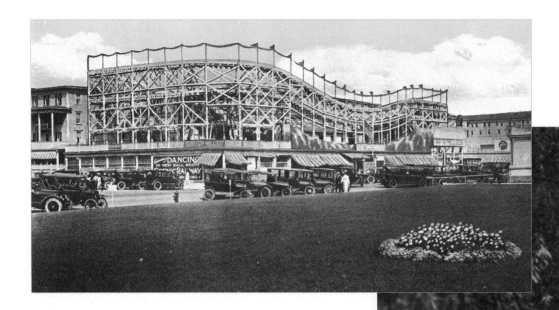

GEORGE TILYOU BEGAN TO FRANCHISE *his Steeplechase brand, and in 1880 the well-established resort of Asbury Park wanted to join the team. The Steeplechase was located on Ocean Avenue between Second and Third Streets. The signature attraction of every Steeplechase was the actual Steeplechase ride (above), which had two groups of horse-racing tracks. Each set contained four tracks; one set of four went in one direction and the other set in the opposite direction. The ride was similar to a small roller coaster, with wooden mechanical horses dipping and climbing along the tracks. Couples would hold onto their "horse" and race against the riders on the three adjoining tracks. Other popular attractions were giant swings, such as the Uncle Sam (right), and the Barrel of Fun, sometimes known as the Barrel of Love, which rolled visitors off their feet. From the Human Roulette Wheel to the Pipe, a giant slide, most of Tilyou's "rides" were designed to loosen visitors' proprieties and bring men and women who were complete strangers into contact with each other. The Asbury Park Steeplechase was demolished in the early years of the Great Depression.*

CAPE MAY, NEVER KNOWN *for boardwalk amusements, was home to what the locals referred to as the Fun Factory. It contained Steeplechase-style amusements that were designed to mix the genders in contraptions such as the Human Roulette Wheel, a revolving barrel, and—one can only imagine what this was—the Human Soup Bowl. It also featured a concert hall, a roller rink, and a stage for vaudeville shows. The tower was covered with thousands of tiny lights and towered more than eight stories over the Atlantic Ocean.*

The Fun Factory was built at Sewell's Point in East Cape May and could be reached by the quaint Cape May, Delaware Bay & Sewell's Point Railroad that ran along the beach from the Fun Factory all the way to the steamboat landing dock on the Delaware Bay. The Fun Factory was part of a major real estate development known as New Cape May that was designed to revive the resort's waning fortunes in 1912. However, the developer went bankrupt, and the ill-fated Fun Factory was converted to a naval base in 1917 and lost in a fire one year later.

THE OLDEST AMUSEMENT FACILITY *on the east side of the Wildwood board-walk began with a carousel built by the Philadelphia Toboggan Company located between Cedar and Schellenger Avenues. The complex also offered a massive wooden roller coaster, known as the Jack Rabbit, and a favorite of those seeking a bit of adventure, Ye Old Mill, pictured here, a combination boat ride and tunnel of love. The complex was known simply as the Amusement Center and eventually evolved into Marine Pier in the early 1930s.*

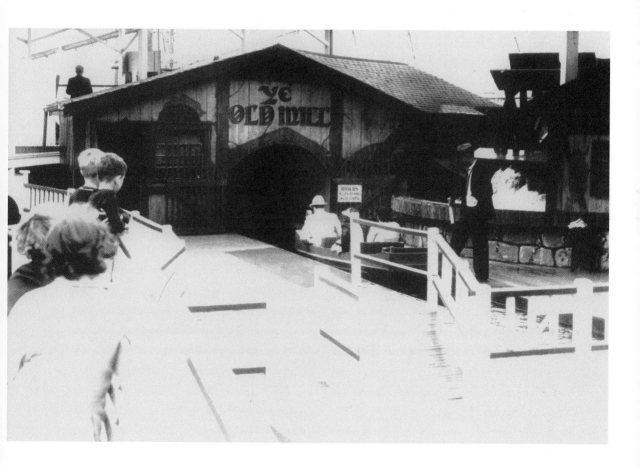

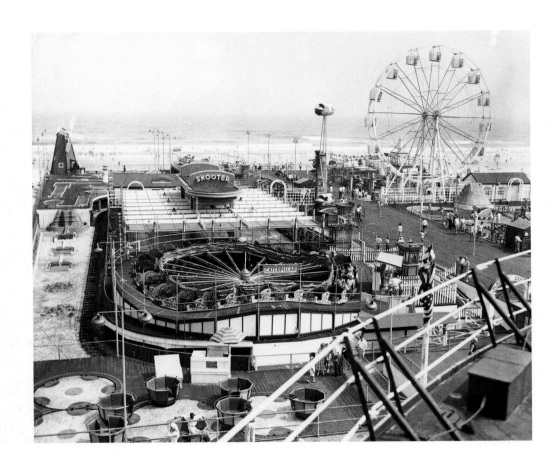

MARINE PIER INSTALLED A SECONDHAND *90-foot Ferris wheel, the popular Caterpillar ride, during the 1930s, as well as a miniature train ride called the Playland Express, shown in this aerial image. By the 1970s Marine Pier Amusements and Playland made up the largest amusement center in Wildwood, with the Marine Pier stretching 500 feet over the ocean and its inland counterpart, Playland, covering the entire block on the* west side of the boardwalk. The Marine Pier was sold to the Morey brothers, whose names are now synonymous with Wildwood Amusement. Marine Pier eventually evolved into just one piece of the Moreys' empire—Mariner's Landing.

Unfortunately, the beloved Ferris wheel was scrapped, along with other vintage rides, making way for flashy 1970s-era high-tech attractions like the Wave Swinger and Enterprise.

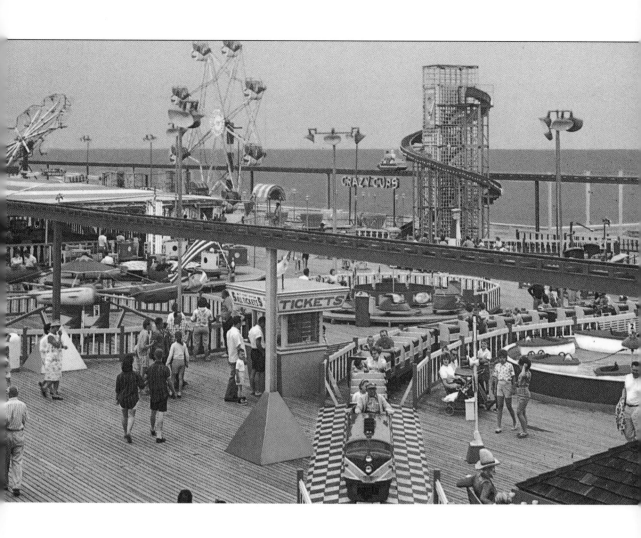

ONE OF THE OLDEST SEASIDE AMUSEMENT complexes, Freeman U.S.A. (now Funtown Pier), was destroyed by a boardwalk inferno in 1955. Beach property was too valuable to remain undeveloped, and in a short time Funtown USA emerged from the pile of kindling that had provided generations of tourists with memories. Lost in the fire was a hand-carved carousel built by the Dentzel Carousel Company of Philadelphia. This photo, taken in the early 1960s, shows the Sky Ride, an elevated monorail that was added to the new amusement center. The pier even replaced the carousel with another hand-carved work of art built by Marcus Illions, who had apprenticed with Dentzel's competitor, Charles Looff. Sadly, the second carousel was broken apart and sold to collectors, and the current Belle Freeman carousel is a mere fiberglass replacement.

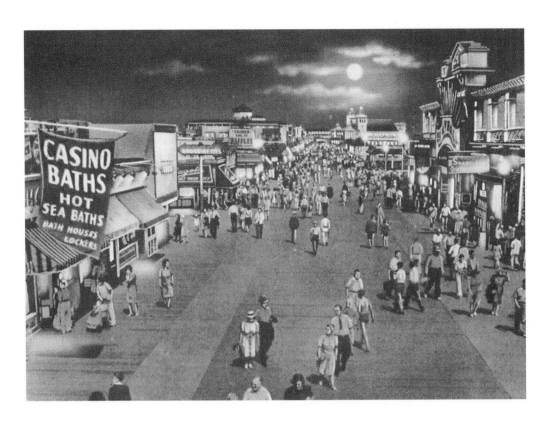

THE POST–WORLD WAR II ERA *was difficult for the resort of Wildwood. Its proximity to Atlantic City made it difficult to compete with America's Playground. The Steel Pier and Million Dollar Pier of Atlantic City were still attracting the big live dance bands, and both piers had massive advertising budgets. A ray of light for Wildwood came in the form of a young disc jockey named Dick Clark. The summer of 1957 was the year that rock 'n' roll was taking its toll on big band music, and on August 5 of that summer, Clark, who had been known only in the Philadelphia area, broad-cast live from the Starlight Ballroom, shown on the right side of this image. The old ballroom was crowded with adoring fans, and ABC-TV broad-cast the show across the nation. Dick Clark became a household name and, with the exception of a few return appearances, moved onto the big time. The owners of the Starlight Ballroom hired another record spinner, and thousands of teenagers crowded the facility all summer long. All of the new acts played the Starlight, including Bill Haley and the Comets and the creator of the Twist sensation, Chubby Checker.*

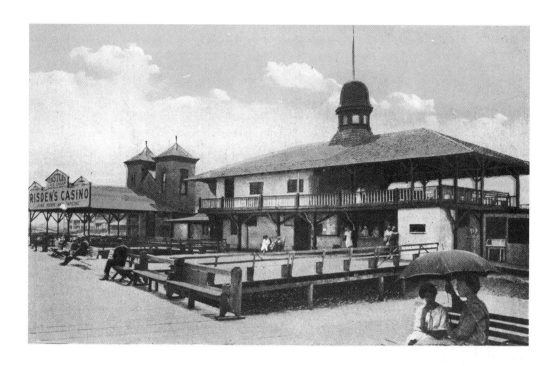

THE FIRST HOTELS IN NEW RESORTS *would often construct an entertainment pavilion along with bathhouses on the beach and provide transportation for their guests. This complex was originally known as the Resort House Bathing Pavilion, built in Point Pleasant Beach in 1884 to serve the clientele of the Resort House hotel. It changed hands in 1913 and became Risden's Casino and Johnson's Bath House. When it was first built, guests were transported to the beach and pavilion by the hotel's horse-drawn trolley. Above the Risden's Casino sign can be seen an advertisement for Castle Ice Cream; the bottom of the sign reads* FINE MUSIC AND DANCING. *Risden's was a Point Pleasant landmark for nearly a half century until a hurricane in the late 1930s damaged it, along with almost 4,000 feet of the old boardwalk. Today there are still bathhouses in operation on an area of the strand called Risden's Beach.*

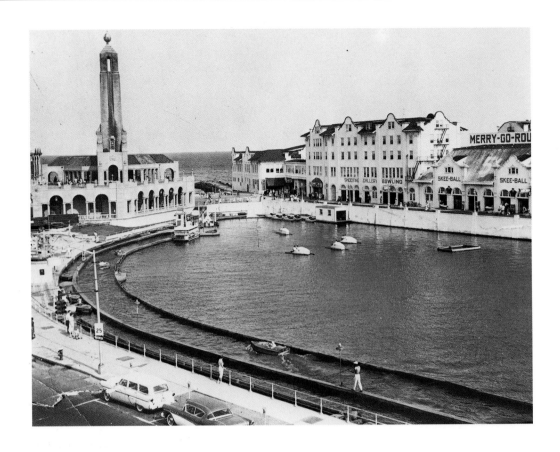

A VISITOR TODAY TO WESLEY LAKE, *the small body of water that separates Asbury Park and Ocean Grove, would never imagine the activity that took place there only forty years ago. This image, taken from the Asbury Park side—where the famous Palace Amusements was located— depicts the popular motorboat course, along with U-Paddle boats in the center of the lake. There was also a gargantuan motorized swan boat ride that could carry an entire family around the lake. The complex on the upper right was the North End Hotel, complete with a shooting gallery, bowling alley, carousel, and the staple of most Jersey Shore amusement centers, Skee-Ball. The exotic looking building on the upper left is the Asbury Park heating plant, which kept the casino and convention hall warm all year long. To the right of the plant can be seen the elevated passageway that connected the hotel complex over the boardwalk that ran from Asbury Park to Ocean Grove. A sign above it reads* OCEAN GROVE. *The small canopy at the corner of the North End Hotel to the lower right of the passageway was the entrance to the Strand Theatre.*

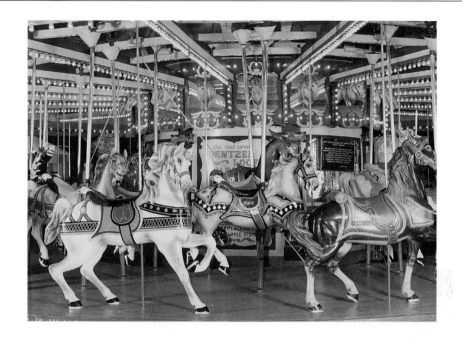

NO VISIT TO THE JERSEY SHORE *would be complete without a magical spin on the only hand-carved carousel still in operation along the 127 miles of Jersey seaside. While more than a thousand hand-crafted carousels once operated in the United States, it is estimated that only 130 exist today. Fires, hurricanes, nor'easters, and general neglect have claimed most of them. Many were dismantled and sold to collectors at auction as carousels fell out of favor and amusement parks and boardwalk piers closed. The carousel at Casino Pier, located on the Seaside Heights boardwalk, is one of the few remaining masterpieces in the country. Known as a "mixed machine," it contains figures carved by a variety of master craftsmen. The artists were a literal "who's who" of nineteenth-century carousel aristocracy, including William Dentzel, Charles Looff, Charles Carmel, and Marcus Illions. The Floyd L. Moreland Historic Dentzel/Looff Carousel, named for the man who saved and lovingly restored the machine, is technically referred to as a menagerie because of the lions, tigers, donkeys, and even camels that spin along with the exquisitely carved herd of stallions. Some are standers—anchored to the spinning platform—while other horses are jumpers and move up and down as the rotating zoo carries the riders to an innocent era of roundabouts and roller coasters. A circa 1920s Wurlitzer Military Band organ provides the music as the animals spin by a myriad of mirrors, hand-painted murals, and hundreds upon hundreds of colorful lights. It is truly a time machine and must for anyone who wishes to experience the Jersey boardwalks of a century ago.*

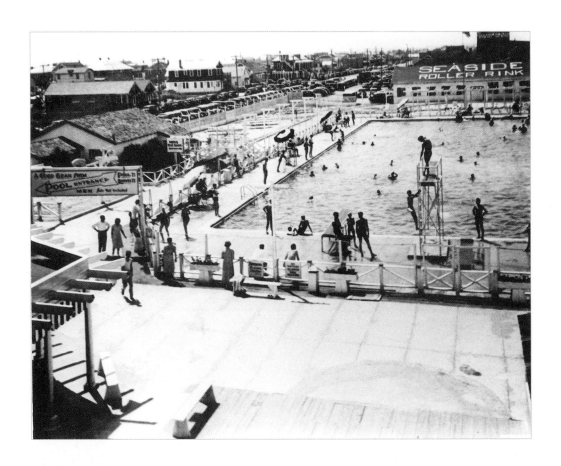

AS THE FREEMAN'S AMUSEMENT COMPLEX (later Funtown Pier) continued to expand on the southern portion of the Seaside boardwalk, promoter Linus Gilbert sought new crowd pleasers to surround his Dentzel/Looff carousel, housed in an expansive exhibition hall known as the Seaside Heights Casino, or, by most everyone else, the Casino. One such tourist magnet was the 165-by 65-foot gargantuan pool that was advertised as the largest chlorinated saltwater swimming pool in the United States. Gilbert's complex included a roller-skating rink, pictured in the upper right-hand corner of this photo, which covered an entire beach block from Grant to Sherman Avenues and extended with priceless riparian rights to Boulevard. A ballroom for summer soirees was added to the complex. As Gilbert filled his 500-foot pier with dozens of additional attractions, he continued to expand seaward, and the now famous Casino Pier took shape. The pool was closed in the 1980s to make room for Water Works amusements.

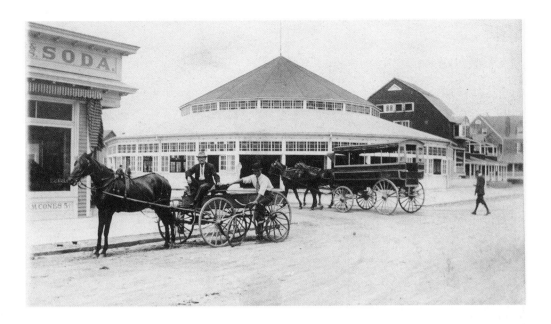

AT THIS TIME, ALMOST EVERY *respectable resort had a carousel. Pictured here is the LaReine Casino's carousel building, in a photograph taken in the late nineteenth century. The carriages you see were available to transport visitors back to their hotel or cottage. The Casino itself was built on both sides of Ocean Avenue in Bradley Beach.*

A RARE ILLUSTRATION *of a seaside shooting gallery from* Harper's Magazine *in October 1878. Americans have always had a love affair with guns, and shooting galleries quickly became a popular amusement along busy boardwalks. For just a few pennies, armchair warriors could show off to their children and sweethearts and demonstrate that they were still up to the task of taming the Wild West.*

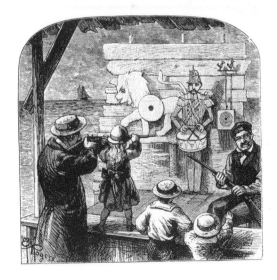

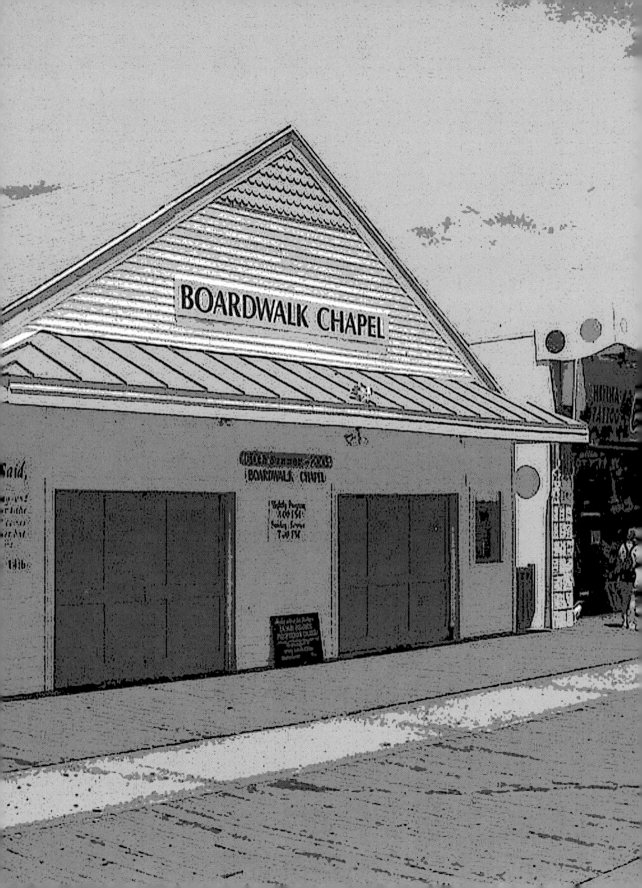

Curiosities

THE JERSEY SHORE IS REPLETE WITH THE STRANGE AND CURIOUS, and at the top of the list is the Boardwalk Chapel in Wildwood. The chapel, sponsored by the Orthodox Presbyterian Church, was dedicated on June 29, 1945. One of the most riotous walkways along the shore provides a religious haven.

Then there's Lucy the elephant. She was related to her long-gone cousins, the Light of Asia in Cape May and the Elephant Hotel (Elephantine Colossus) in Coney Island, New York. Lucy was the dream child of Irish-born promoter James Vincent de Paul Lafferty Jr. The pachyderm was born on the South Atlantic City beach as a real estate gimmick in 1881. She weighed in at 90 tons and stood 65 feet high. Lafferty chose an elephant because the country was in the midst of an elephant craze brought on by P. T. Barnum's Jumbo attraction. Lucy was as big as Lafferty's dreams. Her construction consumed 12,000 feet of lumber, 200 kegs of nails, tons of nuts and bolts, and over 5,000 square feet of tin for her impervious skin. Lucy's tail is 26 feet long, her trunk is 36 feet, and her tusks are 22 feet. The silent giant's legs are 10 feet in diameter and over 20 feet high. When his creature was completed, Lafferty had her painted white—a rather prophetic decision. During her life Lucy became a financial and maintenance burden on all those who owned her.

Estimates are that Lafferty spent over $38,000 of his own money to build Lucy. She did, though, help create the resort of Margate out of the southern Atlantic City beach, and the promoter envisioned building herds of wooden

elephants up and down the East Coast. He overextended himself financially, however, so only two other Lafferty pachyderms were built, in Cape May and Coney Island. Lucy changed hands for years, serving as a tavern, hotel,

and even a summer cottage. The encroaching sea at one point surrounded Lucy in 3 feet of sand, and she was moved 50 feet inland. Storms took their toll, ripping off her howdah and rotting off her monstrous toes. She looked as if she might soon join her relatives in the elephant graveyard when in 1970 a group of determined preservationists moved her to nearby Margate, the town she helped create. The lovingly restored behemoth is now a National Historic Landmark.

Another group of curious-looking creatures can be enjoyed north of Margate on the Seaside boardwalk. Known as a "mixed machine," because it has figures carved by more than one master, the Floyd L. Moreland Historic Dentzel/Looff Carousel is a throw-back to the era when a thousand or more hand-carved carousels brought joy to children and adults in trolley parks, at fairs, and on boardwalks. Riders can take a step into a lost era as they spin to the sounds of a Wurlitzer Military Band organ with its 105 wooden pipes. The carousel has over two thousand lightbulbs and over a dozen vintage paintings to brighten the experience. The Seaside boardwalk beauty, one of fewer than 250 genuine antique carousels still operating in the United States, is named for Floyd L. Moreland, who is responsible for saving and restoring the machine, technically known as a menagerie because tigers, donkeys, camels, and lions spin magically round and round with the herd of galloping horses. The machine features the work of such turn-of-the-century master carousel carvers as William Dentzel, Charles Looff, Charles Carmel, and Marcus Illions.

THE HOEY GARDENS, LOCATED IN *Long Branch, became world famous for their unique designs. John Hoey, the president of the Adams Express Company, began building his compound and exquisite gardens in 1863 and at one time owned several hundred acres of property in Long Branch. He named his beloved estate Hollywood in honor of the indigenous holly plants and soon hired legions of the most talented Italian immigrants he could find to create his masterpiece, gardens of numerous plant varieties that, viewed from above, gave the appearance of Oriental rugs.*

One of his buildings was the Hollywood Hotel, which was surrounded by these formal gardens and was a favorite with the rich and famous. A fire destroyed it in 1926. In the end it turned out that the Hollywood Hotel and other Hoey residences were built on rotten financial foundations. As with a house of cards, each residence collapsed when it was discovered in 1891 that the Adams Express Company had a set of books as elaborate as Hoey's gardens. The company began foreclosure proceedings, and John Hoey, a broken man, died one year later.

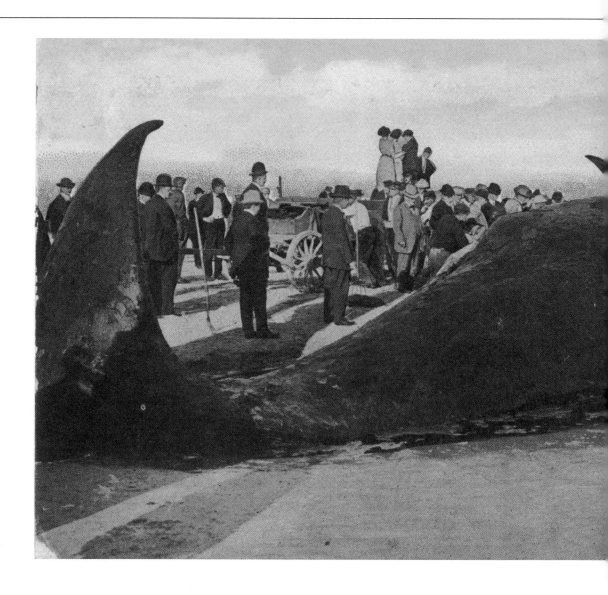

THIS POOR LEVIATHAN WASHED ASHORE *somewhere on the Jersey coast at the turn of the twentieth century. It attracted a crowd of sightseers and became the subject of a popular postcard of the era. The amazing whale must have had mystical powers, because it washed ashore at sev-* *eral popular resorts in the same position with the identical crowd surrounding it: "Enormous whale washed ashore Ocean City, NJ." "Enormous whale washed ashore Asbury Park, NJ." You can't blame the postcard printers for making the most of the curiosity.*

THE RESIDENTS OF ATLANTIC CITY WERE TREATED *to an amazing site when the Hindenburg, the pride of the German-based Zeppelin Company and the Third Reich, passed overhead on one of ten Atlantic Ocean crossings during its first year of service in 1936.*

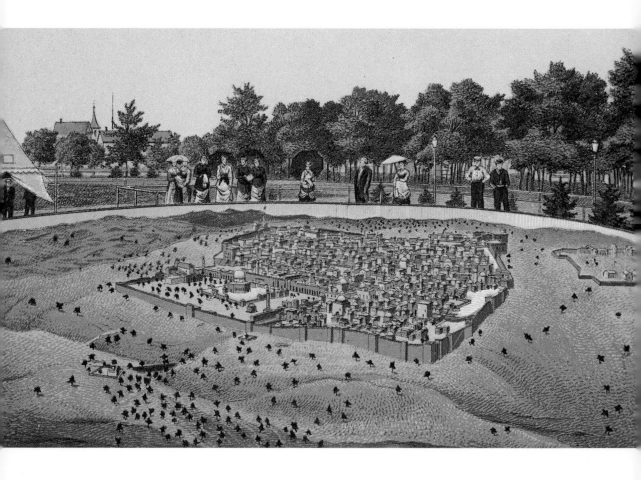

THE RESORT OF OCEAN GROVE *was created as a Methodist Eden by the Sea. The quiet community became known for its famous blue laws intended to shape morality, and for the Great Auditorium, which has been host to presidents and celebrities the likes of Enrico Curuso, Will Rogers, Dr. W.E.B. DuBois (and that's just naming a few). A curiosity in the late nineteenth century was a scale model of Jerusalem, which was donated to Ocean Grove by W. W. Wythe in 1880. He researched it down to the minutest detail, and for years an annual event was held in the resort when the faithful, accompanied by a band, would march around the tiny replica city. A dome that still stands was constructed to house the miniature Jerusalem, but time and nature eventually claimed the curiosity itself.*

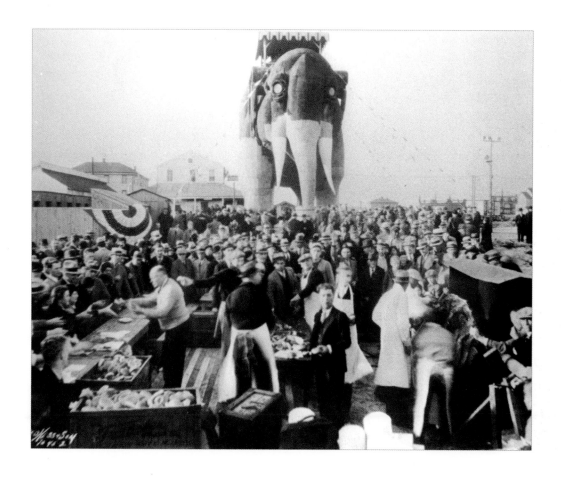

THIS IMAGE, CIRCA 1900, SHOWS AN ATLANTIC CITY *celebration taking place under the watchful eyes of Lucy, a hotel in the shape of a giant elephant commissioned in 1881 by real estate promoter James Lafferty. Lucy was eventually used as a hotel, summer cottage, and even a tavern. After years of neglect, she was moved to nearby Margate, the resort she helped Lafferty launch, by a group of Save Lucy preservationists. Lucy is now listed as a National Historic Landmark and is a wonderful curiosity to visit along the Jersey Shore.*

SANDCASTLE BUILDING *for generations has been one of the favorite pastimes of children enjoying a beautiful summer day along the surf. They work happily for hours, only to see their creations washed away by the rising tide. There was a time when an army of sand artists worked along the boardwalks of busy resorts, creating masterpieces of sand for the nickels and dimes tossed to them from appreciative tourists. The intricate designs are amazing, as depicted here in a rare view of an artist practicing his craft next to a new section of the Atlantic City boardwalk under construction. This photo was taken in the 1940s, after the Great Atlantic Hurricane, but sadly, all things must come to an end, and Atlantic City banned the artists when tourists complained that con men had begun mixing mortar with their sand to protect their sculpture from the tides.*

Laying Foundation for New Walk and Sand Artist.
Atlantic City, N. J.

2076

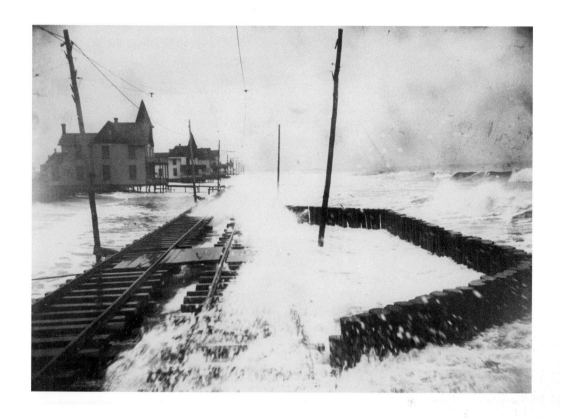

THE ATLANTIS OF NEW JERSEY (*circa 1910*). *Situated comfortably between Cape May and Cape May Point was the beautiful seaside town of South Cape May. Today the western end of Cape May beach ends at Second Avenue and Beach Drive, but in the last century, the streets continued west to Twenty-first Avenue, and a boardwalk and railway paralleled South Cape May along the sea. The railroad, the Cape May, Delaware Bay and Sewell's Point, carried passengers from the far eastern end of Cape May along the beach to the steamboat landing on the Delaware Bay. A century of storms battered the tiny town of South Cape May, and the Great Atlantic Hurricane of 1944 eventually claimed the city forever. Those who could afford to, moved their homes over the years to lots in the west end of Cape May, and the roads, tracks, and infrastructure of the once bustling village now lie beneath the sand and water.*

YOUNG'S MILLION DOLLAR PIER *in Atlantic City was a favorite of crowds during the era of the great piers in America's Playground. John Lake Young, who appointed himself "captain" somewhere along the way, had made so much money in the amusement business that he opened Young's Million Dollar Pier on the beach at the end of Arkansas Avenue on June 26, 1906. Descriptions of the day referred to the pier as a "glittering palace" containing the world's largest ballroom, a hippodrome, and a massive aquarium. The captain loved gimmicks, and his trademark creation was his "daily deep sea net haul." Depicted in this circa 1915 image, crowds would gather around a trapdoor on the pier and watch a crew of men pull in the nets full of the bounty of the sea. It was questionable how deep the sea was under the pier, and onlookers sometimes noticed species not native to the Jersey Shore mixed in with the ocean's bounty, but Captain Young's daily net haul was a genuine crowd pleaser.*

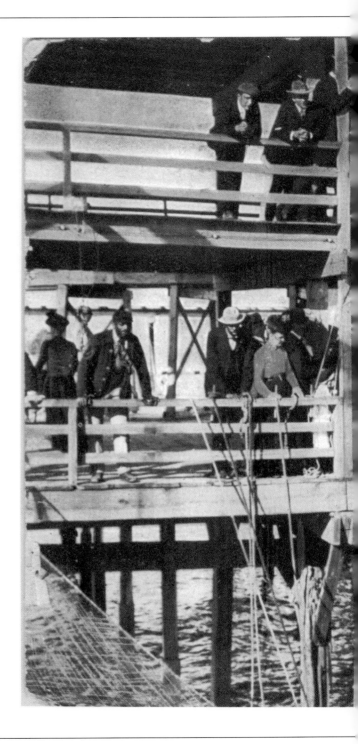

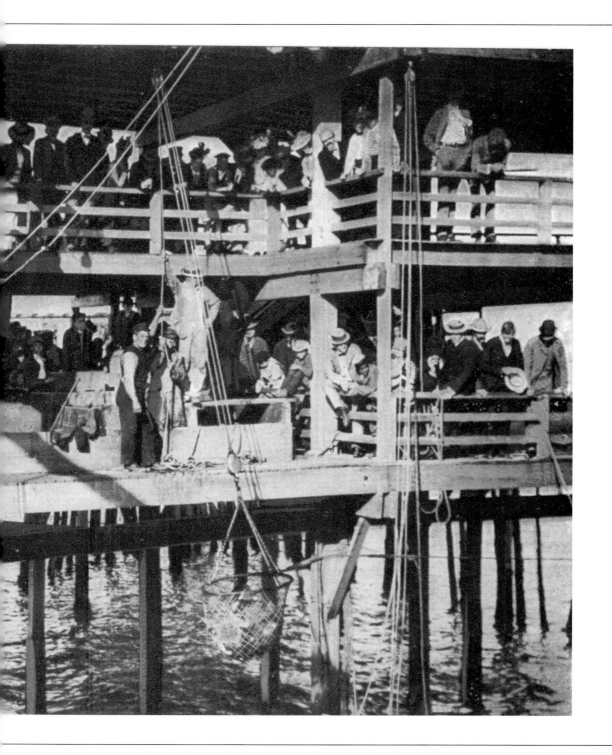

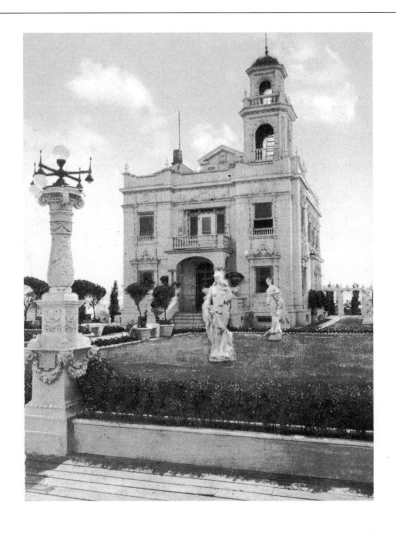

WHAT COULD BE MORE CURIOUS *than a street address of Number One, Atlantic Ocean? That was where the mail was delivered to Captain John Lake Young at his luxurious home built on the ocean end of his Million Dollar Pier in Atlantic City. The captain had an Italian-style villa built, complete with formal gardens, a lush grass lawn, and marble statuary. The view from the bell tower must have been breathtaking. Young imported the finest furnishings from Europe, and the mansion more than paid for itself in the publicity it provided for his amusement business. The amusement titan played host to presidents, industrialists, and all of the major celebrities of the day. In the evening Young's villa was lit by thousands of miniature white lightbulbs designed and installed by fishing buddy and frequent houseguest Thomas Edison. This photo was taken in 1908.*

ONE BRIGHT, SUMMER DAY IN THE LATE 19TH CENTURY, *an event took place unique to the Jersey Shore. Gordon "Pawnee Bill" Lillie, the founder of Pawnee Bill's Wild West Show, took his troupe to Asbury Park for a series of performances. Pawnee*

Bill arrived early on a Sunday and, having promised to show everyone the Atlantic Ocean, assembled his crew of cowboys, horses, and Native Americans for a festive march to the sea. Unaware of the blue laws in nearby Ocean Grove, Pawnee Bill and his colorful band came face to face with good old Methodist morality as they paraded south onto Ocean Grove's walkway. The local town constable ordered them to stop, for they were crossing into the Methodist camp community, where not much of anything with the exception of praying took place on a Sunday: no driving, no amusements, no sunbathing, and no Wild West parades along the boardwalk. Ever the showman, Pawnee Bill reached for his six-shooter (loaded with blanks) and scared the hell out of the shocked policeman. In the ensuing minutes cooler heads prevailed, and Bill placated his troupe by taking them for a ride on the Asbury Electric Trolley. Gordon "Pawnee Bill" Lillie is pictured here on the right next to his fellow showman, Buckskin Jim.

THE FIRST RECORDED USE *of rolling chairs as a novelty and not for the disabled dates to 1876, when they were used at the nation's Centennial Exposition in Philadelphia. William Hayday, a hardware store owner in Atlantic City, may have attended the celebration; although he rented wheelchairs to the disabled for several years, it was only in 1887 that he began renting rolling chairs to anyone who wanted a spin down the lengthy boardwalk. An industry and Jersey Shore tradition were born that year, and by the 1920s it was said that only the hotels employed more people than the rolling chair industry in Atlantic City. The chairs evolved over the decades to sheet-metal motorized models, and today the old-style nonmotorized wicker chairs are back in use.*

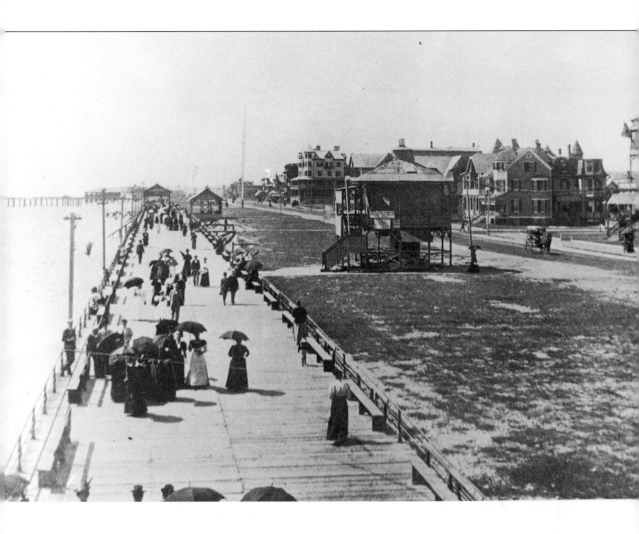

A VIEW OF THE CAMERA OBSCURA, *one of the most popular attractions on the Ocean Grove seaside, located to the right of the boardwalk in this late-nineteenth-century photograph. Invented centuries earlier as a drafting tool for artists, the camera obscura was easily transformed into an amusement before the turn of the century. Just like crowds today, proper Victorians loved to people watch, and for a handful of pennies they could play voyeur for a few precious minutes. Inside the octagonal camera obscura was a darkened room, where a hand-operated rotating lens at the top of the roof provided a 360-degree view of the outside world. The image was cast via a mirror onto a table at the center of the room. Advertised as a way to view ships at sea, hotels, and the Ocean Grove streets, the camera obscura's most requested view was that of lovers spooning on the beach.*

Jersey Shore

ARE THOSE HOUSES MOVING DOWN THE ROAD?

Not long after the Great March Storm of 1962, the city of Cape May was visited by another powerful force, the fundamentalist minister Carl McIntire, leader of the International Council of Christian Churches and broadcaster and star of The Twentieth Century Reformation Hour *radio program, with its four-hundred-plus station outlets in North America. McIntire began to purchase properties, such as Congress Hall, the Virginia Hotel, and the Admiral Hotel, which he renamed the Christian Admiral. One of the minister's projects was to move the Christian-oriented Shelton College from Ringwood, New Jersey, to Cape May. To provide the necessary room for the school, McIntire purchased and moved several buildings to the site of the Christian Admiral. The press and locals of Cape May were treated to a show when in October 1962 the charismatic preacher moved the two Lafayette Cottages, once part of the old Lafayette Hotel, blocks east to Trenton Avenue. Onlookers were transfixed as they watched the structures being moved while the minister broadcast his radio show from the front porch of the lead building. The buildings were eventually abandoned when the organization fell on hard times, but McIntire saved them from the wrecking ball, and today they have been lovingly restored and joined together as one of the more popular bed-and-breakfasts in Cape May.*

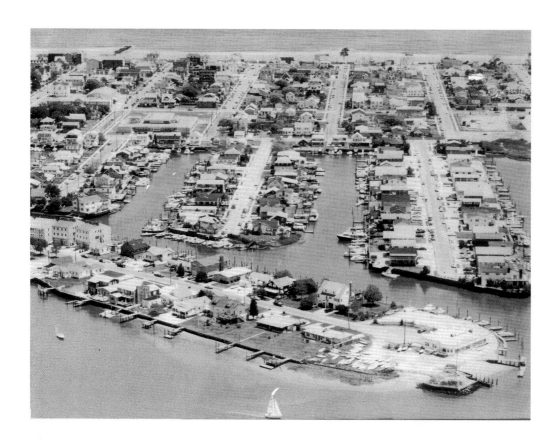

VENICE ALONG THE JERSEY SHORE? *In 1872 successful business owner Charles Landis took the grand tour of Europe and was so taken with Venice that he decided to create his own version of the fabled city. His first step was to purchase one of the Jersey keys (low islands), Ludlam's Island, in Cape May County in 1880, and soon began construction. Landis named his paradise Sea Isle City and went to work developing the resort and attracting the lifeline of all seaside communities, a railway connection. He planned a series of canals, lagoons, and Venetian-style public fountains and statuary, but although the city became a favorite of Philadelphia visitors, he ran out of money, and his dream never became a reality. This 1950s-era aerial view of Sea Isle City shows a glimpse of Landis's dream.*

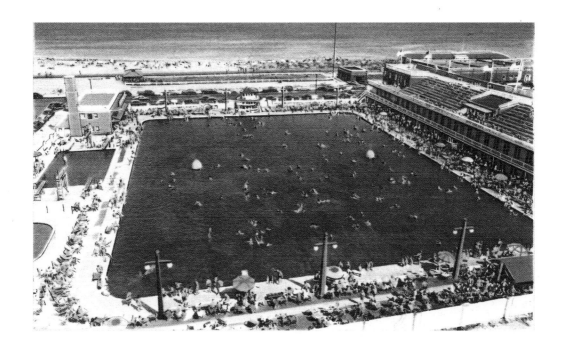

ONE OF THE WONDERS *of the Jersey Shore was the Monte Carlo Swimming Pool, located in Asbury Park. Advertised as the world's largest saltwater swimming pool (there were others that made the same claim), the Monte Carlo covered an entire city block between Ocean Avenue and Kingsley Street. The pool had two dome-shaped water fountains, as can be seen in this photo. The deep end of the pool was in the foreground, on the Kingsley Street side. To the left in this photo (circa 1950) is the deep diving pool for skilled divers determined to attract the attention of the hundreds of admirers who surrounded the pool. Just west of it is the corner of the baby pool. Socializing was concentrated in the two-tier cabana at the right in this photo. The large building in the left-hand corner housed another Jersey Shore curiosity. In addition to serving as a snack bar, as can be witnessed by the crowd in front of the overhang, it was the entrance to a magical tunnel that permitted people to descend a short stairway, walk under Ocean Avenue, and walk up another set of stairs to a much larger body of saltwater—the Atlantic.*

THE ATLANTIC CITY IRON PIER *was acquired by H. J. Heinz and Company in 1898 and renamed the Heinz Pier. Known as "the home of the 57" Heinz varieties, it offered exhibits and free pickles and other company sundries for those who made the journey to the end of the pier. This was the era of the great piers in Atlantic City, and by the late 1920s, there were six of them—Heinz Pier, Steel Pier, Garden Pier, Central Pier, Million Dollar Pier, and the oddball Steeplechase Pier. The Heinz was cut in two and lost in the Great Atlantic Hurricane of 1944.*

FROM MOBSTERS TO LOBSTERS, *the boardwalk in Atlantic City has had it all. Pictured here, circa 1950s, are the famous "lobster waitresses." From a small lunch wagon that operated along the boardwalk in 1912, Hackney's Restaurant developed into the largest in Atlantic City, with a 3,000-seat capacity. To fill those seats daily, the owner, Harry Hackney, entered his costumed waitresses in the Miss America Parade. The caption claims that they were the "prize-winning exhibit of the Atlantic City Beauty Pageant Parade." It is unclear what "prize" they won, but Hackney was not called the "Lobster King" for nothing. He gave out small plastic lobsters to his diners and imprinted his signature red lobster on everything, from linens to sailboats that hugged the shoreline, tempting hungry beach bathers to partake in a crustacean feast. The restaurant lost popularity, as did the resort, after World War II and eventually was destroyed in a fire in the early 1960s. Three generations of Hackneys are pictured here with their lobster waitresses.*

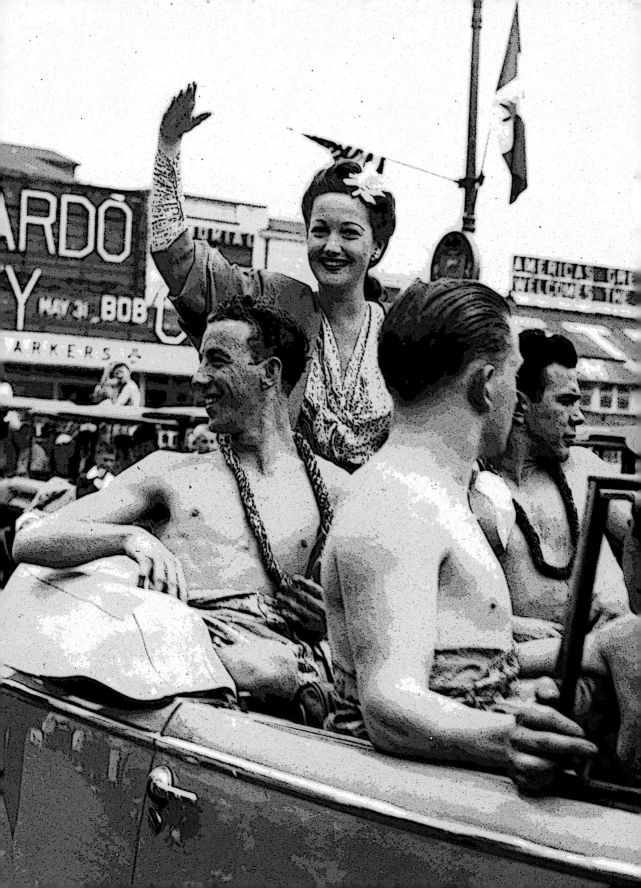

Personalities

SINCE LINKING YOUR TOWN WITH A PERSONALITY meant more business, resorts were at the head of the line in wooing the rich and famous. A wonderful example is Cape May. As the summer season came to an end in 1847, the Queen of the Seaside Resorts was in her prime. Her water transportation monopoly made the resort a genuine rival of Saratoga Springs, New York, and Newport, Rhode Island. Most of the hotels were closing and their staffs gone when the news reached the town officials that nineteenth-century superstar Henry Clay was heading for the resort to relax and mourn the loss of his son in the Mexican War. A media feeding frenzy began immediately, and the city came back to life. Since the hotel bands had left for the season, arrangements were made to have an orchestra travel on the steamboat with Clay. Thousands changed their plans and returned to Cape May to catch a glimpse of the celebrity. A fad of the era was to collect lockets of hair. Clay took a sea bath twice a day and was chased by flocks of women with scissors in hand.

The value of this kind of visit was so great that as soon as Clay made his announcement to visit Cape May, he was inundated with invitations from all over the country. Horace Greeley hired a steamboat and headed to the tiny resort to entice the star to return to New York City with him. Fortunately for Cape May the famous politician refused to change his plans and stayed for two weeks.

On the other side of the coin is the "Washington slept here" syndrome. The same resort that Henry Clay helped make famous bragged for over a

century that Abraham Lincoln had visited the city. The sacred proof was the guest register of the long-lost Mansion House dated July 31, 1849, that documented an A. Lincoln and wife from Philadelphia staying in room 24. It was not until the late twentieth century that it was discovered that the future president had been pleading a case in an Illinois courtroom on that date. Adding to that the fact that a grocer named Abel Lincoln lived in Philadelphia at the time caused even the most adamant believer to admit that they had been confusing the Great Emancipator with a green grocer.

Future, sitting, and former presidents were frequent visitors to the well-established Jersey Shore resorts during the nineteenth and early twentieth century. Cape May did have a legitimate visit from a sitting president in 1855 when Franklin Pierce bestowed his imprimatur on the resort. Other famous visitors included James Buchanan in 1858 and W. E. B. DuBois and Booker T. Washington.

Asbury Park was a magnet for celebrities before it fell into decline, and today it is synonymous with Bruce Springsteen who began his rise to superstardom in the resort.

No resort could brag of more visits from political heavyweights than Long Branch. The city promoters realized early on the value of associating their name with a president of the United States and courted many successfully until the "Branch" fell out of favor. The power of celebrity was recognized, and, more important, respectability was the ultimate goal, especially for a resort that's primary attraction was gambling. The city's first genuine coup was in August 1861 when Mary Todd Lincoln announced that she would spend ten days at one of their most upscale hotels, the Mansion House. Long Branch's success in luring presidents and their families to their hotels, gambling halls, and racetrack can be judged by the old St. James Chapel, later renamed the Church of the Presidents. During the resort's heyday seven presidents at one time or another worshiped at the church: Ulysses S. Grant, Chester A. Arthur, Rutherford B. Hayes, Benjamin Harrison, William McKinley, Woodrow Wilson, and James Garfield.

Although the beautiful actor and later Princess of Monaco Grace Kelly called Philadelphia her home, Ocean City was the Kelly family summer

retreat during her childhood. They owned a home at Twenty-sixth Street and Wesley Avenue. The resort of Ocean City can also claim author Gay Talese as a hometown boy.

When it comes to characters and celebrities, Atlantic City had no equal when it was America's Playground. From Thomas A. Edison to comedians Abbott and Costello, everyone wanted to play on the Boardwalk with a capital B. It would take an entire book dedicated to all of the personalities who either got their start in Atlantic City or vacationed there. Frank Sinatra, W. C. Fields, John Philip Sousa, Dean Martin, Jerry Lewis, Irving Berlin, Bing Crosby, Bob Hope, George Gershwin, Harry Houdini and even the Beatles all entertained the millions of people who visited the resort during its golden years.

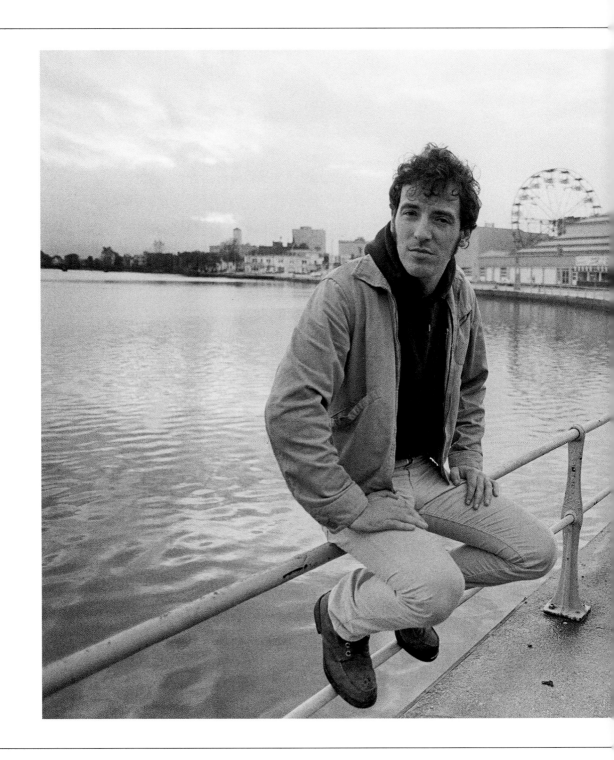

Jersey Shore

MANY AMERICANS WHO HAVE NEVER *seen the Jersey Shore know of Asbury Park and the Stone Pony rock-and-roll club because of this man; The Boss, Bruce Spring- steen. This timeless photograph of Spring- steen was taken by noted rock photographer Joel Bernstein just as the young musician's career was about to skyrocket. This image shows the old Palace Amusements in the background that New Jersey's poet and trou- badour made world famous with songs such as "Born to Run," "Tunnel of Love," and "4th of July, Asbury Park (Sandy)." Legions of fans make the Bruce Springsteen pilgrimage to Asbury Park each year only to see the Palace Amusements gone and a resort trying desper- ately to reclaim its "Glory Days."*

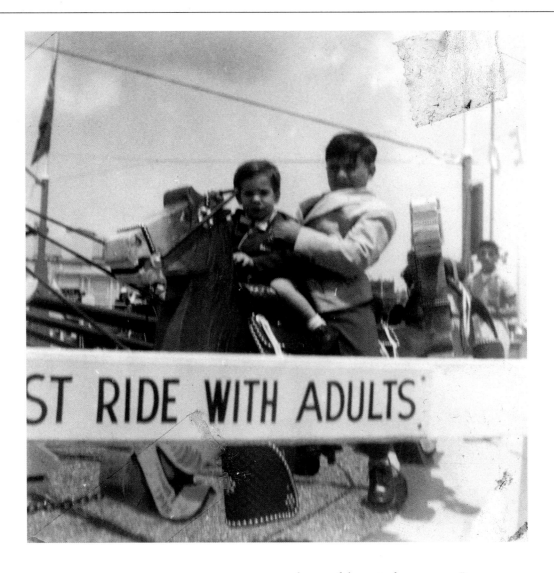

ASBURY PARK WAS STILL A POPULAR *and successful resort when a young Danny DeVito chaperoned his younger cousin Peter Lucia on an amusement ride that required an adult co-rider. The two cousins spent many enjoyable summers in Asbury Park just before the automobile sounded the death knell of the major hotels as day-trippers now spent a few hours rather than a week in what was once called the Duchess of the North Shore.*

A PATRON OF LONG BRANCH *was President James Garfield, one of seven presidents of the United States who summered at one time or another in the then nationally known resort. Garfield's final encounter with Long Branch was not destined to be a happy one: In the summer of 1881, just four months after his inauguration, he was felled by an assassin's bullet on the train platform in Washington, D.C., as he was about to depart for a vacation in the resort. The stricken president was eventually taken to Long Branch where it was thought he would have a better chance of survival by escaping the heat and outbreak of malaria in the capital; but once there, he lasted only twelve days. The nation was captivated by the story of its fallen leader, and pictured here is a popular romanticized illustration of Garfield and the first lady watching the sailing sloops on the Atlantic Ocean.*

LONG BRANCH ALSO ATTRACTED *President Ulysses S. Grant, who loved the horse-racing track, gambling halls, and social events. Grant was not above accepting a gift of a beautiful cottage in Long Branch donated by a group of wealthy friends including publisher George W.* *Childs and millionaire railroad car manufacturer George Pullman. This illustration of President Grant, on the right, attending a dance in Long Branch was published in* Harper's Weekly *in the summer of 1869.*

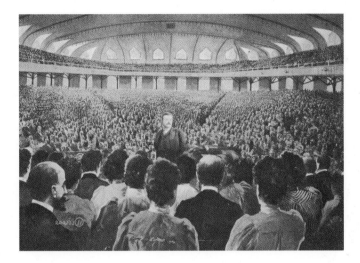

THE GREAT AUDITORIUM OF OCEAN GROVE, *with a seating capacity of almost ten thousand, was a magnet for politicians, celebrities, and powerful guest preachers. On July 7, 1905, President Theodore Roosevelt spoke before a packed house of the National Education Association. Some of the guest speakers or performers who appeared in the Great Auditorium over the years include Enrico Caruso, John Philip Sousa, Billy Graham, Booker T. Washington, and President Richard M. Nixon.*

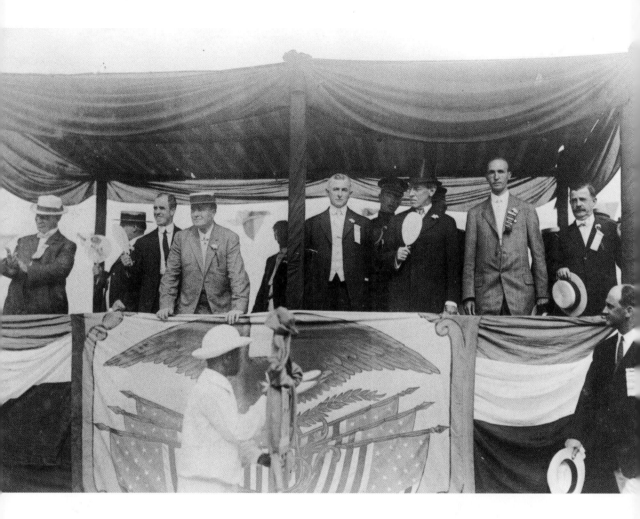

WOODROW WILSON, OUR *twenty-eighth president, made Shadow Lawn, a Long Branch mansion, his summer White House in 1916. He is shown there, third from the right on the platform, during a visit to Long Branch. It is unclear what the event is, but in 1918 a congressional midterm election shifted power to the Republicans, and Wilson's beloved League of Nations was defeated by seven votes in the Senate. The tired and sickly leader believed so strongly in the league that against the orders of his physicians, he toured the nation in an unsuccessful attempt to mobilize public sentiment for it. This may have been one of those tours.*

ORGANIZERS OF THE OCEAN GROVE CHILDREN'S CHOIR *dressed the boys in Rough Rider uniforms to honor President Teddy Roosevelt when he paid their town a call.*

IN 1952 POPULAR MOTION-PICTURE STAR MARILYN MONROE *was asked to fill in as grand marshal of the Miss America parade. She was in town to promote a new film when the original marshal was forced to drop out. At the right of this photo is Miss Utah, exemplifying the girl-next-door image.*

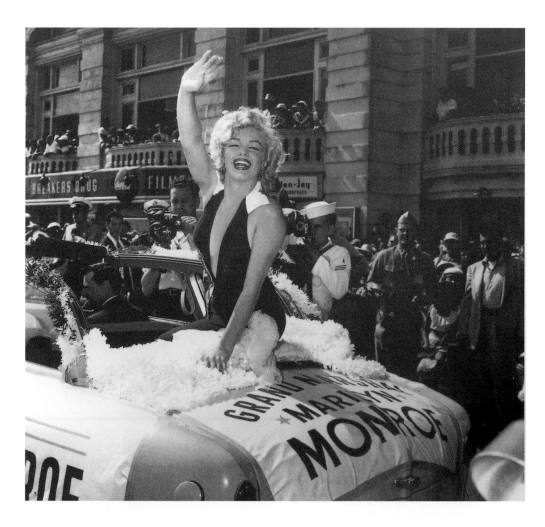

THOUGH TAME BY TODAY'S STANDARDS, THE OUTFIT *Marilyn Monroe was wearing in 1952 was the reason she was never invited back to another Miss America parade in Atlantic City. While the men in the crowd almost rushed the convertible and the sailor with the camera was probably shooting his entire roll of film, the organizers and judges of the parade were horrified by the plunging neckline. The building in the background was the famous Breakers Hotel.*

ANYONE WHO WAS ANYONE PLAYED ATLANTIC CITY *during the heyday of America's Playground. In this staged publicity shot, a very young Bob Hope playfully challenges the regulation for men to wear bathing tops.*

ANOTHER ATLANTIC CITY PARADE *featured motion-picture star Dorothy Lamour, who was best known for her* Road *series movies with Bob Hope and Bing Crosby. This is a wonderful view of* Atlantic City before the resort lost its luster. The Steel Pier in the background featured big names for the era like the Guy Lombardo and Jimmy Dorsey Orchestras.

PAUL "SKINNY" D'AMATO *was born in Atlantic City in 1908, where he ran numbers as a child, and was best known for his famous 500 Club, celebrity pals, and alleged ties to organized crime. A local hero for decades, he experienced Atlantic City's heyday when his club attracted the likes of pals Frank Sinatra and Dean Martin (pictured here in their golden years with Skinny). D'Amato realized early on that people loved celebrity and, through his connection with Sinatra, gave them an opportunity to mingle with people like Eliza-beth Taylor, Milton Berle, Liberace, Marilyn Monroe, and Joe DiMaggio, who had his own booth at the club. Jerry Lewis and Dean Martin were given their start at the 500 Club, and it competed with the best of Las Vegas and New York City nightlife. Eventually, he watched the demise of America's Playground as his 500 Club, a mirror of the tired resort, became a low rent dive, burning to the ground in 1973. He lived long enough to see the casinos tower over the old city and remembered when his club was the center of it all.*

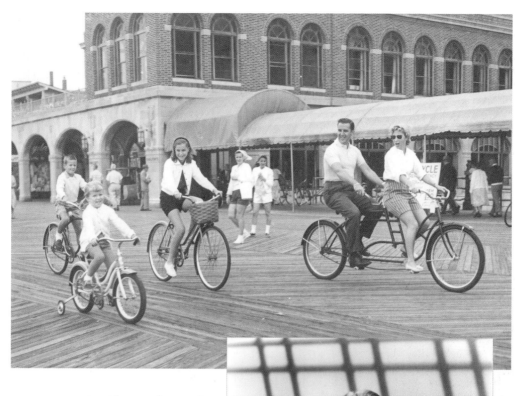

A VERY YOUNG *Ed McMahon and family enjoy a quiet bike ride along the Atlantic City Boardwalk.*

OCEAN CITY HAS BEEN *proud to lay claim to Grace Kelly, who would conquer Hollywood and then the heart of the Prince of Monaco. The Kelly family lived in Philadelphia and spent its summers in a small cottage in Ocean City.*

Parades and Festivals

NO SOONER WAS THE FIRST SECTION OF BOARDWALK completed in Atlantic City than a parade was held that lasted throughout the festive summer night. The wooden walkway hosted the many train-like processions that took place on almost any occasion.

Years before the Miss America Pageant captured the nation's interest, there was the magnificent Floral Parade, first held in the summer of 1902. Lovely young women rode in rolling chairs, which were adorned with colorful floral displays that were the center of attention and the criteria for the grand prize.

In 1914 visitors to Atlantic City were treated to an early-season carnival that culminated with a parade that stretched over seventy blocks, with almost five thousand wheeled vehicles.

As the seasons passed, the promoters of these events realized that the public enjoyed the beautiful women more than the flower-covered rolling chairs, and the first official beauty pageant was held. In 1921 the Atlantic City Beauty Pageant debuted with Margaret Gorman, a sixteen-year-old beauty from Washington, D.C., claiming the title of Miss America. The beauty contest would go under that name until it was officially changed to the Miss America Pageant in 1940.

One amazing parade in 1925 had spectators wondering if their eyes had deceived them. Two railroads, the Pennsylvania and the Reading, had been battling each other for years for the lucrative shore trade, and they both

recognized that marketing was key. In 1924 the Pennsylvania Railroad and its division, the West Jersey & Seashore Railroad, had scored a coup by winning the grand prize in the beauty pageant parade with a float featuring a scale model of the railroad's Delair Bridge. Reading officials and their division, the Atlantic City Railroad, were determined to capture the prize in 1925 and devised a plan right out of a special-effects studio. The company's pride and joy at the time was the Boardwalk Flyer, a 227-ton, 15-foot-high monster that carried carloads of tourists between Philadelphia and Atlantic City. At the height of the railroad era, Reading had twenty of the popular Boardwalk Flyers in action.

Under a veil of secrecy that would rival any covert operation today, employees began working on a full-scale model of the Boardwalk Flyer in the company's service shops in Camden, New Jersey. They began with two Ford chassis and, using the blueprints for the real locomotive, spent six weeks creating and assembling over eleven thousand parts consisting of sheet metal, wood, and handmade fabrics. This work of art was built by hand, and when the magicians were finished, they had conjured up an exact replica of the giant engine and tender. Instead of the 227-ton real-life version, the parade beauty weighed in at 2½ tons. It was secretly shipped by rail to Atlantic City in the dead of night and kept from view until the day of the parade. When it made its appearance, thousands of parade spectators swore the genuine Boardwalk Flyer was traveling down the wooden walkway. Fifteen men were required to operate the monster float. The designers included every detail of the original, including an apparatus that produced steam and smoke. Eyewitness reports indicated that the crowds believed they were viewing the impossible, and many feared their beloved boardwalk would collapse. The most expensive entry in Atlantic City parade history ran away with the grand prize for 1925.

In 1876 the promoters of the Centennial Exposition in Philadelphia anticipated millions of visitors eager to celebrate the nation's birthday. The business leaders of Atlantic City, hoping to tap into the throngs of tourists, created the first Boardwalk Easter Parade, which was held on April 16, 1876. The railroads and newspapers got onboard, and the parade, a marketing triumph, became an Atlantic City tradition.

Many resorts, such as Wildwood, used parades to launch the official summer season, which began on Decoration Day, later known as Memorial Day. The Baby Parade originated in 1890 in Asbury Park. The first event consisted of two hundred children competing for the grand prize, a deluxe baby carriage. The judges, not wishing to be run out of town by a mob of irate parents, wisely awarded the prize based on the quality of the baby carriage decorations and not the beauty of the baby.

Not all parades were whimsical and happy occasions. The horrific Ku Klux Klan parade that took place over four painful hours in Long Branch in 1925 was an occasion the town would love to forget. The event crushed the resort at a time when it was already out of vogue and desperately seeking a way to reinvent itself. Hundreds of Jewish and Catholic families closed their summer homes the next day, many never to return. The year before witnessed another Klan rally in Point Pleasant that resulted in numerous injuries. At the height of this, the First Methodist Church Community House in Point Pleasant hosted over four hundred men in full Klan regalia. The town's dirty little secret became statewide news when the floor of the hall collapsed under the weight of the Klansmen.

The first true sea festival that took place along the Jersey coast originated with the Lenni-Lenape, Navesink, and Minnesink tribes. Local legend has it that the tribes would gather along the shore each autumn for an annual celebration of the ocean and its bounty. Once European settlers claimed the land for their own, local farmers would gather each year in August for what became known as Wash Day or Big Sea Day. They would travel to the seaside by the thousands; many swam in their clothes and after drying out would feast on the sea's bounty, especially clams. In Sea Girt the farmers would meet near Wreck Pond, and by 1894 the festival had turned into a weekend. As resorts began to develop and evolve, the farmers found themselves as unwelcome as the Lenni-Lenape, from whom their ancestors had appropriated the land in the first place. Hotel residents disapproved of the riotous celebration, and by the end of the nineteenth century, the festival began to fade into history. Today a few resorts, such as Spring Lake and Point Pleasant, have their own version of a more serene Big Sea Day.

PARADES HAVE BEEN PART OF *Atlantic City since June 1870 when its first boardwalk opened. The first parade was impromptu and was so well received it lasted until the following day. By 1921 the city was hostng the Atlantic City Beauty Pageant, which by 1940 had evolved into the famous Miss America Pageant. Pictured here is a Miss America circa the early 1970s with her adoring fans, many watching from their rolling chairs. The parade was an Atlantic City tradition until 2005, when television ratings were so low that the pageant abandoned the resort where the parade and contest were born.*

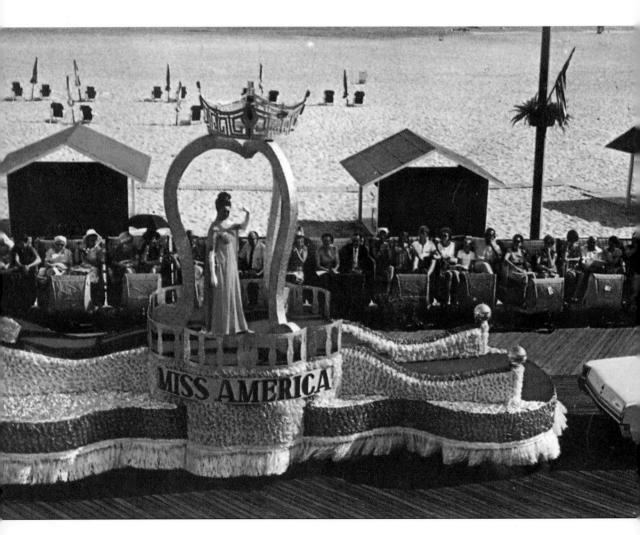

THE ATLANTIC CITY BEAUTY *Pageant began as an intercity beauty contest, with local newspapers sponsoring their own entry for Miss America. It was marketing genius, as all the editors felt it was their duty to rally the locals for their hometown entry. As the parade evolved, the organizers decided to have each state provide a beauty, and the national Miss America pageant was born. This 1920s view shows five beauties of the intercity pageant, with the dethroned former winner on the right, the happy winner on the left, and runners-up on stage. Miss Brooklyn can be seen fourth from the left in the photo.*

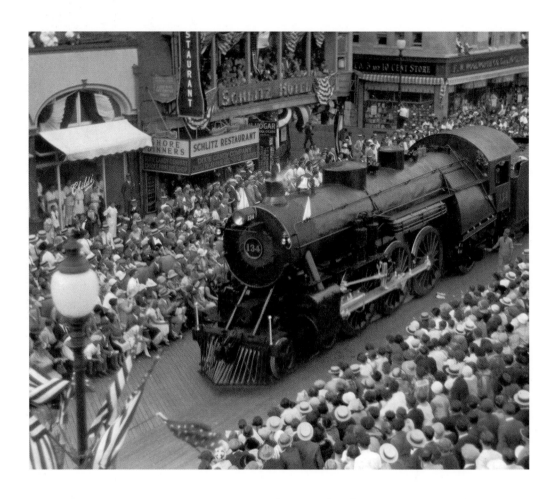

STRIVING TO OUTDO RIVAL *Pennsylvania Railroad's prize-winning parade entry of the year before, the Reading Railroad built a full-scale replica of its Boardwalk Flyer, shown here in the 1925 beauty pageant parade. The Reading Railroad won the grand prize that year and raised the bar, as it was the most expensive float ever entered in the parade.*

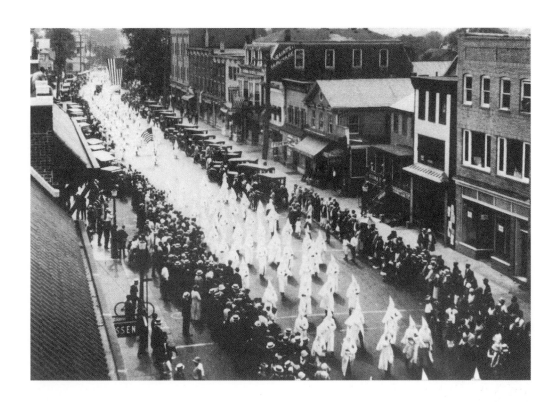

DURING THE EARLY TWENTIETH CENTURY, one of the largest contingents of the Ku Klux Klan in the state was located in Elkwood Park, an aging racetrack/amusement complex near Long Branch, built during happier times by the flamboyant Phil Daly in 1890. The Klan was so powerful by the 1920s that they purchased the park for their hate rallies, and on July 4, 1924, thousands of hooded men from several states marched through Long Branch in a parade that was so large it took four agonizing hours to pass through town. Instead of welcoming the hard-working Catholics, Jews, and numerous other ethnic groups that brought their families to the resort, many longtime residents burned crosses and told them they were not welcome. In the days that followed, hundreds of Jews and Catholics boarded up their summer homes and left for the season—some forever—taking with them the dollars they spent with the local merchants, many who had illogically marched in the parade. Businesses folded overnight, and the resort went into a spiraling decline and took decades to rebound. When good local people, along with the foolish ones who had marched in the procession, realized what they had done to their economy and reputation, most groups disbanded and the Klan lost Elkwood Park.

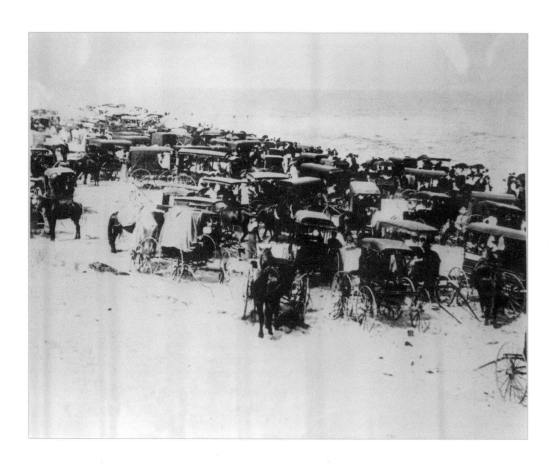

PICTURED HERE IN 1896 *is a Big Sea Day in Point Pleasant. Some reports put the number at ten thousand participants at the zenith of the celebration, but the festival fell out of favor as the shoreline built up with boardwalks and commercial buildings. Point Pleasant today celebrates the Festival of the Sea every September to honor the tradition. Sea Girt also lays claim to a Lenni-Lenape celebration that took place near Wreck Pond Inlet.*

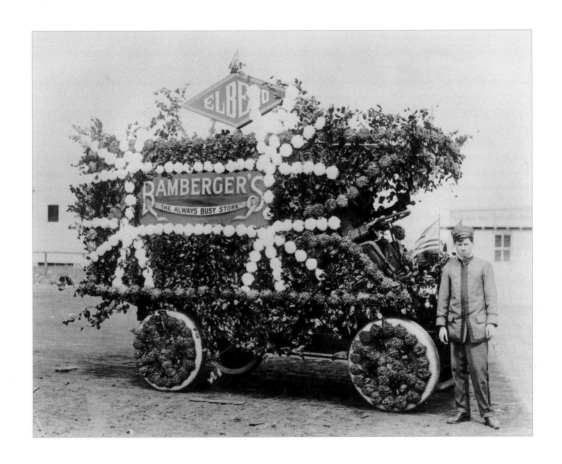

NOTHING EXCEEDS AS EXCESS, *as demonstrated in this flower garden on wheels preparing to represent Bamberger's department store and Elberon in a Long Branch parade. Floral parades were popular in the late nineteenth and early twentieth centuries, and floats like these were sometimes part of a baby parade.*

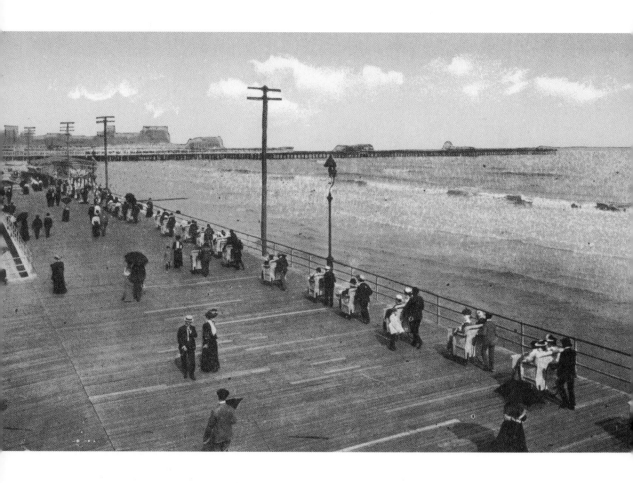

ROLLING CHAIR PARADES WERE VERY *popular in Atlantic City in the early 1900s. Sometimes the chairs would be ornately decorated and judged, but other times the parade was organized just for fun.*

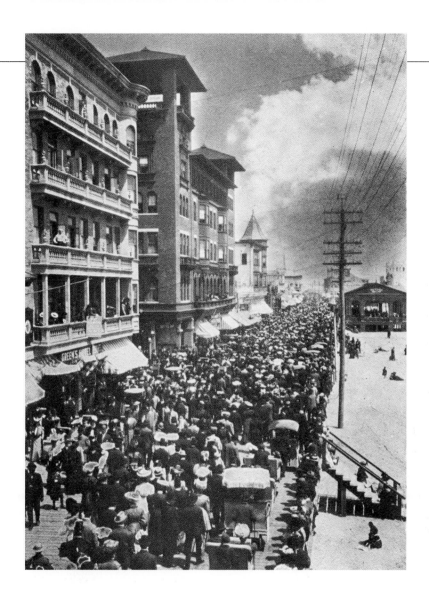

THE MOTHER OF ALL PARADES *in Atlantic City was the Easter Parade or Promenade. This mass of humanity was photographed in 1905. An early Thomas Edison movie of the parade showed two-lane traffic, with each group sizing up the other as they passed in an orderly fashion. The popularity of the resort can be seen in the fact that it attracted so many people before the bathing season. For many decades the Easter Parade marked the beginning of the summer season, but few ventured in the water, and none of the bathhouses were open. By 1910 Memorial Day proved a more fitting date to begin the season. Once the holiday was accepted, the Atlantic City Beach Patrol would hold a ceremony for the public and press in which they would "unlock" the ocean for the season.*

THE ATLANTIC CITY BEAUTY PAGEANT *in September 1924. Resorts along the Jersey Shore have always tried to extend the traditional season. In the case of Atlantic City, the promoters used the Easter Parade in the spring and the beauty pageant (later called the Miss America Pageant) as the autumn approached. This float was sponsored by a local bread company and pulled by six men dressed in white, including white straw hats. The outfit of the bathing beauty sitting in the shell was extremely risqué for the era.*

AT THE END OF THE *nineteenth century, communities along the shore were proud to display their latest firefighting equipment. Nothing was more dangerous than fire to resorts built of wood. This photo of a parade in Long Branch shows onlookers applauding the resort's courageous firefighters.*

THE BABY PARADE TRADITION *in Asbury Park began in July 1890 and grew over the years to draw more than a hundred thousand spectators packed onto the mile-long boardwalk. The most important stop on the Asbury Park Baby Parade was the reviewing stand, where Queen Titania and her court would judge the contestants. The first few parades judged the prettiest babies, the youngest baby, the best decorated coaches, and the most novel float. Angry parents eventually convinced the officials that it was safer to judge the carriages and floats than the actual children.*

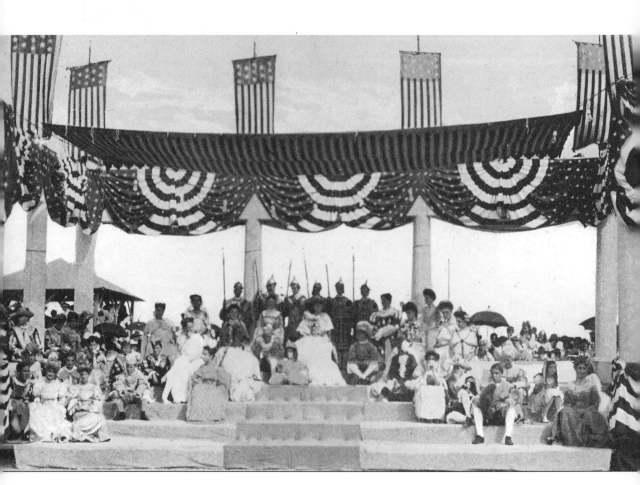

Jersey Shore

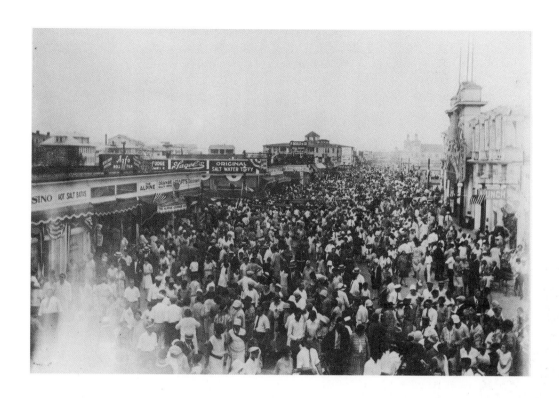

THE CAPTION OF THIS PHOTO *described the 1932 Great Baby Carnival of Wildwood. The towers on the right are part of Hunt's Auditorium. Four years later the* New York Times *would report that a hundred thousand spectators viewed the event. Taking a cue from Asbury Park, the resort named its monarch Queen Oceania. Prizes included taffy, fudge, and cold cash. There was even a fattest baby category. The parade still exists today, with categories including most attractive baby boy and girl; best decorated stroller, coach, wagon, and kiddie car; most original fancy dress; and comic-original dress.*

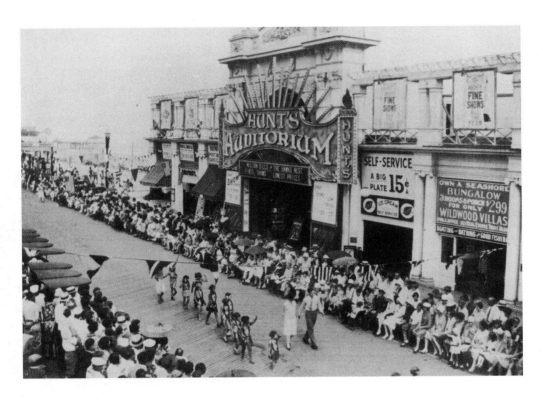

CROWDS LINE THE BOARDWALK IN FRONT OF *Hunt's Auditorium circa 1920 in Wildwood watching the children pass by in full costume. The sign on the right advertises three-room bungalows, complete with porch, in Wildwood Villas for only $299.*

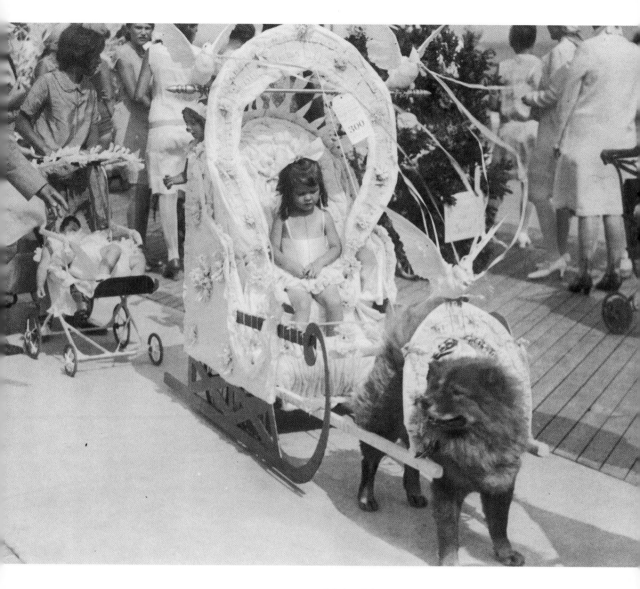

AS PRIZE CATEGORIES EVOLVED, *so did the elaborate entries in baby parades.*
This picture of the 1900 Baby Carnival of Wildwood demonstrates that even the
pets got in the action. A close look at the upper right of the cart indicates that the
little girl and her pet were entry number 300 that year.

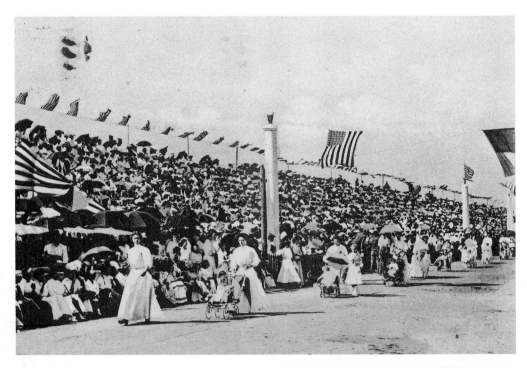

THE BIG MOMENT *in a baby parade was when the children and their proud mothers passed the reviewing stand. Patriotism was very fashionable, as seen in this scene from an early-twentieth-century Asbury Park Baby Parade.*

THE ASBURY PARK BABY PARADE *was one of the most popular along the Jersey Shore, and at the height of its popularity it attracted some of the most amusing costumes, such as the one pictured here from the early twentieth century.*

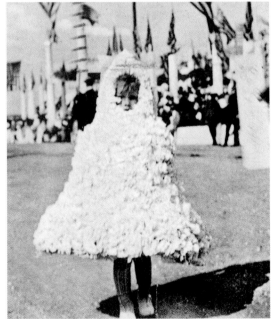

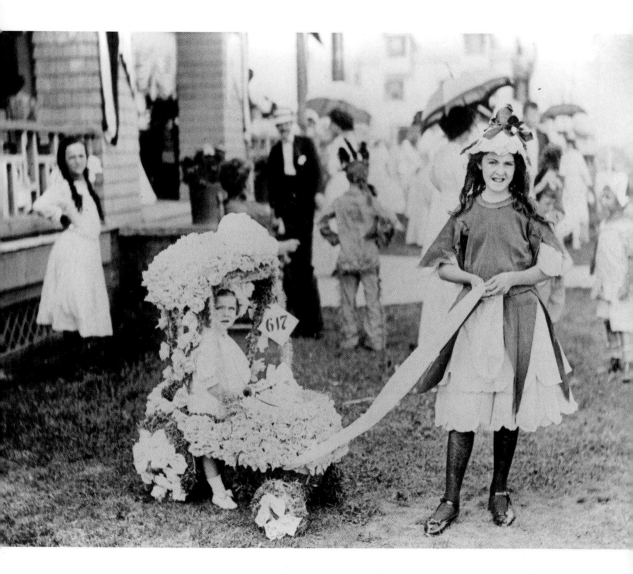

HERE AT THE 1911 LONG BRANCH CARNIVAL, *entry number 617, with big sister in costume ready to roll baby sister down the wooden walkway. Many of the carriages and prams took days to decorate.*

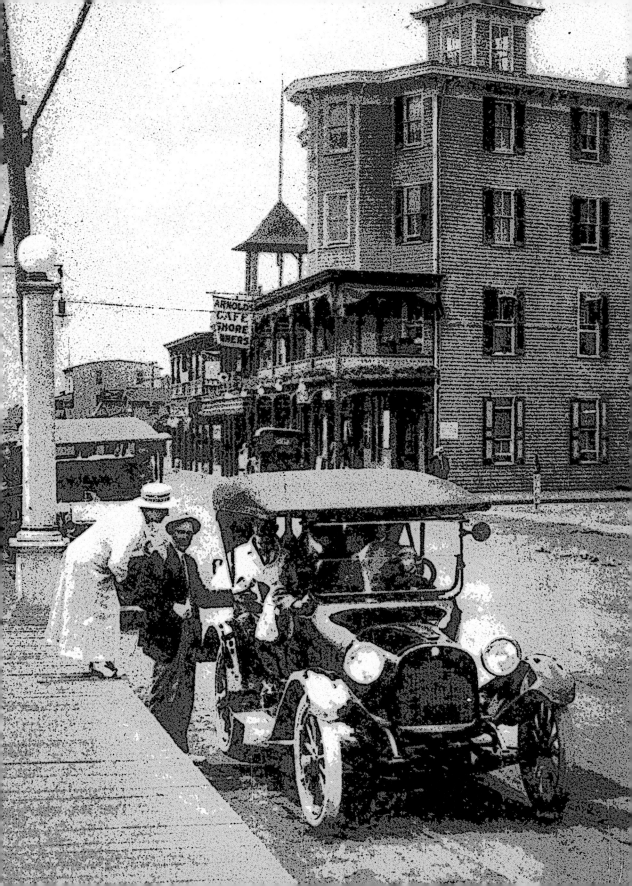

Transportation

"ARE WE THERE YET?" THIS TIMELESS TRAVELER'S QUERY probably began when the first hardy souls took a trip to the Jersey Shore via what were known at the end of the eighteenth century as "jersey" or "shore wagons." These were wagons that traversed the winding, primitive dirt roads that connected Philadelphia and New York City with the Atlantic Ocean. Although their primary purpose was to carry sea products to market, enterprising drivers would "haul" human cargo to the fledgling seaside resorts for a price. A trip by wagon was an arduous one, inspiring one poet to write, "Every bone is aching, after the shaking."

One woman who traveled by coach in 1835 described the New Jersey road her driver took as the "wickedest" that ever was and the coach as a "nefarious black hole on wheels." There was no such thing as speed. Another Jersey traveler, who took a 34-mile horse-drawn railway trip in 1833, noted that it took four hours and that every hour the horses had to be changed for a fresh team.

Because of the conditions associated with land travel, a voyage by water was more desirable, and the resorts that could capitalize on this fact became the winners in the first half of the nineteenth century. The most prominent example was Cape May. Located at the tip of the New Jersey peninsula and within site of the commercial sea travel that took place between Philadelphia and the Atlantic Ocean, the small farming and fishing village was poised to become the state's first nationally known ocean resort. By 1790 Philadelphia

was the largest city in the United States, and it did not take long for several ambitious sloop captains to see the potential of transporting the affluent to the sleepy seaside town. This was the beginning of the New Jersey tourism industry. Travel to Cape May by sailing sloop was eventually replaced by faster, more comfortable steamboats with names like the *General Jackson, Independence, Superior,* and *Linnaeus.* By the summer of 1851, the little village had become the Queen of the Seaside Resorts and was hosting over a hundred thousand people a year.

Steamboat travel also assisted in developing Cape May's first genuine rival on the Jersey coast—Long Branch—and soon a host of steamers, led by the magnificent 1,752-ton *Plymouth Rock,* tapped into the lucrative New York City trade. A succession of piers, culminating with the Ocean Pier, built in 1879, became amusement promenades for the growing crowds and docks for the massive steamboats. Known as the "stepping-stones to the Jersey Shore," these piers and landings provided Cape May and Long Branch with a monopoly on the resort business for over fifty years.

By the mid-nineteenth century, technology and envious promoters would conspire to topple the Queen from her throne. In 1853 Absecon Island was a mosquito-ridden, sparsely occupied, wild patch of land located about 50 miles north of Cape May on the Jersey coastline. That same year one unfortunate traveler, whose ship was wrecked near Absecon Island, wrote of her craft being set upon by "Jersey wreckers," who stole everything in sight, including her clothing, two gold watches, and money.

An event would take place the following year that would change the Jersey coast forever. On July 1, 1854, the first train to Absecon Island, now named Atlantic City, arrived with just eleven passengers from Philadelphia, via Camden. The Camden and Atlantic Railroad had been a dream of a local country doctor named Jonathan Pitney, who realized that Absecon was just 60 miles from Philadelphia, and that a new city by the sea would tap into Cape May's lucrative market. It took Pitney years to convince investors to listen; but eventually he did, and fortunes were made on his railroad to nowhere. The new railroad did not offer luxury at first, but it did offer speed. Cape May could boast of a long pedigree, but it could not compete with the

ninety-minute trip from Philadelphia to Atlantic City that was possible by rail by 1877. The railroad opened vacation travel to trainloads of lower and middle-class workers who could now afford a summer vacation. For the first time it was possible to spend a day at the beach and be back home the same day.

By the twentieth century Cape May was almost forgotten, and its transportation monopoly was long gone. The railroad had turned Atlantic City into America's Playground, but another event would eventually change the face of the Jersey Shore. In 1926 the first automobile bridge connecting Philadelphia with Camden, New Jersey, was built across the Delaware River. Up to that point a railroad bridge was the only practical route between the city and the resort. The railroad officers postured and even threatened to curtail service to Atlantic City, but the genie was out of the bottle. Hordes of cars and buses crossed the bridge that day, and the railroad monopoly was broken.

It took several more decades, but the automobile again transformed the Jersey coast. Atlantic City fell upon hard times, along with Asbury Park, as more mobile families chose to spend a day, no longer a week, inspired by their automobiles and improved roads. The grand hotels that once graced the resort's boardwalks fell prey to the wrecker's ball. It was a new age of motels, day-trippers, and eventually air travel to exotic locations.

As the twentieth century came to a close, the 173-mile Garden State Parkway was the preferred route to the shore, and "What exit?" became part of the New Jersey lexicon. Old resorts struggled to reclaim their former glory, while new favorites emerged. Victorian Cape May, forgotten for decades, and now less than two hours from Philadelphia, and three from New York City by automobile, was "rediscovered," and the Jersey coast transportation wheel had gone full circle.

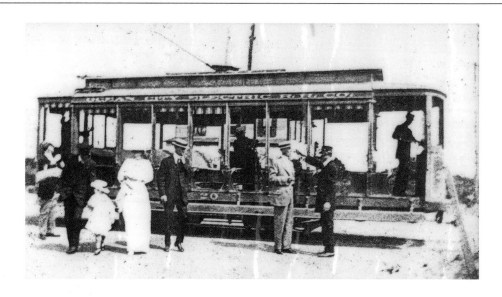

THE OCEAN CITY TROLLEY, *known as the Toonerville Trolley by the locals, was operated by the Ocean City Electric R. R. Company from 1895 until 1929.*

AS EARLY AS THE LATE EIGHTEENTH *century, newspapers referred to the growth in maritime travel to Cape May, and sea captains were more than happy to pick up a few extra dollars delivering Philadelphians who had the time and money to escape the sweltering heat of the city. Pictured here is the sailing vessel* E. C. Knight, *off the coast of Cape May circa 1870.*

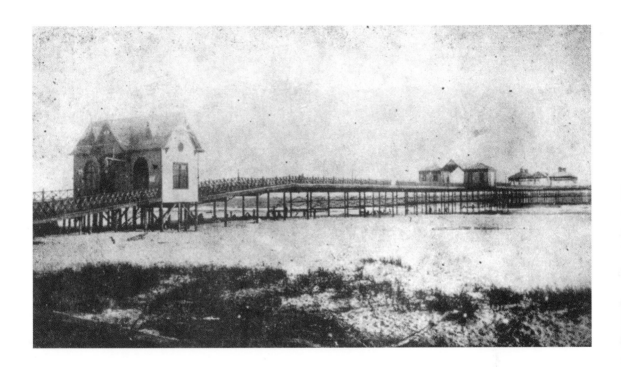

PIERS WERE USED FOR AMUSEMENT *and on a calm day provided a dock for passengers to disembark from sailing sloops and later steam-powered boats. In 1884 Cape May, envious of the success of the iron piers constructed by resorts to the north, decided to build one of its own. The Phoenix Iron Company built a two-level pier that extended 1,000 feet over the Atlantic and provided a half acre of space for a dance hall, theater, amusements, a lower-level fishing facility, and, of course, an artificial wharf. The pier, although a success for over three decades, was razed in the 1920s, a victim of erosion, fire, neglect, and a disastrous collision with a stone-laden commercial barge.*

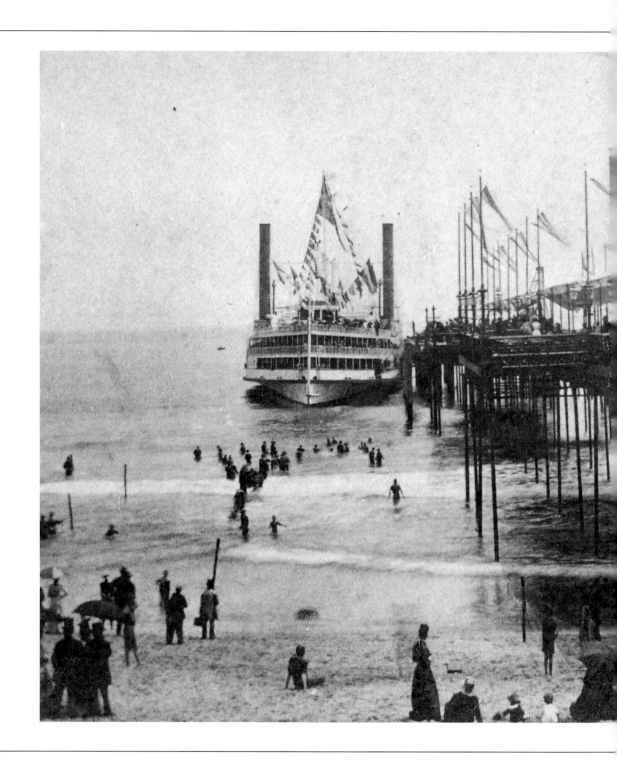

Jersey Shore

A RARE VIEW OF THE *PLYMOUTH ROCK* *docking alongside the famous Iron Pier at Long Branch. The resort had a series of piers that all met with bad luck, as was the case with this pier constructed in 1879 and promptly destroyed in 1880 by a vicious December nor'easter. The pier was quickly rebuilt, but by 1908, with steamboats replaced by the railroad, the remains of the neglected iron pier were razed. The* Plymouth Rock *was a 330-foot, 1,752-ton steamboat that made two trips a day, seven days a week, between New York and Long Branch, with a special excursion rate of 60 cents that included one-way transportation and admission to the pier's amusements. Steamboats opened the resort to a new class of travelers—day-trippers—who would make their way to the foot of West Twenty-second Street in Manhattan on a steamy summer day, board the* Plymouth Rock *at 9:30 a.m., and be frolicking in the Atlantic surf in a few hours. How popular was this new means of transportation? One week after the 1879 pier opened, more than seven thousand people had already paid the one-dime admission fee to secure bragging rights that they had walked the length of the still uncompleted pier. On one fine July 4 weekend in 1880, the* New York Times *reported that the giant* Plymouth Rock, *with almost sixteen hundred excursionists on board, was forced to turn back to New York City because the hotels of Long Branch were already filled to capacity.*

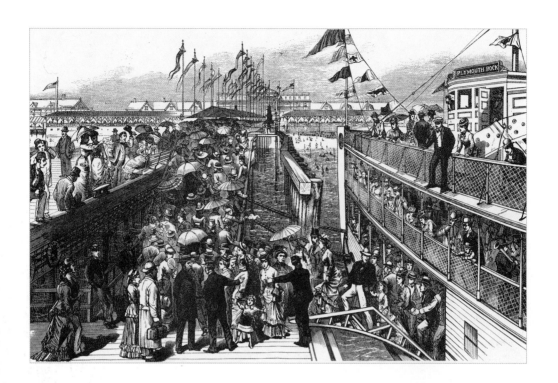

NOTHING COULD COMPARE *to the excitement of more than a thousand excursionists disembarking from the massive steamship* Plymouth Rock, *as depicted here in an 1879 illustration that appeared in* Frank Leslie's Illustrated Newspaper. *The steamship was not only transportation but also a floating palace that reflected the personality of its owner, the flamboyant and controversial Jim Fisk. The* Plymouth Rock *never traveled without a full brass band, and it is said that the dining salon was the home to 250 canaries, each made comfortable in its own gilt cage and each named after one of Fisk's close and personal friends. The ship contained thirty-two luxury suites and was the pride of Fisk's fleet.*

It was the custom of the Ocean Hotel to discharge a cannon charge to announce the arrival of a steamship, which added to the excitement of the moment and signaled the hotel transports to greet the new arrivals. In a symbolic way, the cannon, called Leland's Gun, also signaled the end of an era at the Branch. The elite old money set found the daily arrival of thousands of day-trippers—working-class urban people who had more free time in the new industrial age—not to their liking and moved on to greener pastures like Newport, Rhode Island, and Saratoga Springs, New York.

A BROADSIDE FOR THE "ENTIRELY NEW & FAST" City of Richmond, *a steamboat that made three daily trips from New York City to Long Branch along with the* Plymouth Rock, Adelaide, Taurus, *and* Columbia.

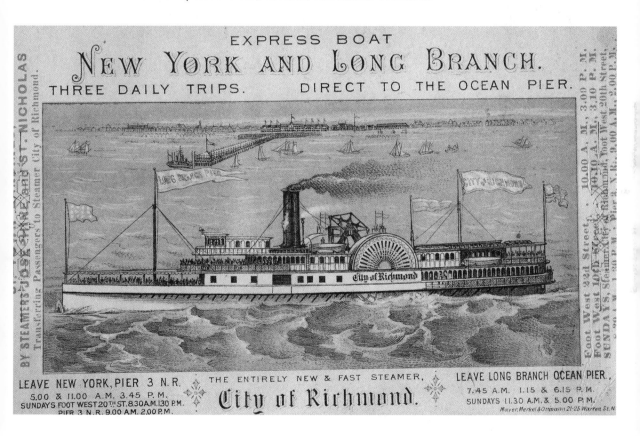

AS CITIES LIKE NEW YORK AND PHILADELPHIA DEVELOPED *into major urban environments, they were horrible places to be during the pre-air-conditioned summer months. In addition to the discomfort and heavy clothing worn by men, women, and even children, there were frequent outbreaks of yellow fever and other diseases, so anyone who had the financial means escaped to the country or popular seaside resorts.*

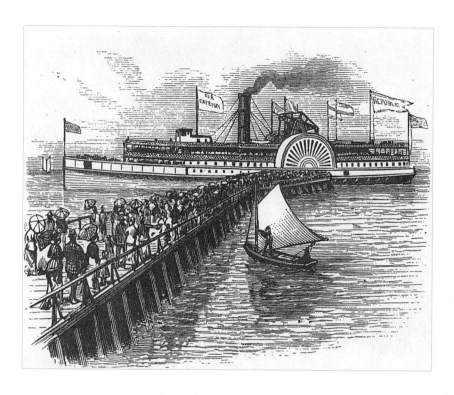

THE *REPUBLIC* WAS THE LAST *and most luxurious of the side-wheel steamboats to service the resort of Cape May and was in operation from 1878 until 1903. The popular three-level deck boat was rechristened the* Cape May *during its last year of operation. The boat survived, although the railroad had finally connected Cape May to the world in 1863, because many longtime visitors preferred the luxury of the boat to the efficient but unremarkable train trip. A dining room provided breakfast, dinner, and supper with a priceless view of the banks of the Delaware River while a band serenaded the guests. Gimmicks were popular during the era, and the* Republic *featured a little person, Commodore Doyle, dressed in a miniature uniform complete with sword and proclaimed to be the smallest sailor afloat. The* Republic *departed from the wharf at the foot of Race Street, Philadelphia, and a round-trip fare cost $1. Upon arrival the boat docked, as seen here at the landing on the Delaware Bay side of Cape May Point, where the travelers were greeted by hundreds of hotel wagons and carriages that would take them to the dozens of hotels and guesthouses that existed at the time. Travelers could also relax in the Delaware Bay House, an excursion house located near the landing. The owner of the* Republic, *Jonathan Cone, eventually created the Delaware Bay and Cape May Railroad that ran along the beach from his steamboat landing to Cape May City.*

One of "THE READING'S" Famous TRAINS TO THE SEA

From FOOT OF CHESTNUT STREET
Philadelphia

The FINEST Seashore TRAIN SERVICE in the World

The Boardwalk Flyer
The Reading

PASSENGER TRAFFIC REPRESENTATIVES

EDWIN L. LEWIS
Passenger Traffic Manager
E. D. OSTERHOUT
General Passenger Agent
GEORGE F. INGRAM
Asst. General Passenger Agent
Offices:
Reading Terminal, Philadelphia

PHILADELPHIA, PA.
Chas. C. Williams, Dist. Passenger Agent
1341 Chestnut Street
READING, PA.
D. L. Mauger, Dist. Passenger Agent
23 North 6th St.
ATLANTIC CITY, N. J.
J. Sidman Selby, Dist. Passenger Agent
Boardwalk and N. Carolina Ave.
WILLIAMSPORT, PA.
G. O. Roper, Dist. Passenger Agent

THE INTRODUCTION AND EVOLUTION of the railroad, in a matter of a few years, magically transformed a featureless, worthless patch of land such as Absecon Island into the wonderland known as Atlantic City in 1854 while simultaneously threatening the survival of older established resorts. A group of investors planned the resort of Atlantic City at the terminus of their 60-mile railroad that connected Philadelphia via Camden, New Jersey, to the Atlantic Ocean; and almost overnight Cape May lost its transportation monopoly and its lock on Philadelphia tourists. As train service improved, it became possible to travel from the Quaker City to the seashore in a little more than an hour, opening a huge market for the resort. It now became possible to spend a Sunday at the seaside and be back at the job bright and early Monday morning. Upper-middle-class families could build summer cottages, and fathers could commute from the city. At the peak of the railroad era, the Reading Railroad was famous for its Boardwalk Flyer advertised on this brochure.

THE HORSE AND BUGGY MEETS THE IRON HORSE, *as pictured in this wonderful circa 1910 view of private carriages and hotel wagons awaiting the arrival of the train at a station in Asbury Park.*

ANOTHER VIEW OF THE OCEAN GROVE *and Asbury Park Depot located in Asbury Park showing the business end of the station.*

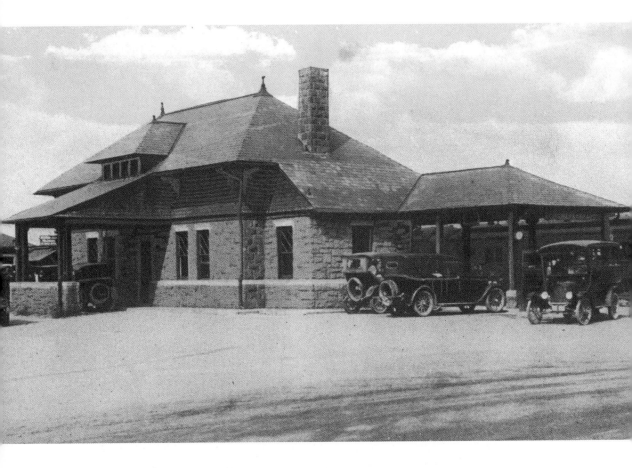

AN EARLY-TWENTIETH-CENTURY VIEW *of the train station at Point Pleasant located on the Barnegat Peninsula. The railroad business model of seaside development was no more in evidence than in the founding of this popular resort. In 1877–1878, a group of investors formed the Point Pleasant Land Company, constructed the first hotel, the Resort House Hotel, and the rest was history. With an eye on the Philadelphia market, the company wisely laid out the streets in a gridlike configuration familiar to residents of the Quaker City, and by 1890 Point Pleasant was a bustling resort town with hotels, summer cottages, churches, schools, and amusement facilities.*

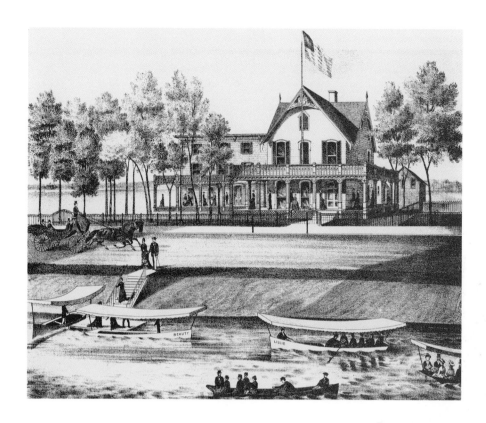

OCEAN BEACH, KNOWN TODAY AS BELMAR, *was another town that developed as the New York and Long Branch Railroad ventured south of older seaside favorites like Ocean Grove and Asbury Park. A group of developers from Ocean Grove believed that the railroad connection would provide a wealthier class of people an opportunity to build more stately homes on larger lots in this undeveloped area, and they purchased 372 acres for just over $1,000. In his book* New Jersey Coast and Pines, *published in 1889, Gustav Kobbe wrote:*

> *"The twelve chief avenues of Ocean Beach extend from the sea to Shark River; they are 80 feet wide, and each house is required to have a space of at least 20 feet between house and front line of lot, which insures a road-opening of 120 feet."*

Pictured here is the Fifth Avenue House built in 1889, when a one-year commuter rail pass from New York City to a dream beach cottage would cost $145.

BY THE TIME THIS PHOTO *was taken around 1910, an interesting and arduous journey could be undertaken from Cape May Point to Atlantic City. The first leg of the trip involved taking the Cape May and Sewell's Point Railroad to Sewell's Point, located at the far eastern end of Cape May City. From there travelers would board a steam launch for a quick trip to Wildwood Crest, where they would board a trolley to Anglesea, now North Wildwood. Once they were there, another steam launch would convey them through the barrier islands to Stone Harbor, where a train would transport them to Ocean City. Then it was one more steam launch to Longport and a short trolley ride to the boardwalk at Atlantic City.*

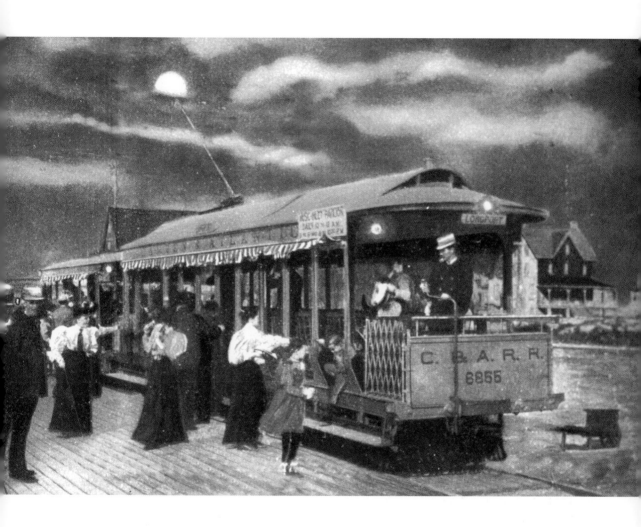

ON THIS NIGHT CIRCA 1910, *riders are about to board the Camden and Atlantic R. R. electric trolley for a moonlit ride south to Longport and eventually Ocean City.*

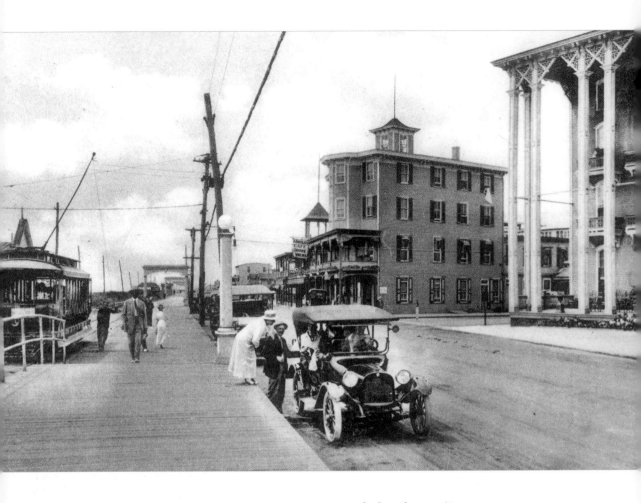

NO ONE VIEWING THIS CHARMING PHOTO *of a horseless carriage next to the Cape May boardwalk and electric trolley around the year 1918 could ever imagine the changes that would take place when the automobile became the preferred method of travel to the Jersey Shore.*

THE EXCITEMENT OF THE ARRIVAL OF THE MORNING TRAIN *at Long Branch is captured in this nineteenth-century illustration. Eager travelers would board the omnibuses provided by the major hotels, while others took advantage of the carriages and wagons that would take them to their hotel for a fee.*

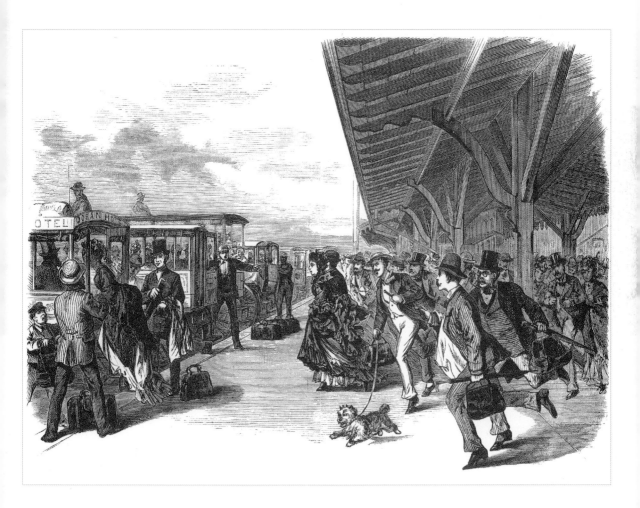

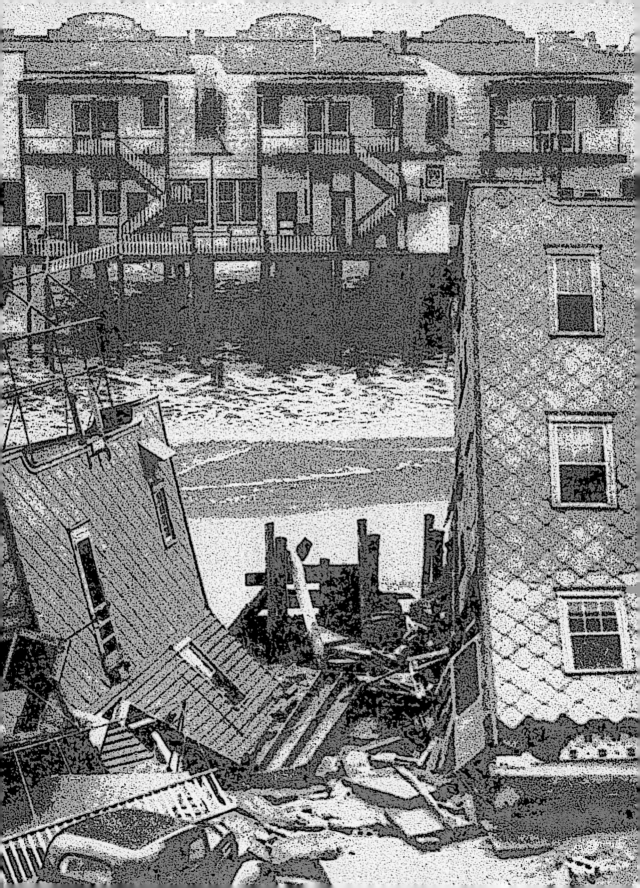

Storms and Hurricanes

THE RESORTS ALONG THE JERSEY COAST HAVE PAID DEARLY over the centuries for building too near the domain of King Neptune. Until resorts became popular in the mid- to late nineteenth century, most of the storm damage was to wharfs and ships. Newspapers of the era often carried notices of these storms, such as the violent January gale in 1751 that destroyed docks along the coast and sent many vessels and their crews to their doom. The watery graveyard off the Jersey coast was fed by the robust shipping traffic to and from Manhattan, primitive navigational equipment, and the dangerous shallow shoals that dotted the uneven coastline.

Once people decided to vacation on the shore, storms began to take their toll on hotels, cottages, piers, and boardwalks. The history of the Long Branch piers is typical. The first attempt, the Bath House Pier, was constructed at the foot of Bath Avenue in 1828. It survived for twenty-six years until a nor'easter in November 1854 reduced it to a pile of waterlogged kindling. A second attempt in the summer of 1875 produced a pier and pavilion that lasted exactly one week before Neptune claimed it. The year 1879 saw the completion of the popular Ocean Pier, built of sturdy tubular iron. In July of that year, over seven thousand eager tourists paid a dime each to take a walk on the uncompleted massive structure. Nature was again angered over this new encroachment, and in December 1880 a blizzard sent the pier into the history books. Not to be beaten, the promoters rebuilt the next year; that pier lasted until 1893, when it was rammed by a tugboat.

Hurricanes took their toll on the new resorts. Many were simply known by the year they struck, since storms began to be named only after 1953. The Hurricane of September 1938 did over $500,000 worth of damage. One of the worst storms to raise havoc along the coastline was the Great Atlantic Hurricane of 1944. Boardwalks were shattered, several resorts were submerged under 6 feet of water, and some towns had their amusement sectors covered in 4 feet of sand.

Locals spoke of the 1944 hurricane as the storm of the century until 1962, when the Ash Wednesday Storm, or Great Atlantic Storm, paid a visit to the Jersey Shore and rearranged the coastline forever. The storm was not technically a hurricane but rather a deadly combination of conspiring factors: a new moon, force 10 and 11 winds, three days and nights of flood tides, and a succession of seven 25- to 35-foot waves, each of which smashed buildings and turned the debris into flying deadly missiles. Before the storm abated, the damage toll was $100 million.

Nor'easters and winter storms have always moved sand offshore; much of it moves back to shore during the summer. A series of nasty nor'easters in the early 1990s did great damage to the coastline. The 1991 Halloween Storm

began as a nor'easter off Nova Scotia and drew some power from weakening Hurricane Grace. A coconspirator was a Canadian high-pressure system that stalled the Halloween surprise and drove it clockwise along the New Jersey coast. Similar to the Great Atlantic Storm of 1962, the event lasted two days; before it vanished, it had caused close to $100 million worth of damage in New Jersey. No sooner had the residents taken a deep breath when another storm, in January 1992, ravaged the eroded and weakened coastline, quickly followed by another damaging storm on December 11.

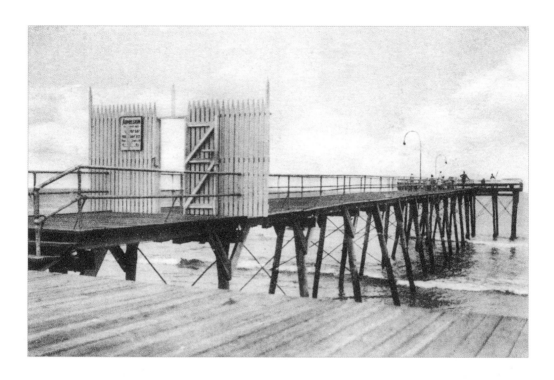

IMAGES OF GHOSTS ABOUND ON THE JERSEY SHORE—*buildings, piers, and boardwalks that were claimed by Mother Nature throughout the centuries. The resort of Beach Haven on Long Beach Island has been without a boardwalk since the Great Atlantic Hurricane of 1944 claimed it, along with several buildings and the beloved fishing pier pictured here. The town leaders decided that it was too costly to rebuild and sold some of the lumber that was salvageable to Atlantic City to repair that city's walkway, which had been damaged in the same storm.*

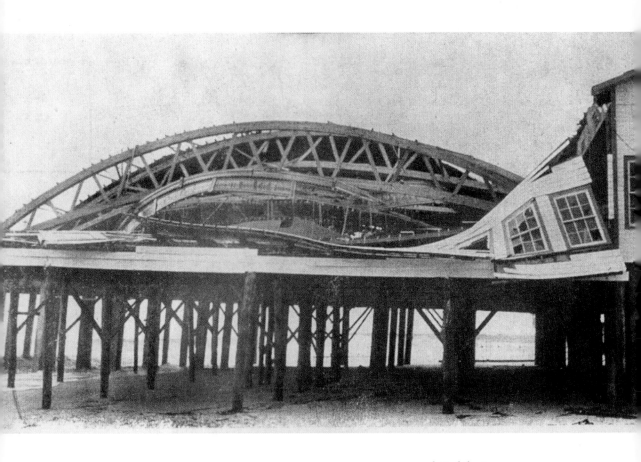

A CENTURY AGO DOZENS OF HAND-CARVED CAROUSELS *dotted the Jersey coast. One by one the wonderful amusement machines fell to the wrecker's ball, greedy collectors, and storms like the Great Atlantic Hurricane of 1944 that flattened the old carousel in Long Branch.*

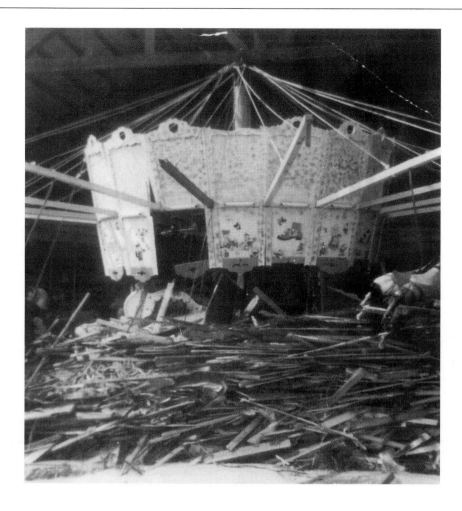

ANOTHER PRICELESS CAROUSEL *claimed by the angry Atlantic Ocean was the beauty that had graced the Sea Isle City boardwalk for decades. This time the storm was another twentieth-century monster, the Great Atlantic Storm of 1962, a nor'easter that tore most of the Jersey coast to shreds. The carousel was built by the famous craftsman William Dentzel, who worked in the Philadelphia area in the late nineteenth century.*

Sadly, in an attempt to form a breakfront to prevent further flooding in the resort, bulldozer operators crushed the remains of the beautiful wooden figures along with other storm debris. Local Sea Isle City historians have been unable to locate a photograph of the Dentzel carousel that created generations of memories on their boardwalk. Pictured here is all that remained after the 1962 storm.

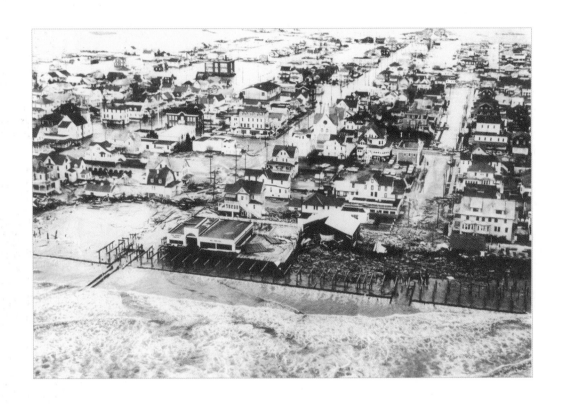

FEW STORMS DURING THE TWENTIETH CENTURY *packed the destructive power of what became known as the Great Atlantic Storm of 1962. This aerial view of Sea Isle City documents the devastation. The building that housed the Dentzel carousel can be seen in the center of the photograph just west of the boardwalk pilings.*

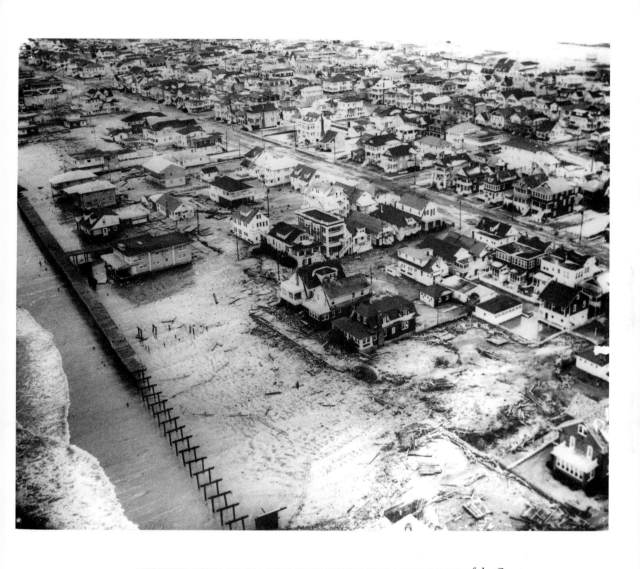

ANOTHER VIEW OF SEA ISLE CITY SHOWS THE AFTERMATH *of the Great Atlantic Storm of 1962. The resort had rebuilt its boardwalk after previous storms like the 1944 hurricane, but after 1962 Sea Isle City gave up on a wooden walkway and installed a promenade—in actuality a macadam seawall.*

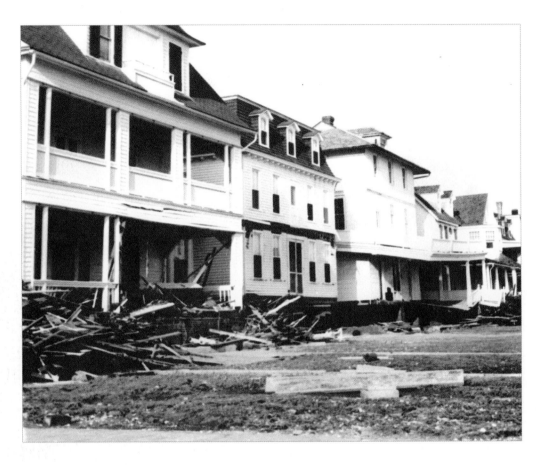

CAPE MAY DID NOT ESCAPE *the Great Atlantic Storm of 1962, as can be witnessed by the damage to the homes along Beach Drive.*

AN UNEXPECTED VISITOR TO THE JERSEY COAST *was the hurricane of 1938. While it ran head on into Long Island and New England, it glanced New Jersey and Manhattan and did considerable damage along the Jersey Shore, as pictured here at Tenth Avenue and Ocean in Belmar.*

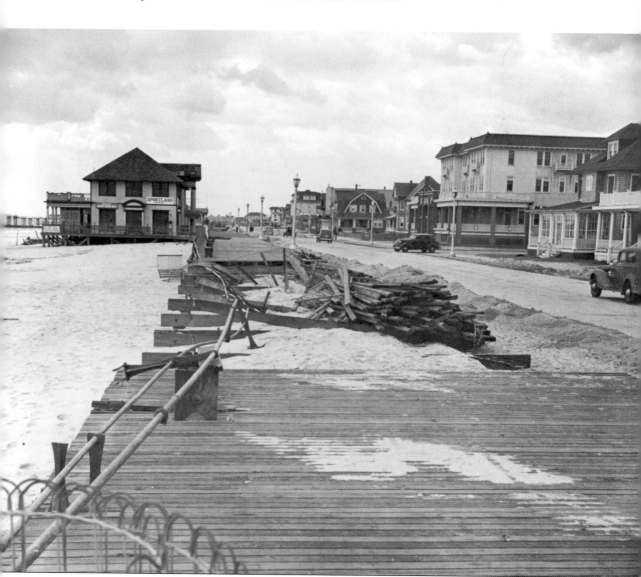

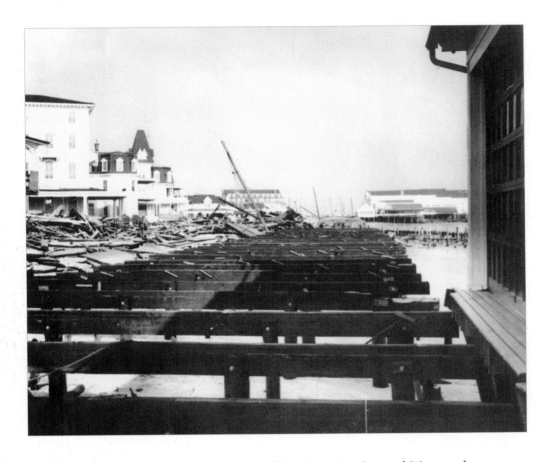

THE MARCH 8, 1962, HEADLINE *of the* Cape May Star and Wave *read,* *"Storm Wrecks Cape Beachfront," and it was a fact. The article stated that what had been a summer playground for centuries "now lies stricken, buried under untold tons of wreckage, sand and mud, victim of the most destructive coastal storm on record." Cape May, like its neighbor to the north, Sea Isle City, cried "uncle" and replaced the old wooden walkway with a macadam seawall that is still referred to as the boardwalk.*

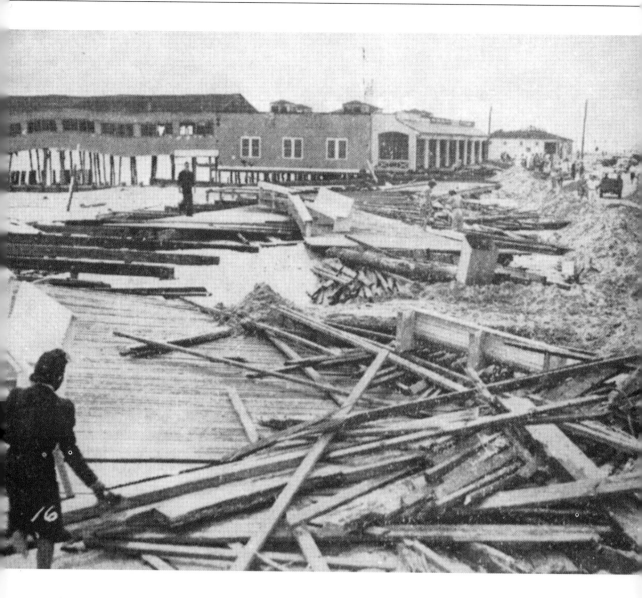

CAPE MAY WAS NO STRANGER *to violent storms, as can be seen by the photograph taken during the aftermath of the Great Atlantic Hurricane of 1944. The beachfront and boardwalk had the appearance of a war zone.*

THE NORTH END HOTEL AND BOARDWALK *at Ocean Grove after the 1944 hurricane. The storm destroyed every foot of the boardwalk, along with the resort's pavilion, and tossed boards like kindling into the hotels and cottages that bordered Ocean Avenue.*

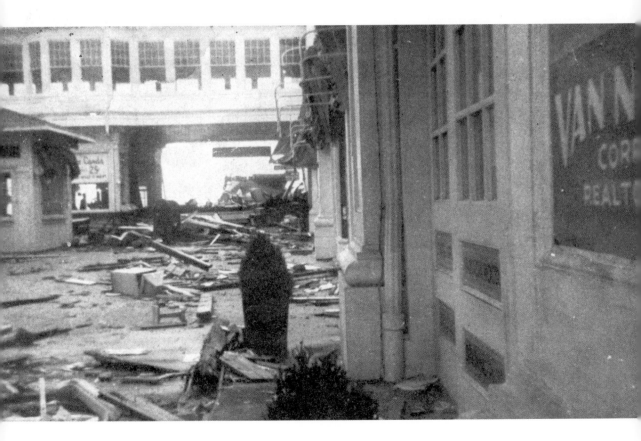

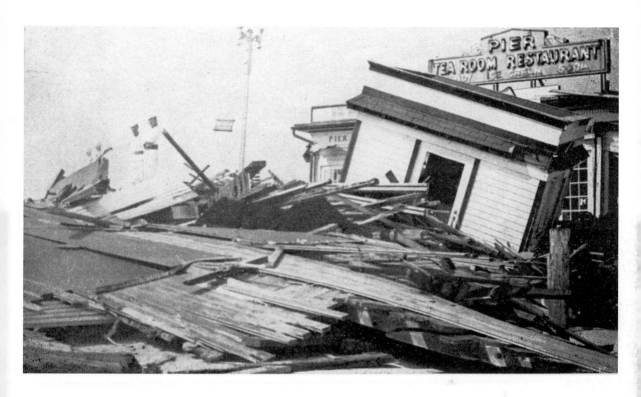

THE 1944 HURRICANE HAD NO MERCY *on the Asbury Park walkway. The fishing pier and concessions near the Casino were piled on each other in a mountain of debris. The storm was powerful enough to knock the news of World War II from the headlines for a few days that September.*

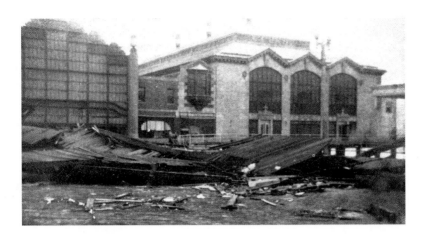

THE CASINO IN ASBURY PARK, *above, was damaged by the Great Atlantic Hurricane of 1944 but survived to see another day.*

ONE OF THE HARDEST HIT TOWNS *on the Jersey coast during the Great Atlantic Hurricane of 1944 was Ocean City, below. As the crushed and battered boardwalk and buildings offered no protection to the city, over fifty homes were destroyed, and hundreds of others were damaged. One of the first resorts to be hit by the hurricane, Ocean City was covered with over 6 feet of water, as house after house disintegrated under the power of the gargantuan gale.*

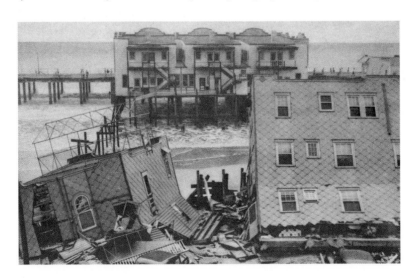

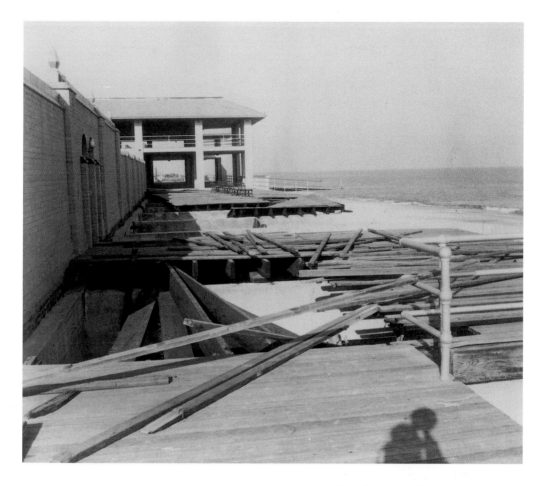

THOUGH NOT AS DESTRUCTIVE AS THE *1944 and 1962 storms, a hurricane in November 1953 left the boardwalk of normally tranquil Spring Lake in shambles.*

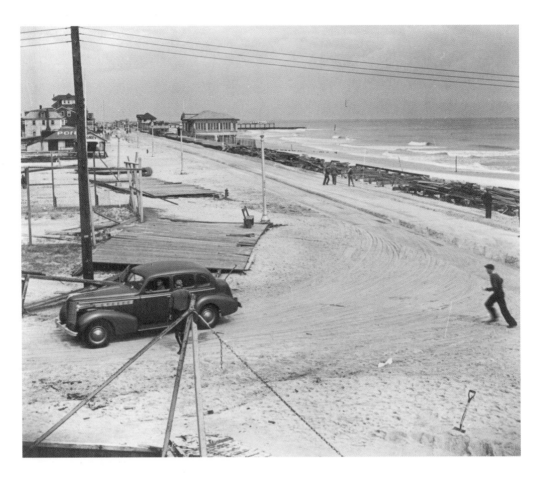

THE BELMAR BOARDWALK AFTER *the hurricane of September 1938. The caption of this image describes the damage as caused by a "tidal wave." This view is from Eighteenth to Seventeenth Avenues. September is the high season for hurricanes, and this monster storm surprised forecasters when, instead of heading east into the Atlantic near Cape Hatteras, North Carolina, as predicted, it headed north, crashing into Long Island and New England with ferocity not seen in the region for over a century. Although New Jersey was spared the full brunt, the near miss reminded those who chose to live by the sea of nature's unfathomable fury.*

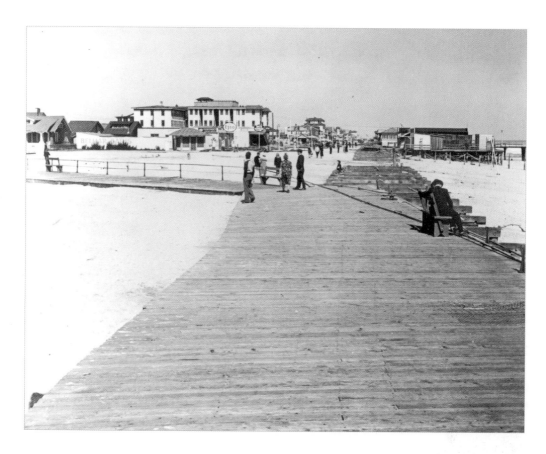

THIS VIEW OF THE BELMAR BOARDWALK *shows the extensive damage caused by the September 1938 hurricane. Storm surges of this magnitude could effortlessly toss large sections of the wooden walkway inland. Remnants of the boardwalk between Sixteenth and Fifteenth Avenues were scattered along the beachfront like pieces of kindling.*

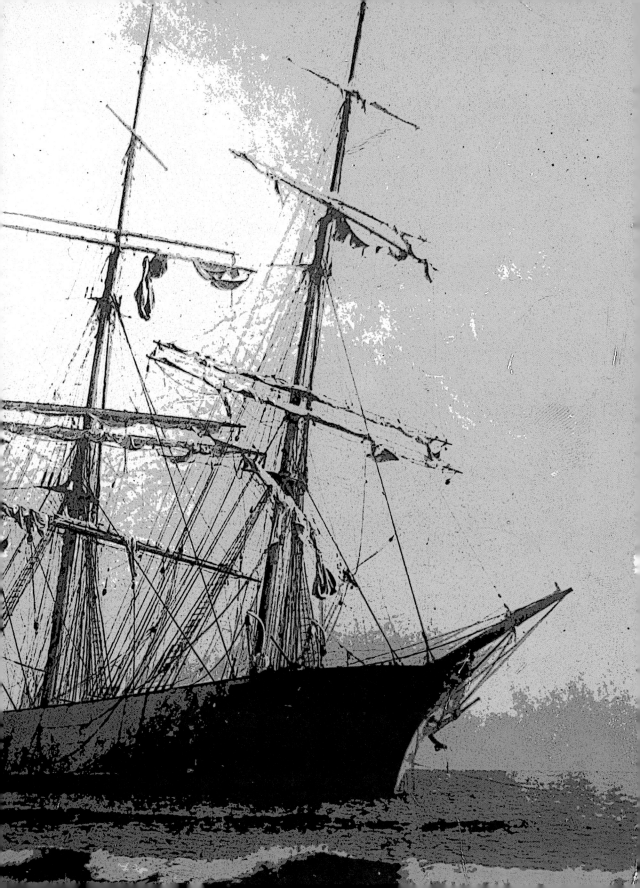

Shipwrecks and Lifesaving

IN 1766 A REPORTER DESCRIBED THE DESPERATE SCENE of a shipwreck off the Jersey coast, "I saw them, poor hearts, in the heights of their distress, where wind and sea had no pity, but could do no more than, regret and sympathize with my fellow mortals, while overwhelmed with calamities in the waging waves." That particular wreck took place off Cape May as the Scow *Nancy* on her voyage from Jamaica was destroyed by a violent gale that claimed twenty-three lives.

Eighteenth- and early-nineteenth-century newspapers were full of such reports of shipwrecks, and it is estimated that more than two hundred ships lie on the ocean floor off the coast of New Jersey. Thankfully, many crews were more fortunate than the victims of the *Nancy*. On another wreck that took place the same year off the coast of present-day Atlantic City, all were saved except the captain and first mate who foolishly attempted to launch a rowboat to shore during the gale and were lost to the sea. The rest of the crew waited until the next morning and at low tide walked to shore and safety. One of the survivors stole a wagon, helped himself to the surviving cargo, and was captured on his way to Philadelphia to sell his ill-gotten loot.

Plundering was a problem, especially among remote seaside villages where the residents barely scraped out a living. Most locals felt that someone else's loss was their gain. Some unfortunately took it to another level. Folklore along the coastline spoke of "wreckers" who would intentionally lure ships aground. An old trick was to hang a lantern from a mule's neck and to walk the beast back and forth along the shoreline on a misty or stormy

evening. An unfortunate captain who lost his bearings would think the light was from another vessel, a safe distance from shore, and would suddenly find his vessel snagged on a deadly shoal. "Pickens" filled many a seaside homestead or inn, and there were even reports of locals refusing to provide assistance, and rifling through the bodies as they came to rest on the beach.

Most shipwrecks occurred over the winter months, and in one nasty storm season—December 1826 to January 1827—two hundred wrecks occurred along Absecon Island. Records show that on one night alone five wrecks occurred on the Atlantic City beach with tremendous loss of life. A conservative estimate has the number of lives lost at twenty-five per season. As the nineteenth century progressed, more efforts were made to protect the valuable sea vessels and their crews. The federal government stepped in and constructed the second New Jersey lighthouse at Cape May in 1823. The first, eventually taken over by the government, had been built at Sandy Hook in 1761 by several Manhattan merchants seeking to protect their investments.

Lighthouses were saving lives; and by 1900 the United States government was operating fifteen lighthouses and a variety of smaller beacons along the 127-mile beachfront from Sandy Hook to Cape May. New Jersey has the honor of being the first state to appropriate funds—in 1848—for surfboats, rockets, and other lifesaving apparatus to save life and property.

William Newell, a congressman and later governor of New Jersey, is credited with these appropriations and other lifesaving initiatives. He was responsible for improvements on the breeches buoy, which came to national attention during an event in 1850. A brig *Ayrshire* out of Scotland was wrecked off of the wild shores of Absecon Island. More than two hundred Irish and British immigrants were aboard the *Ayrshire* in search of the American Dream, and had it not been for Newell's contraption they would have all gone to the bottom of the frigid Atlantic. A group of dedicated local fisherman carried a cannon-like device that fired a ball tethered to line that was then attached to the sinking vessel. A closed car was attached by a set of sturdy rings to the line, and over two days all but one of the passengers were saved.

The United States Life-Saving Service was formed in New Jersey from a group of battered huts along the windswept, desolate shores. An article in

Harper's Weekly in 1884 mentioned Long Branch and how the summer visitors were unaware of the small, standardized stations and their fearless crews who faced hardship and danger from September to May. By the time the article was written, the coasts of the United States were dotted with the stations, and loss of life in wrecks had been reduced by 75 percent. New Jersey had forty stations along its coast. The United States Life-Saving Service, forgotten now by most Americans, was absorbed into the United States Coast Guard Service at the beginning of the twentieth century.

THIS ILLUSTRATION DEPICTS THE INTERIOR *of a typical U.S. Life-Saving Service station. While some stations were unique, most adhered to the standards of this station.*

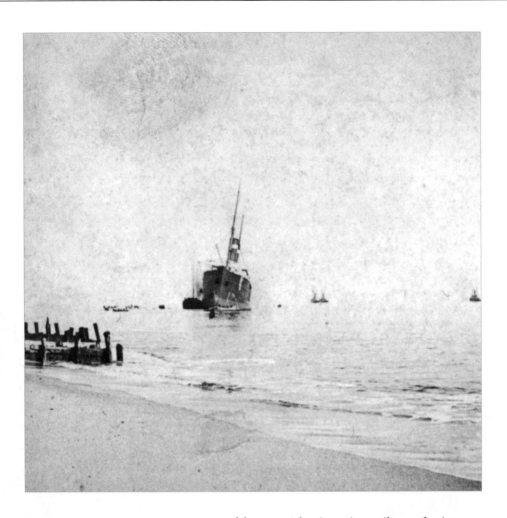

THE *ST. PAUL* WAS THE PRIDE *of the trans-Atlantic service until an unforgiving winter storm in 1896 off Long Branch drove the beautiful liner into the beach. This moment in time was captured for the popular stereograph market; and during the month that the ship was held in the Atlantic Ocean's powerful grip, tens of thousands of the curious visited the site. Special excursion trains were put into service to accommodate the crowds, and vendors lined the beach and made a killing. By early February the ship was freed with only minor damage; and the passengers and crew had a story to tell their families: They had escaped the wreck of the St. Paul.*

NOT ALL SHIPS WERE AS FORTUNATE *as the* St. Paul. *This wonderfully detailed illustration from 1867 depicts the skeleton of the* Dora A. Baker, *which had been viciously driven into the Long Branch bluff and battered to kindling in front of the Howland Hotel. Eight of the crewmembers were fortunate and survived as they slid down a rope that ran from the ship's mast to a beach piling. The famous bluffs are long gone, claimed by erosion and development.*

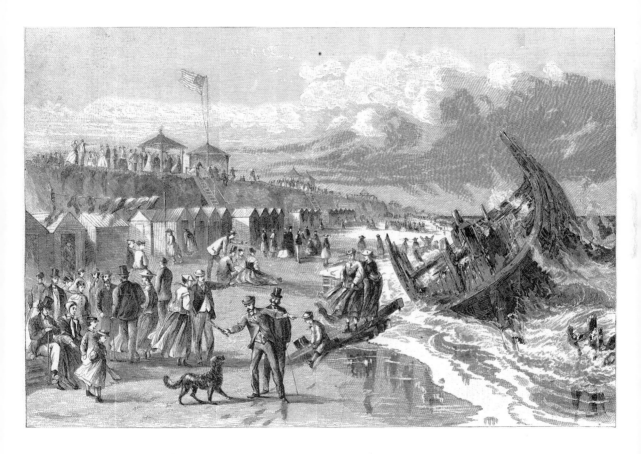

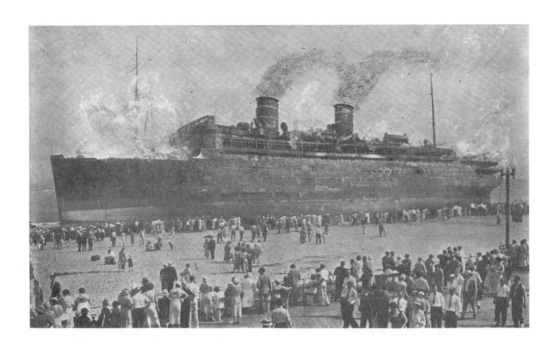

THE LUXURY LINER S. S. MORRO CASTLE, *once the pride of the Ward Line, looks like a scene from a Hollywood special effects wizard as it burns off the coast of Asbury Park on September 9, 1934. Although a brutal nor'easter paid a visit to the Jersey Shore during that September, it was not responsible for the loss of the ship. Fire destroyed the* Morro Castle, *and the cause has been shrouded in mystery for well over half a century. Arson and sabotage were suspected, for there had been previous attempts, but what is certain is that 455 people lost their lives on the ill-fated ship. The call of "fire" spread through the liner as it passed by Spring Lake during the early morning of September 8. The doomed vessel was covered in flames as it drifted toward Convention Hall in Asbury Park, eventually coming to rest on the busy resort's beach. A magnet for thousands of the curious, the ship burned itself out and slowly died on the Asbury Park coast well into that winter. In the end nothing but a gutted shell remained. A makeshift morgue had to be created in Sea Girt as bodies drifted ashore for months as far south as Manasquan.*

IN 1901 THE BRAVE MEN OF THE *Ocean City, New Jersey, U.S. Life-Saving Service were put to the test when the 3,068-ton, 329-foot, four-masted, steel-hulled bark* Sindia *was driven ashore by a four-day gale that the ship had encountered off the coast of Cape May. The crew of thirty-three, including Captain Allen McKenzie, fought the gale fearlessly until the seventy-mile-per-hour winds and waves drove the* Sindia *onto a sand bar off Ocean City and eventually split her hull in two. The ship, now filling with sand and water, came to rest parallel to 16th and 17th Streets. All hands were saved by the U.S. Life-Saving Service. The owners, the principal partner being oil mogul John D. Rockefeller, sent a salvage ship immediately to guard their property and save the contents of the wreck. Many locals helped themselves to "souvenirs" before the salvagers arrived on the scene. Money has privilege, and a U.S. Customs officer was assigned to the ship as a watchdog for four years as it sank deeper and deeper into the sand. There was always a*

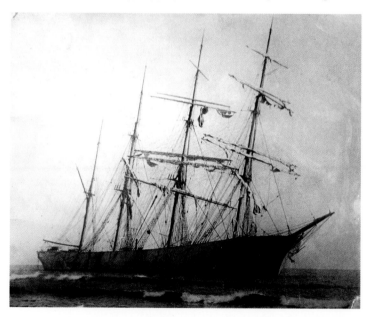

bit of a mystery surrounding what the cargo of the Sindia *was, with speculation ranging from silk and porcelain to a solid gold statue of Buddha. One mast of the* Sindia *was still visible in 1944 when the Great Atlantic Hurricane destroyed it. In 1962 the Great Atlantic Ash Wednesday Storm uncovered part of the ship and gave tourists a new photo opportunity. In 1991 the Ocean City beach was increased by almost 100 feet beyond the wreck in an ambitious Army Corps of Engineers beach replenishment project. Today, the remains of the* Sindia, *and possibly its secret treasure, are buried beneath the sand where thousands of beach lovers frolic each season. A small marker on the boardwalk is the only reminder of the doomed ship and indicates the location to those who stop and take a look.*

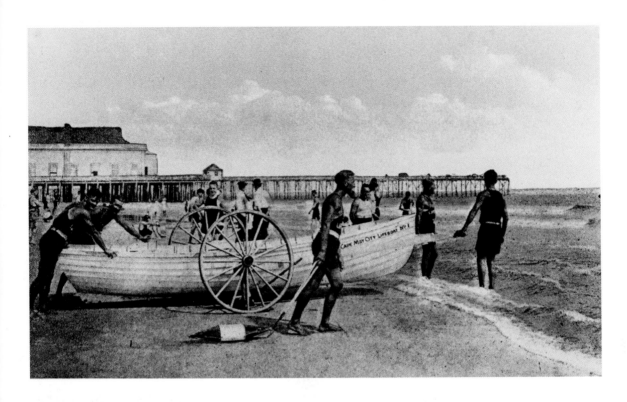

LIFE BOAT CREW NO. 1 AT CAPE MAY PREPARES TO LAUNCH *in this photo taken circa 1900. The boat crews would stay in the surf during bathing hours unlike the method used today of lifeguard lookout perches. Until these organized units were hired by the resorts, swimmers were pretty much on their own. A strong swimmer could collect sizable rewards for saving those who got caught in the undercurrent or wandered too far out to sea. Cape May had a local celebrity, Peter Paul Boynton, known as the "Pearl Diver," a gifted swimmer who made enough money rescuing tourists that he opened a gift shop in Cape May in the late 1860s. It is said that he saved over seventy lives in Cape May before moving on to Coney Island.*

IN 1839 DR. WILLIAM A. NEWELL, *of New Egypt, New Jersey, witnessed thirteen men lose their lives as they attempted to swim to shore when their ship, the* Count Perasto, *came aground off Long Beach Island. It was only 300 yards to shore but each man died in the turbulent seas as he made the futile attempt for shore and safety. Dr. Newell, determined to never see needless deaths like this again, created the concept of shooting a lifeline to a doomed vessel from a mortar-like device on shore. He petitioned the United States Congress, and in 1848 the first U.S. Life-Saving Service station using his new invention was funded and built on Sandy Hook. Deaths from shipwrecks were greatly reduced when Newell combined his invention with another New Jersey creation—an unsinkable life car that could run on Newell's line and carry stricken sailors and passengers to shore. By 1854 there were twenty-eight U.S. Life-Saving Service stations spaced five miles apart along the Jersey coast. This turn of the century image captures the Atlantic City seven-man crew preparing to launch its lifeboat.*

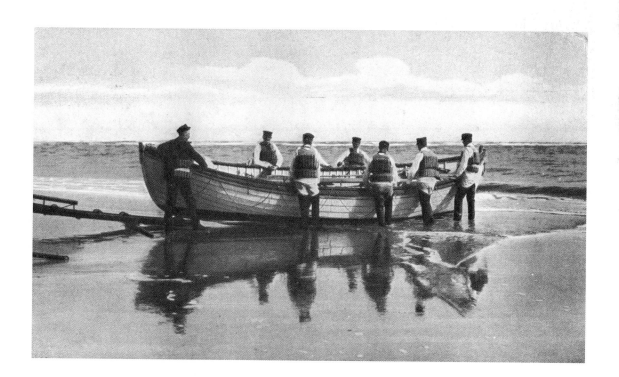

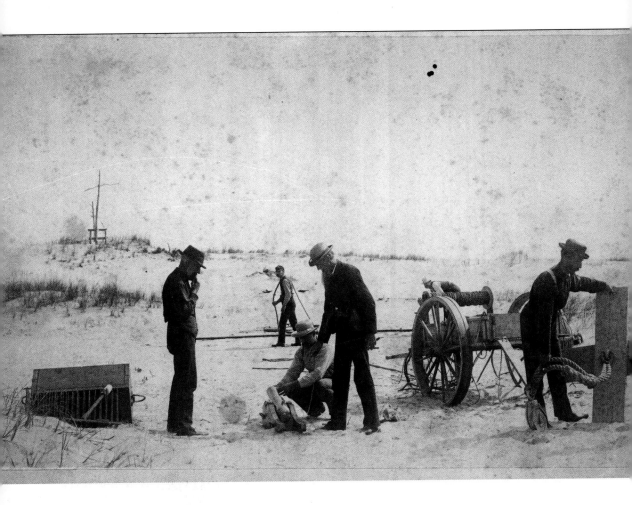

THIS VINTAGE CIRCA 1890 VIEW SHOWS A TYPICAL *U.S. Life-Saving Service crew training on the cannon line before the service required standardization in 1899. The cross in the upper left hand of the photo is being used as a target simulating the mast of a stricken ship. The cannon the crew is using is a short-barreled, 175-pound Lyle Gun that in the right hands was accurate up to 600 yards. The unit had to be portable yet powerful enough to launch an almost twenty pound projectile that carried the lifeline and the promise of rescue to the vessel.*

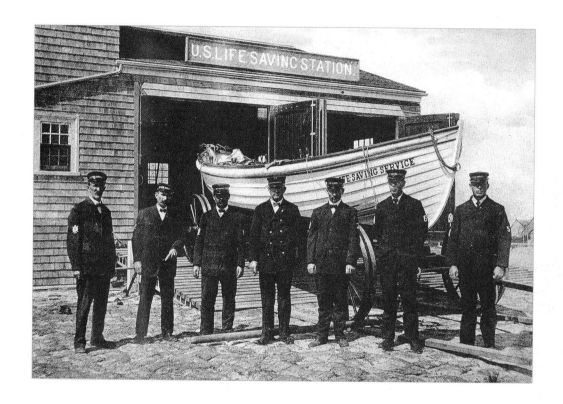

EACH U.S. LIFE-SAVING SERVICE *station along the coast was manned by seven-man teams—a keeper and six crew members. They were expected to occupy the station straight through from September through April. The men of the Long Beach station in Beach Haven pose proudly in front of their boat and station for this photo taken around 1912. Theirs was one of six stations that once protected the coastline of Long Beach Island. Each station along the Jersey coast was standardized in size, entrances, and even color—red. Not unlike vintage firehouses of today, stations had a small mess, bunkhouse, and a room for the crew's equipment and boat.*

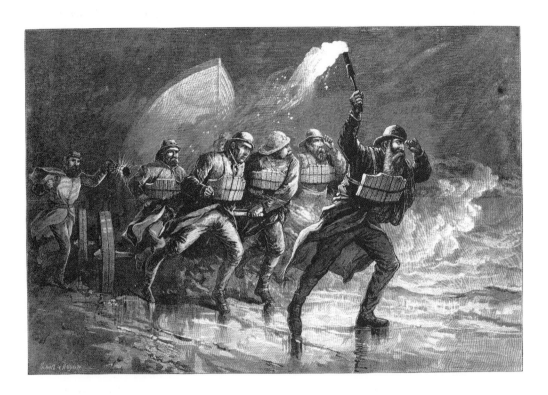

THE TERROR OF A SHIPWRECK *at night is depicted in this nineteenth century illustration. The men of the U.S. Life-Saving Service were skilled fishermen and expert boat operators. Their rescue boats were transported to the wild surf on two-wheeled carriages. Two men boarded the boat as the others would push and pull the craft as far into the surf as the carriage would permit. Once the boat was afloat, four additional oarsmen would jump on and bend their backs rowing furiously and courageously to reach the stricken vessel. Two men would leave the station during the night for their lonely four-hour watch, one heading south and the other north. As they met their counterparts from the next station, they would exchange a small brass token to document that they were on duty and would part ways torch in hand.*

AS MUCH A CURIOSITY *as a shipwreck, the concrete ship* Atlantus *is pictured here when it was still visible from shore in Cape May Point. The ship was one of twelve concrete-hulled cargo vessels built during World War I because of a steel shortage. It did not take long to realize that making ships out of concrete was not a wonderful idea, and the dozen heavyweights were the last of their kind. For years the public and land investors realized the value of a reliable ferry service that would connect the tip of the Jersey cape with Delaware. There were just twelve miles of water connecting the destinations, and a ferry would eliminate the 170-mile automobile trip over rough roads between Cape Henlopen, Delaware, and Cape May Point, New Jersey. Cape May would no longer be the dead-end of the Jersey peninsula. It was the roaring twenties and nothing seemed impossible. Jesse Rosenfeld, a Baltimore businessman, planned to create a ferry service between Cape May and Delaware by purchasing three of the 250-feet long concrete ships and sinking them near the old steamboat landing at Cape May Point to form a Y-shaped dock. The* Atlantus *was towed from the James River in Virginia, and although it seemed*

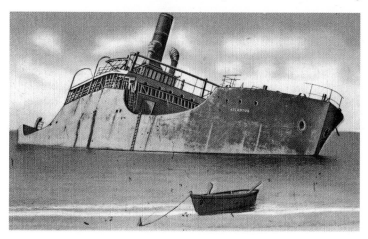

to want to sink for most of the harrowing trip, it arrived safely in New Jersey on June 8, 1926. Ferry fever ran high and investors realized the potential of Rosenfeld's scheme, but it was not to be: Before the other two boats could be relocated, the Atlantus, *still determined to sink on her own terms, broke her moorings during a violent Atlantic gale and sank deep into the sand in shallow waters within sight of land. The ferry dream collapsed, and the concrete ship became the subject of boatloads of postcards and a stop on the Cape May sightseeing tour. The public would have to wait another forty-three years before ferry service became a reality. The rusting hulk was subjected to the fury of the Atlantic and disappeared deeper into the sand each year and into the history books.*

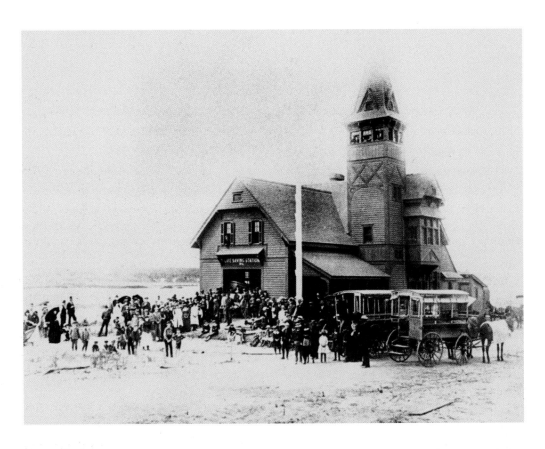

THE U. S. LIFE-SAVING SERVICE *stations were mandated to be standardized, but it was impossible to prevent the wealthier communities such as the town of Deal from showing off a bit as documented in this photograph of the Deal Life-Saving Service station. The ornate structure of the building gave it the appearance of a summer cottage rather than a station. The quarters may have had the appearance of privilege, but the crew that* *occupied it was known as one of the best and most fearless on the coast. In 1882, the year the station was under construction, the men rescued over sixty souls from a stricken vessel off the north Jersey coast. Since the crew was always on duty during the season, it was not unusual for the community to visit them on Sundays or holidays as depicted in this photograph.*

Bibliography

Ayres, Shirley, and Troy Bianchi. *Bradley Beach.* Mount Pleasant, SC: Arcadia, 2004.

Barrett, Richmond. *Good Old Summer Days, Newport, Narragansett Pier, Saratoga, Long Branch, Bar Harbor.* Boston: Houghton Mifflin, 1952.

Beitel, Herb, and Vance Enck. *Cape May County, A Pictorial History.* Virginia Beach, VA: The Donning Company Publishers, 1998.

Boulton, Agnes. *Part of a Long Story.* New York: Doubleday, 1958.

Buchholz, Margaret Thomas, ed. *Shore Chronicles, Diaries and Travelers' Tales from the Jersey Shore, 1764–1955.* Harvey Cedars, NJ: Down The Shore Publishing, 1999.

Burton, Hal. *The Morro Castle.* New York: Viking Press, 1973.

Cappuzzo, Michael. *Close To Shore: A True Story of Terror in an Age of Innocence.* New York: Broadway Books, 2001.

Coad, Oral S. *New Jersey in Travelers' Accounts 1524–1971: A Descriptive Bibliography.* Metuchen, NJ: The Scarecrow Press, Inc., 1972.

Cunningham, John T. *The New Jersey Shore.* New Brunswick, NJ: Rutgers University Press, 1958.

———. *The New Jersey Sampler: Historic Tales of Old New Jersey.* Upper Montclair, NJ: New Jersey Almanac Inc., 1964.

Davis, E. *Atlantic City Diary: A Century of Memories.* Atlantic City, NJ: Atlantic Sunrise Publishing Company, 1985.

Dorsey, Leslie, and Janice Devine. *Fare Thee Well.* New York: Crown Publishers, 1964.

Dorwart, Jeffrey. *Cape May County, N.J.: The Making of an American Resort Community.* New Brunswick, NJ: Rutgers University Press, 1992.

Ellis, Franklin. *History of Monmouth County, New Jersey.* Philadelphia: R. T. Peck and Company, 1885.

Federal Writers' Project of the Works Progress Administration for the State of New Jersey. *Stories of New Jersey.* New York: M. Barrows and Company, 1938.

Fernicola, Richard. *Twelve Days of Terror.* Guilford, CT: The Lyons Press, 2001.

Fraley, Tobin. *The Carousel Animal.* Berkeley, CA: Zephyr Press, 1983.

Francis, David, Diane Francis, and Robert J. Scully Sr. *Wildwood by the Sea: The History of an American Resort.* Fairview Park, OH: Amusement Park Books, 1998.

Funnell, Charles E. *By the Beautiful Sea.* New Brunswick, NJ: Rutgers University Press, 1983.

Futrell, Jim. *Amusement Parks of New Jersey.* Mechanicsburg, PA: Stackpole Books, 2004.

Genovese, Peter. *New Jersey Curiosities.* Guilford, CT: The Globe Pequot Press, 2003.

———. *The Jersey Shore Uncovered: A Revealing Season on the Beach.* New Brunswick, NJ: Rutgers University Press, 2003.

Immerso, Michael. *Coney Island, The People's Playground.* New Brunswick, NJ: Rutgers University Press, 2002.

Johnson, Nelson. *Boardwalk Empire: The Birth, High Times, and Corruption of Atlantic City.* Medford, NJ: Plexus Publishing, Inc., 2002.

Kent, Bill, Robert E. Ruffolo Jr., and Lauralee Dobbins. *Atlantic City, America's Playground.* Carlsbad, CA: Heritage Media Corp., 1998.

Kobbe, Gustav. *The New Jersey Coast and Pines.* New York: Gustav Kobbe Company, 1889.

Lee, Harold. *Ocean City Memories.* Ocean City, NJ: Centennial Commission, 1979.

Levi, Vicki Gold, and Lee Eisenberg. *Atlantic City: 125 Years of Ocean Madness.* New York: Clarkson N. Potter, 1970.

Lloyd, John Bailey. *Eighteen Miles of History of Long Beach Island.* Harvey Cedars, NJ: Down The Shore Publishing, 1986.

McMahon, William. *So Young . . . So Gay! Story of the Boardwalk 1870–1970.* Atlantic City, NJ: Atlantic City Press, 1970.

Miller, Fred. *Ocean City, America's Greatest Family Resort.* Mount Pleasant, SC: Arcadia, 2003.

Moss, George H. Jr. *Steamboat to the Shore.* Locust, NJ: Jersey Close Press, 1966.

Moss, George H. Jr., Karen L. Schnitzspahn, and John T. Cunningham. *Victorian Summers at the Grand Hotels of Long Branch, New Jersey.* Sea Bright, NJ: Ploughshare Press, 2000.

Nowever Then, official Web site of Peter Lucia. *Asbury Park.* www.noweverthen.com/ap index/html.

Roberts, Russell, and Rich Youmans. *Down the Jersey Shore.* New Brunswick, NJ: Rutgers University Press, 1993.

Salvini, Emil R. *The Summer City by the Sea: Cape May, New Jersey—An Illustrated History.* New Brunswick, NJ: Rutgers University Press, 1998.

Santelli, Robert. *The Jersey Shore: A Travel and Pleasure Guide.* Charlotte, NC: The East Woods Press, 1986.

Savadove, Larry, and Margaret Thomas Buchholz. *Great Storms of the Jersey Shore.* Harvey Cedars, NJ: Down The Shore Publishing, 1993.

Scovell, Jane. *Oona, Living in the Shadows. A Biography of Oona O'Neill Chaplin.* New York: Warner Books, 1998.

Stafford, Mike. *I'd Do It All Again . . . But Slower. The Philly/Sea Isle Connection.*

Stansfield, Charles, A., Jr. *Vacationing on the Jersey Shore.* Mechanicsburg, PA: Stackpole Books, 2004.

Sterngass, Jon. *First Resorts, Pursuing Pleasure at Saratoga Springs, Newport & Coney Island.* Baltimore and London: The John Hopkins University Press, 2001.

Waltzer, Jim, and Tom Wilk. *Tales of South Jersey, Profiles and Personalities.* New Brunswick, NJ: Rutgers University Press, 2001.

Wilson, Harold F. *The Story of the Jersey Shore.* Princeton, NJ: D. Van Nostrand Company, Inc., 1964.

———. *The Jersey Shore: A Social and Economic History of the Counties of Atlantic, Cape May, Monmouth and Ocean.* New York and Chicago: Lewis Historical Publishing Company, 1953.

Woolman, H. C., and T. T. Price. *Historical and Biographical Atlas of the New Jersey Coast.* Philadelphia: Woolman and Rose, 1878.

Wortman, Byron C., *The First Fifty: A Biographical History of Seaside Heights.* Edited by George Zuckerman. Seaside Heights, NJ: 50th Anniversary Committee, 1963.

Wrege, Charles D. *Spring Lake, An Early History.* Spring Lake, NJ: Bicentennial History Committee, 1976.

Writers' Program of the Works Progress Administration for the State of New Jersey. *Entertaining a Nation, The Career of Long Branch.* American Guide Series. Long Branch, NJ, 1940

Collection and Photo Credits

York Public Library, Astor, Lenox and Tilden Foundation

Page 62, Rick Zitarosa, Point Pleasant, NJ

Page 63, Author's Collection

Page 64, Peter Lucia

Page 65, Peter Lucia

Pages 66/67, Author's Collection

Pages 68/69, Author's Collection

Pages 70/71, Author's Collection

Page 72, H. Gerald McDonald

Page 73, Courtesy of Wildwood Historical Society

Page 74, Morey's Mariners Landing Pier, Wildwood New Jersey

Page 75, Author's Collection

Page 76, Author's Collection

Page 77, Author's Collection

Page 78, Author's Collection

Page 79, North Light Photographers, Edison, NJ

Page 80, Ocean County Historical Society

Page 81, (Top) Ayres/Bianchi

Page 81, (Bottom) Author's Collection

Page 82, Emil Salvini

Page 84, Author's Collection

Page 85, Robert N. Dennis Collection of Stereoscopic Views, Miriam and Ira D. Wallach Division of Art, Prints and Photographs, The New York Public Library, Astor, Lenox and Tilden Foundation

Pages 86/87, Author's Collection

Page 88, Author's Collection

Page 89, Author's Collection

Page 90, Author's Collection

Page 91, Courtesy of Cape May County Historical Society

Pages 92/93, Author's Collection

Page 94, Author's Collection

Page 95, Author's Collection

Page 96, Author's Collection

Page 97, Author's Collection

Pages 98/99, Curtis Bashaw

Page 100, Sea Isle City Historical Museum

Page 101, Peter Lucia

Pages 102/103, Author's Collection

Page 104, From the collection of Robert E. Ruffolo, Jr., Princeton Antiques

Pages 108/109, © 1978 Joel Bernstein. Used with permission.

Page 110, Peter Lucia

Page 111, Author's Collection

Pages 112/113, Author's Collection

Page 114, Monmouth County Historical Association Library and Archives

Page 115, Author's Collection

Page 116, From the collection of Robert E. Ruffolo, Jr., Princeton Antiques

Page 117, From the collection of Robert E. Ruffolo, Jr., Princeton Antiques

Page 118, From the collection of Robert E. Ruffolo, Jr., Princeton Antiques

Page 119, From the collection of Robert E. Ruffolo, Jr., Princeton Antiques

Page 120, From the collection of Robert E. Ruffolo, Jr., Princeton Antiques

Page 121, (top and bottom) From the collection of Robert E. Ruffolo, Jr., Princeton Antiques

Page 122, Courtesy of Wildwood Historical Society

Page 126, Author's Collection

Page 127, Author's Collection

Page 128, R.C. Maxell Collection Emergence of Advertising On-Line Project. John W. Hartman Center for Sales, Advertising & Marketing History, Duke University Rare Book, Manuscript, and Special Collection Library

Page 129, Author's Collection

Page 130, Monmouth County Historical Association Library and Archives

Page 131, Monmouth County Historical Association Library and Archives

Page 132, Author's Collection

Page 133, R.C. Maxell Collection Emergence of Advertising On-Line Project. John W. Hartman Center for Sales, Advertising & Marketing History, Duke University Rare Book, Manuscript, and Special Collection Library

Page 134, R.C. Maxell Collection Emergence of Advertising On-Line Project. John W. Hartman Center for Sales, Advertising & Marketing History, Duke University Rare Book, Manuscript, and Special Collection Library

Page 135, Monmouth County Historical Association Library and Archives

Page 136, Author's Collection

Page 137, Author's Collection

Page 138, Courtesy of Wildwood Historical Society

Page 139, Courtesy of Wildwood Historical Society

Page 140, Asbury Park Public Library, Asbury Park, New Jersey

Page 141 (top and bottom) Monmouth County Historical Association Library and Archives

Page 142, H. Gerald MacDonald

Page 145, Author's Collection

Page 146, (top) Ocean City Historical Museum, Inc.

Page 146, (bottom) Author's Collection

Page 147, Author's Collection

Pages 148/149, Author's Collection

Page 150, Author's Collection

Page 151, Author's Collection

Page 152, Author's Collection

Page 153, Author's Collection

Page 154, Author's Collection

Page 155, Author's Collection

Page 156, Author's Collection

Page 157, Author's Collection

Page 158, H. Gerald MacDonald

Page 159, Author's Collection

Page 160, H. Gerald MacDonald

Page 161, Author's Collection

Page 162, Author's Collection

Page 164, Author's Collection

Page 165, Author's Collection

Page 166, Author's Collection

Page 167, Sea Isle City Historical Museum

Page 168, Sea Isle City Historical Museum

Page 169, Sea Isle City Historical Museum

Page 170, Courtesy of Cape May County Historical Society

Page 171, Author's Collection

Page 172, Author's Collection

Page 173, Author's Collection

Page 174, Author's Collection

Page 175, Author's Collection

Page 176, (top and bottom) Author's Collection

Page 177, Spring Lake Historical Society

Page 178, Author's Collection

Page 179, Author's Collection

Page 180, Ocean City Historical Museum, Inc.

Page 183, Author's Collection

Page 184, Ocean City Historical Museum, Inc.

Page 185, Author's Collection

Page 186, Author's Collection

Page 187, Ocean City Historical Museum, Inc.

Page 188, Author's Collection

Page 189, Author's Collection

Page 190, Ocean City Historical Museum, Inc.

Page 191, Author's Collection

Page 192, Author's Collection

Page 193, Author's Collection

Page 194, Author's Collection

Page 197, Author's Collection

Index